THE GEOMETRICAL FOUNDATION OF NATURAL STRUCTURE

THE GEOMETRICAL FOUNDATION OF NATURAL STRUCTURE

A SOURCE BOOK OF DESIGN

Robert Williams

DOVER PUBLICATIONS, INC.
NEW YORK

Published in Canada by General Publishing Company, Ltd., 30 Lesmill Road, Don Mills, Toronto, Ontario.
Published in the United Kingdom by Constable and Company, Ltd.

This Dover edition, first published in 1979, is an unabridged and corrected republication of the work originally published by the Eudaemon Press, Moorpark, California, in 1972 under the title *Natural Structure*. The author has contributed a new preface and additional bibliography to this Dover edition.

International Standard Book Number: 0-486-23729-X
Library of Congress Catalog Card Number: 78-74118

Manufactured in the United States of America
Dover Publications, Inc.
180 Varick Street
New York, N.Y. 10014

My intention in writing *Natural Structure* was to present in a single book a comprehensive body of theoretical information on geometric form in space--*form language*--for the use of architects, environmental designers, and scientists. The book remains an important resource for those exploring the beautiful interrelationships among geometric forms. It is a logical whole, complete in itself.

The Dover volume retains this wholeness. I have taken the opportunity presented by this new edition to make many improvements in phrasing, to correct small typographical errors, to change a few of the illustrations, and to enlarge the bibliography substantially. Beyond this, the work is the same. All the geometry contained in it is derived from such scientific disciplines as mathematics, physics, chemistry, botany, and virology.

In the seven years that have elapsed since the original publication, the chief emphasis of my research has been on the symbolic content of form, and today I would no longer stress the strictly scientific approach. Logical argument now seems to offer only a partial explanation of the universal language of nature, in which a form, in the words of D'Arcy Thompson, is really a "diagram of forces." I now see geometry as touching our sense of being, as a bridge between the universe and each of us.

Nevertheless, whether or not scientific principles are considered as paramount, *Natural Structure*, with its purely scientific foundation, is still a basic research tool.

Robert Williams

San Cristóbal de las Casas

Chiapas, Mexico

PREFACE TO THE FIRST EDITION

A forest of oil derricks has darkened a mountain in my city for thirty years. When I was five years old my father pointed it out to me. I went home later and built a model of a derrick from toothpicks and glue. Since that day structure has been a love of mine.

As an undergraduate, I built other enlaced structures which could cradle loads I once thought impossible. I owe Peter Pearce a debt of gratitude for those design problems, and for introducing me to the writings of R. Buckminster Fuller. They inspired me in those years. I met Fuller on one occasion near the beginning of my two years of graduate study in Design at Southern Illinois University. Although I owed him an intellectual debt, I decided soon after our meeting that I could learn more on my own. I spent the two years by myself, really, studying concepts of structure from everything I could grasp in physics, biology, botany, chemistry, virology, metallurgy, mathematics, psychology, sociology, and anthropology. My studies were random, intuitive, incomplete, chaotic, and exciting. I recommend this approach to everyone.

I thank H. F. W. Perk, now Chairman of the Department of Design, and Dr. Ronald Hanson, Director of the Office of Research and Projects, Southern Illinois University, for their interest and support during those two years. Through Bill Perk I was introduced to the mathematician-astronomer, Dr. Albert G. Wilson, Director of Environmental Sciences, McDonnell-Douglas Advanced Research Laboratories. I was later invited to the laboratories as a visiting research associate to be a member of a small group of scientists investigating *general structures*. I was something of an experiment to Al Wilson— an artist trying to become a scientist. He and mathematician Donna Wilson spent a great deal of time with me. It was principally through their efforts that I learned the value of methodologies, and expanded my ideas of structure to areas I had not considered before. I very much needed all of this.

In early 1969 I left the laboratories to join the Department of Design, Southern Illinois University, as a visiting lecturer. At about this time, from readings in linguistics, the following idea germinated: If properly organized and presented, the forms and structures that I had investigated in physical and life science could be considered as basic components of a *Form Language* for the field of environmental design. Until this time my principal concern was with the application of physical form to the human environment by translating forms into engineering structures. The concept of a

Form Language had a broader base and would be useful, not only to those with interests in industrialized building, but also to those who were beginning to use new architectural forms as expressions of the universal consciousness in living.

This work is a significant expansion of my *Handbook of Structure*, published by the McDonnell-Douglas Advanced Research Laboratories in 1968. The illustrations were started in late 1969. The writing began in earnest in mid 1970, after I joined the research staff of Eomega Grove, an educational-research community founded by Donna and Al Wilson. Many ideas found here were developed at workshops in design methodologies at both DARL and Eomega Grove. I thank Donna and Al Wilson for their valuable help in these studies. Appreciation also goes to Robert Brooks, Ernest Callenbach, Eugene Nutt, and Mary Richardson for discussions and criticisms.

This work is primarily concerned with geometric form in space derived from natural structures. It is also concerned with the reasons why those who design need to develop a generalized consciousness of form—a *Form Language*—to be more meaningful in their work. This consciousness can manifest itself in two ways: First, it can enable designers to have a working vocabulary of form, rather than catalogues of existing artifacts, upon which to draw in creating designs. Second, it can release those who design to direct their energy to the problems in the design process, particularly those problems relating the user to the form, which are often neglected in contemporary designs.

As in any developing, changing, and vigorous area of human concern, design integrates both knowledge and methodologies from other areas and uses new information in solutions to design problems. Unlike those in many fields, the designer finds many areas of human concern relevant to his field. For example, designers, artists, architects—those who make form—have consistently borrowed from science, religion, and nature itself in order to give a unified or integrated view of man and the universe. In this tradition, the data and methodologies presented here—comprising the basis for a unified *Form Language*—are taken from many scientific sources in many specialized fields. The information is organized in ways that are useful to those who design and others—scientists and engineers--who believe that a knowledge of geometric form in space is vital to their work. For those who are visually oriented, over 500 descriptive drawings of form are presented. A descriptive text is also included, together with basic mathematics of form through which one can develop another kind of understanding of form.

Part One, consisting of one chapter, is concerned with *Models*. Our models are not the physical forms with which the designer, engineer, and architect feel most comfortable. Rather, they are conceptual models—models that men have found helpful in descriptions of various natural phenomena, models that may be useful in the develop-

ment of a *Form Language*, models that have been useful in descript-
ions of physical space, and models of hierarchies of forms.

Part Two, consisting of four chapters, is concerned with *Geometry*
and the elucidation of forms from both geometry and natural structure,
useful in spatial organizations of all kinds. Our concern here is
with organizations of circles and polygons in the two-dimensional
plane; then with polyhedra, sphere packings, and polyhedra packings
in three-dimensions.

Part Three is concerned with the *Methodologies* through which we
can conceptualize and visualize change in physical form. We begin
with simple methods, then move to complex methods, and conclude with
examples of the uses of the methodologies. *Part Three* is both the
most difficult and, I believe, the most important part of the work.
It is difficult because, for each method, only a few examples are
given. In order to fully appreciate the value of the methods, we
should be familiar with the forms in *Part Two*. (In this respect,
extensive use of physical models of forms is most helpful.) It is
important because from these methods countless new forms can be gen-
erated. Our imagination is the only limitation.

References to every source accessable to me are included in the
text for the reader who wishes to begin his own studies. A selected
bibliography of the sources that I found most helpful is included in
the back of the book. To be entered, a book had two characteristics:
First, it synthesized a great deal of information; second, it includ-
ed extensive references and bibliographies for further independent
research.

Finally, I hope that the forms presented here are not simply
extracted and applied to the human environment without careful con-
siderations of the impact that form has on human spirit, psyche, and
behavior.

<div align="right">Robert Williams</div>

Eomega Grove
Topanga, California
18 December 1970

ACKNOWLEDGEMENTS

I wish to thank the following for permission to copy drawings from copyrighted material: S. Baer, M. Burt, D. L. D. Caspar, K. Critchlow, L. Fejes Tóth, G. A. Jeffrey, L. Pauling, S. Samson, C. S. Smith, D. Stuart, A. F. Wells, and M. I. T. Press.

I also wish to thank the following for permission to print passages from copyrighted material: C. Alexander, C. Argyris, Mrs. H. D. Duncan, R. Sommer, and M. I. T. Press.

CONTENTS

xiii

CHAPTER 3
POLYHEDRA

CHAPTER 4
AGGREGATIONS OF SPHERES

CHAPTER 5
POLYHEDRA PACKING AND SPACE FILLING

PART THREE METHODOLOGIES

CHAPTER 6
GENERATING FORM

PART ONE
MODELS

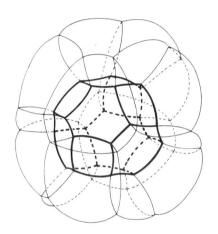

CHAPTER 1

INTRODUCTION: DESIGN AND THE FORM LANGUAGE CONCEPT

Aristotle's article of faith—*Nature does nothing in vain*—has stimulated Western thought, from religious to scientific to aesthetic, from the moment it was written 2500 years ago. Theologians transformed *nature* to mean *god*, and through this they were able to give Western man a formalized higher purpose. Scientific thinkers interpreted the statement to mean: *nature* has an inherent order beyond that which man brings to his observations. This thinking allowed them to interpret *nature* through the use of powerful algorithms—mathematics. The artist—maker of form—usually found himself somewhere between these two positions, making the best use of each for his personal purposes or for the purposes determined by his culture. At certain times in history the artist relied heavily on religious scholasticism for interpretations of natural phenomena; today he moves toward an exclusively scientific interpretation.

The apparent corollary to Aristotle's statement—*Nature is economical*—was probably stated, or felt at least, long before the twentieth century. Scientists were particularly fascinated with the economic motions and economic use of space exhibited in natural systems.

It was not until the mid-nineteenth century, however, that the corollary began to offer important insights into architecture, engineering, and design theories. For example, Joseph Paxton's *Crystal Palace*, inspired by the leaf formation of the *Victoria regia*, was one of the first building systems using mass production techniques.[1] Paxton's pioneering fundamentally redirected the conceptual bases, analyses, and construction techniques for later buildings and structures.

Since the *Crystal Palace*, important architectural structures have been developed using the geometry of natural structures, from soap films to crystals, as the conceptual basis for designs. Some

[1] Wachsmann, K. 1961. *The Turning Point of Building*. New York: Reinhold Publishing Corp.

3

of the invented structures have shown that the geometry of natural structures provide economies not previously considered possible. Among many worth mentioning are the invention of the tetrahedron-octahedron truss (circa 1900) by Alexander Graham Bell;[2] the invention of the geodesic dome (circa 1950) by R. Buckminster Fuller;[3] the thin shell constructions of Felix Candella[4] and Pier Luigi Nervi;[5] and the tension structures of Frei Otto.[6]

It is not my purpose here to decide whether structures in nature are economical in themselves, or whether their application to the human environment is economical or even worthwhile. Rather, the purpose of this work is three-fold: First, to propose and set guidelines for the development of a *Form Language*, based on natural structure systems, which can be used by designers for environmental purposes; second, to present a detailed and comprehensive description of the important geometric forms which present themselves through the study of natural structure; third, to offer methodologies by which forms can be generated.

1-1. DESIGN: A DEFINITION

Design is the process of generating form for the purpose of enriching human existence. This definition is purposely quite restrictive. While we recognize that a great number of the entities that find their way into our environment are not intended to enrich lives, but to confine and restrict them, our definition is given as an ideal to move toward, not as a statement of contemporary conditions. We easily see that most office, classroom, and prison conditions are restrictive rather than enriching environments for the persons in them, but that they *may* be seen by designers as necessary for the enrichment of society as a whole. While I do not share this point of view, I do appreciate it as an effective rationale for

[2] Bell, A. G. 1907. "Aerial Locomotion," *National Geographic*. v. XVIII, pp. 1-34.

[3] Fuller, R. B. U. S. Patent #2,682,325. The earliest geodesic dome was designed by Dykerhoff and Widemann for a planetarium. See: "Fortschritte im Bau von Massivkuppeln," *Der Bauingenieur*. v. VI, no. 10, (1925), pp. 362-366.

[4] Candella, F. 1957. *Shell Forms*. Los Angeles: University of Southern California Press.

[5] Nervi. P. L. 1956. *Structures*. New York: McGraw-Hill.

[6] Otto, F. 1967. *Tensile Structures*. Cambridge, Mass.: M. I. T. Press.

maintaining present conditions. Obviously the concept of enrichment is many-valued. It will be assumed that most people who design feel that their work enriches human existence in some way. For our purposes, however, a *rich environment* is one that assists, or at least does not arrest, the self-actualization processes[7] of the persons in it.

The concept of form can take a number of meanings. For example, we speak of the 'form of human social interactions,' generally meaning the customary ways that persons relate to and deal with other persons in specific situations. The concept of form also refers to the physical shape of some entity—a building, for example. Ideally designers should be concerned with both manifestations of the concept of form.

Today the results of design processes generally manifest themselves in inanimate physical entities of one kind or another. Since this work is concerned principally with physical form and methods of generating physical form based on geometric models of natural phenomena, a first distinction is drawn: *Form* designates inanimate physical entities; *pattern* will designate any kind of human interaction.

1-2. BASES OF DESIGN

In Western culture, contemporary designs derive from three primary bases: an intuitive base, a behavioral base, and a mathematical base.

<u>The Intuitive Base</u>. Designers are correctly proud of their intuitive capabilities. The cogency of intuition, however, is determined by how it is used in the design process. It is quite unfortunate that the tendency toward increased reliance on intuition brings with it increased skepticism of the value of other fields of human endeavor to design problems; designers in many cases use intuition as a primary source of personal development, and view a method as an invasion or suffocation of creative processes. On the other hand, a person such as a scientist, who has a strong foundation in method,

[7] I use *self-actualization* in the sense that it is used by A. H. Maslow: "By definition, self-actualizing people are gratified in all their basic needs (of belongingness, affection, respect and self-esteem). This is to say that they have a feeling of belongingness and rootedness, they are satisfied in their love needs, have friends and feel loved and loveworthy, they have status and place in life and respect from other people, and they have a reasonable feeling of worth and self-respect." From: "A Theory of Metamotivation: the Biological Rooting of the Value-Life," *Jour. of Humanistic Psychology*. v. 7, no. 2, (Fall, 1967), pp. 93-127. See also: Maslow, A. H. 1962. *Toward a Psychology of Being*. Princeton, N. J.: D. Van Nostrand Co.

although he does use intuition, tends to view the behavior of design-
ers as just so much phantasmagoric machination. This being the case,
it is infrequent when a designer and a scientist can work together
in other than superficial ways.

Although it is principally from the intuitive base that a design-
er makes his contributions, his intuitive processes must be balanced
by foundations in and concern for all work done in the past which
may have any conceivable relationship to design. Intuition tends to
become a weak and ineffectual base when it dominates or excludes
areas of human knowledge that may apply to design problems. Examples
of this exclusion can be seen at all levels of design, from the
client-designer type to 'funk architecture.' In the first case,
whether the design is a single dwelling, a large apartment complex,
or a school, it is almost impossible to find actual considerations
for social and psychological impact on the persons actually using
a design. In the second case, the designers are usually the users,
and they vaguely insist that their designs do 'great things for your
head,' without any clear understanding of what they mean.

The Behavioral Base. In theory, the behavioral base has two as-
pects which are complementary, but are treated as mutually exclusive
in practice. To illustrate both aspects of the behavioral base, con-
sider an overriding theme dominating the work of R. B. Fuller: Do
not attempt to change or reform man; rather, change the environment,
and man will change.[8] Aside from being a circular proposition, over-
simplifying complex problems, this statement presents two approaches
to design with a behavioral base.

One approach, the *pattern-pattern approach*, is concerned exclu-
sively with human interactions and neglects the impact of physical
form. A basic assumption in this approach is that behavior exhib-
ited by a human being is determined by the environment created for
him by assumptions made about him by other persons. Environment *is*
pattern; patterns change through modified assumptions. Form is not
significant. In *Personality and Organization*, C. Argyris puts it
this way:

> The latest available research suggests that, basically, all
> human behavior in an organization is caused by any one or
> a combination of:
> 1. *Individual factors*—requires an understanding of person-
> ality factors and principles.
> 2. *Small informal group factors*—requires understanding
> principles of social psychology, one aspect of which is
> group dynamics.
> 3. *Formal organizational factors*—requires understanding
> of traditional principles of organizing people (staff-

[8] Fuller, R. B. 1963. *Ideas and Integrities*. Englewood Cliffs,
N. J.: Prentice-Hall, Inc.

6

line, chain of command, specialization of tasks, production layout and control, and so forth).[9]

Although Argyris focuses on the relationships between large corporate bodies and the individuals which function within them, the arguments and examples he presents can be extended to other environments. For example, support of this view is found in a well-known study on the behavior of disadvantaged school children. In the study, scientists concluded that students performed poorly or excelled primarily because their teachers *expected* that behavior from them. The physical environment played a minimal role at best.[10]

The second approach, the *pattern-form-pattern approach*, emphasizes the use of physical form as a primary agent of change in human patterns. A basic assumption here is that man, by his nature and through his culture, has spatial needs that must be carefully considered in the design of the environment.[11] In contrast to the pattern-pattern approach, where environments are human assumptions and human interactions, this approach considers the environment as physical form and spatial organization.

Although architects and designers have been concerned with the human physical environment for a long time, the disciplined study of spatial environment is relatively recent. In *Personal Space*, R. Sommer explains:

> The stage that each design profession has reached can be measured along a scale from pure artistry at one end to pure scientism at the other. Closest to the artistic end are the interior designers who operate mainly on a pre-empirical intuitive level. The notion of Period Design relies on historical research of a sort, but the net effect is one of copying or weaving elements into a coherent pattern without attempting to evaluate the effects of different arrangements. Architecture is somewhat further along in that it is an empirical art, relying heavily on the accumulation of experience with different building types. When it comes to materials and structures, architects join engineers in carrying out systematic research, but in the behavioral realm, the way buildings affect people, architects fall back on intuition, anecdote, and casual observation. Consultants

[9] Argyris, C. 1957. *Personality and Organization*. New York: Harper & Row, Inc., p. 7.

[10] Rosenthal, R. and L. F. Jacobson. 1968. *Pygmalion in the Classroom: Teacher Expectation and Pupil's Intellectual Development*. New York: Holt, Reinhart & Winston, Inc.

[11] Hall, E. T. 1959. *The Silent Language*. Greenwich, Conn.: Fawcett Publications, Inc.; ———. 1969. *The Hidden Dimension*. Garden City, N. Y.: Doubleday & Co., Inc.

flourish in the design fields because there is no body of
information assembled in such a way that it is useful to
architects and other design professionals. Hence the tre-
mendous importance of library consultants, church consul-
tants, hospital consultants—all experts by experience,
older men and women whose ideas may be behind the times.[12]

Sommer goes on to discuss relationships between behavior and spa-
tial organization based on research in hospitals, schools, bars, and
hotels. Although he does not clearly differentiate between those
problems that are within the domain of the designer and those that
are within the domain of the behavioral scientist, his work does point
to important areas of neglect by many designers.

Although it seems that both pattern and form play complementary
roles in behavior, depending on conditions, neither Argyris nor
Sommer seemed to recognize the other; i.e., there is little cross-
referencing or acknowledgement of their respective areas. One study,
however, interested both writers: The report dealt with worker pro-
ductivity in a large public utility company in the 1920's. Scientists
found that as working conditions (in terms of the physical environ-
ment) were improved, the productivity of the workers increased accord-
ingly. When working conditions were made worse, the worker produc-
tivity still increased. This became known as the *Hawthorne Effect*.[13]

Both Argyris and Sommer deal with problems posed by the Haw-
thorne studies in interesting ways. Argyris, whose position is
grounded in an extensive body of knowledge, says simply:

Arnsberg...noted that many of the results reported about
the relay assembly occurred *after* the girls were placed
in a work situation where they were (1) made "subjects"
of an "important" experiment, (2) encouraged to partic-
ipate in decisions affecting their work, (3) given veto
power over their supervisors to the point where, as the
girls testify, "we have no boss."[14]

Sommer, who is not supported by the extensive body of knowledge to
fully support his position, says:

...what the Western Electric study showed conclusively
was that environment did make a difference. Almost every
change in environmental conditions had its effect on the
workers and, often, on their production. The study also
demonstrated that there is no simple relationship between

[12] Sommer, R. 1969. *Personal Space: The Behavioral Basis of
Design*. Englewood Cliffs, N. J.: Prentice-Hall, Inc., pp. 5-6.

[13] Roethlisberger, F. J. and W. J. Dickson 1939. *Management
and the Worker*. Cambridge, Mass.: Harvard University Press.

[14] Argyris, C. *op. cit.*, p. 69.

single environmental elements and complex human behavior. The effects of environmental changes are *mediated by individual needs and group processes*. The worker does not react to improved lighting or a coffee break as the rat does to the lever in his cage that brings him a food pellet. In an atmosphere of trust and understanding, he accepts environmental changes as indications that management is interested in his welfare. In an atmosphere of distrust and hostility, he wonders how management hopes to exploit him by changing his working conditions; he looks on environmental programming as manipulation.(my italics)[15]

Argyris negates the experiment by saying that pattern changes were solely responsible for behavior changes; Sommer concedes to pattern changes, but considers form a significant factor.

An important lesson can be learned here: A professional has a strong tendency to define a problem in ways which insure that the tools, skills, or solutions he has at hand can solve it. Since designers and architects deal with form, there is a strong tendency to attempt solutions to environmental problems—problems of human meaning and the like—only through form. What has consistently happened is that form was changed, but there was little or no interest in the pattern emerging from the changed form because most patterns were ignored in the initial formulation of the problem. For example, we see urban renewal projects consistently fail in terms of enriching human existence because: first, designers and entrepreneurs, in spite of their rhetoric, are not willing to turn control to the persons who will inhabit projects; second, the persons who inhabit a project rarely feel that they have a piece of the action with respect to the society as a whole. These are the major patterns that account for failures of urban renewal projects. Even if professional sociologists, psychologists, anthropologists, etc., were involved in planning a project, they do it only in terms of making form. Were they to suggest that buildings are not *the* problem, but only one of the problems, that the people should have control of how funds were spent, and the like, they would simply no longer be involved in the project. No matter how much wishful thinking we do, it does not seem that simply changing the physical environment, without carefully estimating and testing the effects in behavior, will necessarily enrich human existence. Much more needs to be taken into account.

It might be possible to begin a dialogue on this problem by asking a few fundamental questions: To enrich human behavior, is it a necessary and sufficient condition to manipulate either pattern or form in certain prescribed ways? Under n conditions, to what extent does pattern and to what extent does form influence behavior, *if at all*? For the architect, designer, environmental planner: How do

[15] Sommer, R. *op. cit.*, p. 165.

9

forms and changes of forms influence behavior? Answers to these questions can *only* come when environmental problems are stated in ways that allow other disciplines, not relying on forms as solutions, to be significantly brought to bear on them.

The Mathematical Base. In several other approaches, design problems are formulated as mathematical statements, but the use made of the mathematics varies considerably.

Engineering or structural design uses one approach. First, a form is determined by various means, generally not related to engineering. The engineer then applies his methods to insure that the form will withstand various forces of differing magnitudes. His task is primarily mechanical, not concerned with pattern or the relationships between pattern and form.

Another approach uses mathematical formulations of natural processes in the actual design. For example, in "Toward a Cybernetic Factory,"[16] S. Beer proposes an automated factory modelled after one kind of *self-organizing system*, which characteristically responds to outside stimuli by behavior changes.[17] In this case outside stimuli might be changes in demand, technological advances, and the like. The factory responds automatically by increase or decrease in production, or change in materials produced.

A third approach attempts to relate physical form and pattern through mathematical formulations based on set and group theory. This is presented by C. Alexander in *Notes on the Synthesis of Form*[18]

[16] Beer, S. 1962. "Towards the Cybernetic Factory," *Principles of Self-Organization*. New York: Macmillan Co., pp. 25-89.

[17] This is only one class of self-organizing system, exemplified by the Central Nervous System. The CNS is considered self-organizing because, with an outside stimulus, each cell, as it becomes activated, undergoes a slight change that makes it easier to activate on a future occasion; it changes (learns) by stimulation through time. The entire CNS becomes more efficient in terms of time lag between stimulus and response. Two other basic classes of self-organizing systems are: (1) those in which entities aggregate to perform certain collective or unitary tasks (e.g., the spherical *Volvox* colonies); and (2) those in which entities specialize through time (e.g., the cellular development in the development of an animal from a single cell to fetus). Self-organization principles are used as models of societal organizations, etc. See: Yovits, M. C. and S. Cameron (eds.). 1960. *Self-Organizing Systems*. London: Pergamon Press; Ashby, W. R. 1954. *Design for a Brain*. London: Chapman and Hall.

[18] Alexander, C. 1967. *Notes on the Synthesis of Form*. Cambridge, Mass.: Harvard University Press.

and is perhaps the closest to relating the intuitive, behavioral, and mathematical bases. Here a design is viewed as the result of a complex set of forces—social, cultural, economic, and physical—which must be considered in order to have a successful solution. When the success of a form is dependent on interactions of varied and complex forces with a minimum of conflict, mathematical formulations of this kind can provide a reasonable assurance that all forces are identified and inter-related. At the very least, these formulations can allow the designer to clearly understand those forces considered and those forces ignored in a design. He would no longer be able to naively believe that his designs actually solve many of the problems he intuitively believes they solve.

1-3. CRITICISM OF THE BASES

Design processes that stem from the three bases are incomplete in three ways.

The Lack of Overlap. To understand our universe we first differentiate, then categorize, then investigate categories, then re-categorize, and on... The process creates the illusion of security in that we can really know something of our categories. But when we look at the universe again as a whole instead of a part, we tend to retreat into our special part for security. Although we sense a whole we do not generally grasp it. *We do not overlap.* Although we talk of integrative and interdisciplined approaches we have few methods for integration.

The Lack of Concern for Psychological Content and Symbolic Meaning. In our environment, psychological effects on entities are almost totally ignored in favor of economic considerations. This tendency can be easily seen in the extraordinarily poor quality of most entities we find in the environment, in the over-abundance of meaningless entities in the environment, in the psychological conditions of employees (and employers) on all levels, and in the psychological conditions with which we live in cities. We seem to assume that when economic problems are resolved, the psychological problems will take care of themselves. Psychological content can and should be within the domain of the designer.

The lack of concern for psychological content ultimately manifests itself in the symbolic meanings[19] we attach to entities in the envi-

[19] A distinction is made here between *sign* and *symbol*. A sign is a sound, image, etc., which acts as a medium for transfer of ideas, thoughts, feelings, etc. For example, a 'stop sign' is a sign. A symbol can also do this. However, a symbol must have deep *personal* significance for a person. Money, the Cross, possessions, etc., in many cases can begin to assume symbolic characteristics.

ronment. Symbolic meaning is not the direct responsibility of the designer because symbolic meaning is beyond the control of form makers. However, symbolic meaning can be indirectly dealt with through initial and early concern for psychological content in the entities we design. If psychological content was a primary concern, distorted symbolic meanings attached to wealth, status, possessions, and the like would not afflict us as totally as they do today. The unconsciousness of designers in this respect is responsible for a considerable number of environmental problems we now face.

The Lack of Elements of a Form Language. Although the main effort of most design processes is toward resultant forms of one kind or another, no methodology exists for generating, perceiving, and manipulating pure form: it it totally intuitive. In short, design has no basis for a complete *Form Language*.[20]

Consider the problem in this way: Suppose two persons wish to compose music—say, two symphonies. They gather the finest resources on music available; they study them in great detail. However, when they begin to generate their compositions one finds that he is tone deaf, every tone sounds the same to him; while the other, for various reasons, has only one sound available to him. Now it might be possible for them to compose a melody or two, but the chances are nil that they will accomplish what they set out to do.

In the same sense, a designer, or even a group of designers, who are either tone deaf to the order and variety of forms, or have only a few forms—the cube, its distortions, and a few others—in a repertoire, may be able to design forms that successfully relate to the context, but the chances are that the result of their effort will not be a stimulating or responsive environment—one enhancing human qualities.

We have only to look about us to understand this. The total effect of design efforts by those tone deaf to both the order in form *and* to the variety of form is that our environment has a completely chaotic and meaningless variety on one hand, or a rigid and uninteresting orderliness on the other. We need only to observe a business section in any suburb to find examples of meaningless variety and chaos; we find rigid orderlines in the principally orthogonal street lay-outs and buildings in city centers. It is possible to begin to develop a consciousness of form and, more importantly, a consciousness of the relationships among forms through *Form Language*. We can have variety without chaos and order without rigidity.

[20] By *Form Language* I do not mean the so-called architectural 'orders' that we often find mentioned in the literature in terms of 'language of form.' My intent is not to say that we have no formal solutions to fall back on when our ingenuity fails us, but that our methods of logically generating form are almost non-existent.

1-4. MANIFESTATIONS OF THE LACK OF FORM LANGUAGE

As studies of Sommer and Argyris have made all too discouragingly clear, there is no meeting ground between the visual thinking of the designer and the analytical thinking of the physical scientist, the data of the social scientist, and the feelings of the persons who live in designed environments. A knowledge of forms and their relationships could provide a basis for dialogue between those using analytical thinking and those using visual thinking. It would provide a systematic vocabulary from which designers could make conscious choices to use one form instead of another, and from which others could question and evaluate the use of one form over another.

An important manifestation of the lack of a *Form Language* can be seen in the complete awe of certain forms that are intuitively generated. Sociologist H. D. Duncan speaks of this tendency in *Culture and Democracy*:

> What begins as a solution to a social need often ends in a form whose 'purity,' 'beauty,' or 'holiness' removes it from any test of relevance to social action. The more successful the form, the more it determines the content of social experience; the more proper, right, and sacred the form becomes, the more it fails to satisfy our need for change and flexibility.[21]

Consider, for example, the form called the *geodesic dome*. Originally designed as a solution to problems of space-utilization, economic considerations, and mass production techniques, it is being replicated in various sizes for various human environments by both amateur and professional builders under the assumption that it is somehow the best solution to any problem. This fad thinking is, unfortunately, particularly characteristic of many people who have 'dropped out' and consider that they are creatively seeking enriched environments. Since they have little understanding of the great variety of forms that may be appropriate for desired patterns, they rely on a few existing forms appearing to represent revolutionary concepts and ideals, but which really represent only an impoverished design vocabulary.

The most important role for the designer in this respect is to provide information and methodologies through which a person can design and control his own environment. One thing is clear: The less we are allowed to participate in the creation of our environment—whether it be the home in which we live, the place in which we work, or the conditions in which we find ourselves working, living, and playing—the less we are *able* to care for our existence. When

[21] Duncan, H. D. 1965. *Culture and Democracy*. Totowa, N. J.: The Bedminster Press, Inc., p. 588.

we begin to understand that many distinct forms can successfully re-
late to a desired pattern, we can begin to play and design. No par-
ticular form is important in itself. Rather, its importance lies in
the appropriate relationship between a form and a pattern, as deter-
mined by the user. The basic forms and methods of generating form
need to be learned and taught, played with and used, just as we
learn to speak and write; once mastered, they can be expanded upon
and even discarded when necessary, just as James Joyce fractured
English grammar. The real value of possessing a vocabulary of basic
forms lies in their ability to stimulate concepts, playfulness in
the design process, and expansion of design methods and concepts.

1-5. LANGUAGE AND PERCEPTION

Language has long been considered to be a *tool* used to express
sensation, feeling, thinking, and intuition. It was usually assumed
that one would have a sensation or thought, and search his vocabulary
until he found the appropriate word or words to express this sensation
or thought. This view of the relation between thought and language,
however, is greatly oversimplified.

In his studies of the culture of the Hopi and Shawnee Indians,
Benjamine Lee Whorf found that the tool concept of language is only
partly true. Rather, perceptions of the external world are largely
determined by one's inherited language. In *Language, Thought, and
Reality*, Whorf explains:

> It was found that the background linguistic system (in other
> words, the grammar) of each language is not merely a repro-
> ducing instrument for voicing ideas but rather is itself the
> shaper of ideas, the program and guide for the individual's
> mental activity, for his analysis of impressions, for his
> synthesis of his mental stock in trade. Formulation of
> ideas is not an independent process, strictly rational in
> the old sense, but is part of a particular grammar, and
> differs, from slightly to greatly, between different gram-
> mars. We dissect nature along lines laid down by our native
> languages. The categories and types that we isolate from
> the world of phenomena we do not find there...on the con-
> trary, the world is presented in a kaleidoscopic flux of im-
> pressions which has to be organized by our minds—and this
> means largely by the linguistic systems in our minds. We
> cut nature up, organize it into concepts, and ascribe sig-
> nificances as we do, largely because we are parties to an
> agreement to organize it in this way—an agreement that holds
> throughout our speech community and is codified in the pat-
> terns of our language. The agreement is, of course, an im-
> plicit and unstated one, but its terms are absolutely oblig-

atory; we cannot talk at all except by subscribing to the organization and classification of data which the agreement decrees.[22]

This idea, if extended to mean that the designer's expression is determined by the richness of the elements of the *Form Language* used, has strong implications. No matter how sophisticated his design process, no matter how concerned he is with human behavior and its enrichment, if the designer's vocabulary of form is limited to a few basic shapes and their distortions, then his ability to generate varied environments is severely restricted. If a designer asks, "What are the possible forms I can use to enhance or assist a particular feeling or behavior or quality?", but has in his repertoire nothing but cubes and their distortions, then we should not be surprised that the physical environment lacks richness in ordered variety of form.

1-6. CONCEPTS OF LANGUAGE

A *language* is a set of entities with rules for their combination; when entities are combined they transfer ideas and information; they generate thoughts, feelings, and behavior. In a restricted etymological definition of language, that is, one in which sounds are produced by vocal organs and received by hearing organs, only spoken language (and possibly its written counterpart) is admitted to the class. Our broader definition of language admits many more aspects of human experience; it includes functions that transfer meaning, such as music, mathematics, painting, sculpture, pasimology, proxics, and countless visual images.

A language can be considered to consist of four components: a grammatical component, a syntactical component, a semantic component; and a symbolic component. The first three are from linguistics; the the last from depth psychology.

Rules of combination make up the *grammatical component*. Rules can be derived by convention, from physical laws, or by logical processes. A grammar, complete in the sense that it has no ambiguities inherent in its structure, must contain an adequate description of how entities are used by both the *speaker* and the *listener*.[23]

[22] Whorf, B. L. 1956. *Language, Thought, and Reality*. New York: The Technology Press and John Wiley & Sons., pp. 212-213.

[23] In linguistic theory, N. Chomsky divides grammar into two levels: *surface structure* and *deep structure*. Surface structure is the grammar we are taught to use in school; e.g., subject, predicate, etc. Deep structure consists of the fundamental organizational principles of language. Surface and deep structures are related by

15

The system for organization of entities in a language is the *syntactical component*. Meaning is associated with the syntactical component in the sense that a change in organization of entities can result in change of meaning.

Meaning is also the domain of the *semantic component*; but where syntax is concerned primarily with organization of entities related to meaning changes, semantics is concerned with analysis of the actual meanings that are transferred.

The *symbolic component* is perhaps the most elusive of the four. Meaning is associated with the symbolic component, not in the sense of the 'what is meant' of semantics, but in the sense of the unconsciously and collectively associated meanings of entities in a language. Here meaning goes beyond any inherent quality of the entity itself. An entity functioning as a symbol elicits emotional responses not accounted for in any of the other three components.

Considered as a *hierarchical system*, three fundamental levels can be associated with language. In this system the grammatical and the syntactical component, absent of any meaning, fall within the formative level; the semantic component is within the purportive level; the symbolic component is within the symbolic level.

On the *formative level* we distinguish the smallest perceivable entities in a language; that is, the minimum combinatorial elements comprising the sub-systems of the language. Included on this level are some of the rules for combining entities, as well as rules for their manipulation. No meaning is assigned to the entities or their combinations at this level.

On the *purportive level* meanings are assigned to the entities and their combination. The assignment of meaning is arbitrary and accomplished principally by consensus. On this level the competence of both the speaker and the listener can be evaluated. The competence of the speaker is determined by how well he is able to manipulate the entities on the formative level, and by his ability to clearly transfer what he desires. The competence of the listener is determined by his ability to assimilate entity manipulations and by his ability to understand meanings.

On the *symbolic level* meaning is unconsciously associated with entities by both the speaker and the listener. Entities on this level assume qualities—in addition to semantic interpretation—

a *transformational grammar* which allows us to form and understand new sentences—sentences we have never conceived previously—and, hence, learn and use language dynamically and creatively in everyday life. It is yet too soon to determine whether any of these concepts from linguistics can apply to *Form Language*. See: Chomsky, N. 1968. *Language & Mind*. New York: Harcourt, Brace, & World, Inc.; ———. 1965. *Aspects of the Theory of Syntax*. Cambridge, Mass.: M. I. T. Press.; ———. 1966. *Current Issues in Linguistic Theory*. The Hague: Mouton & Co.

of cosmic, global, national, or familial scale.

Some languages function most fully when all three levels are operating. This is particularly true of the arts—literature, music, dance, painting, and so on. Other languages are considered to be operating most successfully when only the formative and purportive levels function. In mathematics, for example, the highest achievements of elegantly manipulated language result from the removal of *all* ambiguity in logical structure and assignment of meaning.

1-7. THE CONCEPT OF A FORM LANGUAGE

A *Form Language*, as all languages, is a set of entities with rules for their combination; when entities are combined they transfer ideas and information; they generate thoughts, feelings, and behavior. The *statements* made with *Form Language* are the actual physical entities in the environment. They communicate meaning. The concept of design as *Form Language* intimately ties the designer and the user together, as we shall see presently.

Form Language has the fundamental *hierarchical levels* associated will all language:

On the *formative level* are geometric forms in their purest and simplest manifestations. Forms are reduced to their minimal identifiable components of vertices (points), edges (lines), faces (planes), and volumes. Rules for combining and relating the components are identified, along with methodologies for changing identities and for generating entirely new forms. Geometric and topological[24] relationships are also manifest on this level. They include:

Isolated forms —

Two-dimensions: the morphogenesis of polygons; perimeter and surface area relationships.

Three-dimensions: the morphogenesis of polyhedra; volume relationships; surface area relationships; and symmetry families.

Aggregated forms —

Two-dimensions: packing and covering the plane with circles and polygons; area and perimeter densities of aggregated circles and polygons; packing ratios; and symmetries.

Three-dimensions: packing and covering space with spheres and polyhedra; perimeter, surface area, and volume densities of aggregated spheres and polyhedra; packing ratios; and symmetries.

[24] Geometry is concerned with the measurement and angular properties of points, lines, surfaces, solids, etc. Topology, sometimes called *rubber sheet geometry*, is concerned with the relationships among these entities.

All forms—
Methods and rules for relating forms, changing identities, and generating new forms.

These aspects of the formative level are the major emphases of the present work. However, we also observe on this level what are termed *grammatical rules of architecture and design*. These are the personal rules, mostly intuitive, used by designers in changing pure form of *Form Language* into their statements. They are the stylistic considerations that manifest themselves in the use and manipulation of materials, textures, and the like. Without the extensive basic vocabulary of *Form Language*, a designer is limited to those few forms to which he is traditionally exposed; rarely does he have the capability to go beyond the manipulations of materials and textures— surface embellishments—of the few forms he knows. At this time, with very few exceptions, no meaning is associated with the forms at this level. This contrasts with spoken or written language, which has both a dictionary of terms *and* assignments of meaning. *Form Language* is more analogous to music, where meanings are not associated with individual notes; the meaning appears as notes are combined by the artist into a composition. Meaning, then, in *Form Language* is manifest on the purportive level.

On the *purportive level* geometric form and style are placed into the environment. The designer relates the form to the user. The form acts as a vehicle for the *message*. The message focuses on the question: *What does the designer care about?* If his concerns are for the techniques of form making, for satisfying an entrepreneur, or for the persons who use the form, they are always communicated, however subtly, to those in the environment, through the form.

On this level form merges with pattern; the competence of a designer can be evaluated. A designer, as all language speakers, deals in probabilities; that is, he tries to arrange the entities of his language in a way which will increase the probability that his intent is realized, either in terms of the user's understanding of the forms or in the behavior elicited by the form. If the designer considers form in the environment as a medium through which he and the user may have a dialogue of sorts, then a measure of the competence of the designer is forthcoming. If the form is understood and used as the designer *intends*, then he is a competent designer. However, intent cannot be stated in such vague terminology as 'better environment' or 'make the world work' if it is to be truly insightful and meaningful in evaluations. Contrast these statements with the following:

IF: There is any internal space S in a building where
people spend more than a few minutes at a time, awake...
THEN: The space S must have windows with the following
characteristics:
1. The windows look onto some other place, which has a life
as refreshing and different as possible, from the life in-

side S...

2. The windows should be divided into as many different openings as possible. The distance between the openings should be at least 12 inches.

3. The windows should go as low as possible - if possible all the way to the floor - especially if the place in question is above ground.[25]

A statement of this kind is insightful because it is open to evaluation in terms of intent, as well as offering a clear basis for an evaluation of a particular aspect of a design. It relates the user to the form in concrete ways. Statements such as 'better environment', while we would undoubtedly agree with them, offer no basis for evaluation of form; they are useless.

On the *symbolic level* form assumes qualities beyond the specific intent of the designer and the user. Although the designer can, in many ways, take into account the symbolic meanings of the forms he designs through thoughtful considerations of their psychological impact, he cannot *create* a symbol. A form becomes a symbol through use, through care, and through recognition. For example, although hemispheres or domes have been used for dwellings in a few cultures, they are taken almost universally to represent places of worship, symbolizing the cosmos and the almighty. The symbolic meaning of the dome form evolved independently of any conscious plan for the symbolic content inherent in it.

1-8. NATURAL PHENOMENA AND NATURAL STRUCTURE

What natural phenomena are used as models for elements of *Form Language*? Obviously, we make a careful and limited selection, since there are many natural phenomena and many ways of looking at them. One way of approaching natural phenomena is through physics. Natural forces such as electricity, magnetism, and gravity are not particularly revealing in themselves, but, rather, in terms of the physical forms resulting from such forces. In a beautiful book on biological form, *On Growth and Form*, D. W. Thompson views form as "a diagram of forces."[26] Here I have emphasized the diagrams, not the forces. I have selected those geometric diagrams demonstrating certain commonalities and relationships among various areas of the physical and biological worlds. For example, we find geometric commonalities

[25] Alexander, C., S. Ishikawa, and M. Silverstein. 1968. *A Pattern Language Which Generates Multi-Service Centers*. Berkeley: Center for Environmental Structure, p. 133.

[26] Thompson, D. W. 1963. *On Growth and Form*. London: Cambridge University Press., p. 16.

between some atomic crystals and some viruses, and between some atomic crystals and ideal bubble aggregations. Although other concepts derived from natural phenomena (such as those one finds in discussions of self-organizing systems,[27] which offer conceptual bases for responsive, changing, and self-renewing environments) are valuable, they are not directly considered here, except perhaps as overriding concepts.

In observing the universe one finds an enormous variety of phenomena, both in terms of size and diversity of function. Figure 1-1 charts the size relationships among entities found in the universe.[28] The natural phenomena of concern to scientists range in size and distance from approximately 10^{-2} Angstroms to 10^9 light years. My concentration is within a small range, on entities from approximately 10^{-10} to 10^{-2} meters, because it is here that the beauty, order, and variety in nature is most readily visible to man. The elements of *Form Language*, then, are drawn from data found in the study of atomic arrangements in crystals, virus morphologies, biological and botanical cell aggregations, liquid structures, and the like.

What is a structure? The term *structure* is given many meanings depending on one's area of interest. In engineering, a structure is defined as a physical form that will withstand certain forces; in social science a structure can be a mapping of human interactions. In a broad sense, a structure is a set of perceived relationships. A *natural structure*, then, is a set of perceived relationships observed in the phenomena which make up the physical universe. These relationships can be described as mathematical structures, or they can be described as physical structures, such as models of crystals. A *structure*, for our purposes, is defined as a perceived, orderly arrangement of physical entities in n-dimensional space, static in space and time. We are not concerned here with the reasons why a form is static or stable, but, rather, with the forms themselves.

A related concept here established is the concept of *transformation*: the process of change in form from one static state to another. Many relationships among structures can be perceived through a transformation; they are considered in Chapter 6.

[27] Yovits, M. C. and S. Cameron. *op. cit.*; Von Foerster, H. and G. W. Zopf. (eds.) 1962. *Principles of Self-Organization*. New York: Macmillan Co.

[28] Williams, J. R. 1955. "The Measure of Things," Kirtland Air Force Base, Albuquerque, New Mexico.

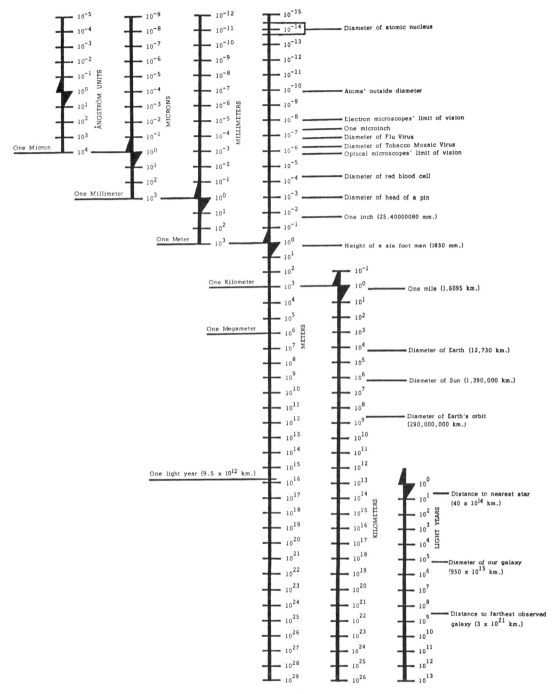

Figure 1-1. Micro-, macro-, and mega-structures from atoms to galaxies.

1-9. ASPECTS OF THE NATURE OF PHYSICAL SPACE

Fundamental to *Form Language* is a concept of space. Although scientists have found conceptions of hyper-space and various curved spaces necessary in solutions to a number of problems,[29] the designer, because he works on a relatively limited scale, finds Euclidean two- and three-dimensional space the most useable in actually generating designs. This is not to say that other concepts of space are of no value in design; the designer should have some understanding of these spaces, and the relationship of Euclidean space to them. As with Newton's Laws of Motion, Euclidean space is quite adequate when one is concerned with entities of limited scale. For example, one does not need to be concerned with the curvature of the earth's surface when designing a building; Euclidean concepts are adequate. However, it might be of some interest to the designer to understand some of the relationships among elliptic, hyperbolic, and Euclidean spaces: Euclidean space—with the sum of the angles of a triangle equal to π—although it has an existence of its own, can also serve as a transition between elliptic space—with the sum of the angles of a triangle $> \pi$—and hyperbolic space—with the sum of the angles of a triangle $< \pi$.

In the seventeenth century Isaac Newton and Gottfried Wilhelm Leibniz explored and debated two contrasting concepts of space.[30] Newton accepted Plato's idea that space had an existence independent of the entities in it; things are put *into* space. Leibniz, following the theory of Theophrastus,[31] attributed independent existence *only* to physical entities or bodies. Space was the ordering or organization of the bodies themselves. Of course, the Platonic-Newtonian view is quite familiar to us, since it is the concept adopted by science from Newton's time. It is interesting to speculate on how different our view of the universe might be had Leibniz' concept of space been accepted.

Euler's Law: The Fundamental Combinatorial Rule on the Formative Level of Form Language. In geometry, dimensionality is usually conceived as a set of independent, mutually perpendicular space coordinates x, y, z,... They are the logical extension of the planar coordinates developed by Rene Descartes. For convenience, when

[29] Jammer, M. 1969. *Concepts of Space: The History of Space in Physics*. Cambridge, Mass.: Harvard University Press; Lanczos, C. 1970. *Space Through the Ages*. London: Academic Press.

[30] Whitrow, G. J. 1962. "Why Space has Three Dimensions," *General Systems*. Ann Arbor, Michigan: Society for General Systems., pp. 121-129.

[31] Jammer, M. *op. cit.*, p. 23.

higher dimensional spaces are considered the notation is x_1, x_2, x_3, x_4,...x_n. Dimension is not ordinarily considered to be a 'level' or to be associated with an 'emergent whole' of higher order that arises from lower order elements;[32] that is, dimension is strictly Platonic-Newtonian, independent of entity. Consider Figure 1-2. The coordi-

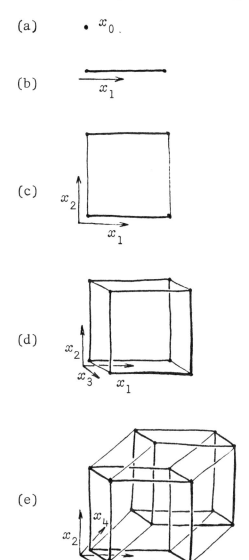

Figure 1-2. Dimension and entity: (a) n = 0, a point; (b) n = 1, a line, (c) n = 2, a plane; (d) n = 3, a solid; (e) n = 4, a hypersolid.

[32] Bunge, M. 1960. "Levels: A Semantical Preliminary," *Review of Metaphysics.* v. 13, pp. 396-406.

nates for each dimension, $n = 0$ through $n = 4$ are shown along with a simple entity that can be generated in each. In (a) a point can be generated; in (b), a line; in (c), a plane; in (d), a volume; and in (e), a hyper-solid. I would like to point out a sense in which dimension can be considered *hierarchical*, and give illustrations of emergence using geometric polytopes[33]—the elements of the *Form Language*.

Eighteenth century geometers realized[34] that a certain algebraic sum of geometrical entities in a polytope is either equal to zero for $n = 0, 2, 4, \ldots$, dimensions, or equal to two for $n = 1, 3, 5, \ldots$, dimensions. This relation, known as Euler's Law,[35] was generalized to n-dimensions by Schläfli[36] and proved by Poincaré.[37] This law can be written:

$$N_0 - N_1 + N_2 - \ldots + (-1)^{n-1}N_{n-1} = 1 - (-1)^n, \qquad \text{Eq. 1-1.}$$

where N is the number of entities, and the subscript is dimension. Specifically, N_0 is the number of vertices; N_1, the number of edges; N_2, the number of faces; N_3, the number of solids;...

To appreciate how a new level emerges from combining entities of lower dimension, consider the case of Eq. 1-1 for a two-dimensional tessellation,[38]

$$N_0 - N_1 + N_2 = 1. \qquad \text{Eq. 1-2.}$$

[33] Polytope is the term used for the general n-dimensional geometric entity. A *point* is a polytope for $n = 0$; a *line*, a polytope for $n = 1$; a *polygon*, for $n = 2$; a *polyhedron*, for $n = 3$;...

[34] Coxeter, H. S. M. 1963. *Regular Polytopes*. New York: Macmillan Co., p. 165. (Dover reprint)

[35] Euler, L. 1752. "Elementa doctrinae solidorum," *Novi commentarii Academiae scientiarum imperialis petropolitanae*. v. 4, pp. 109-160.

[36] Coxeter, H. S. M. 1968. *Twelve Geometric Essays*. Carbondale, Ill.: Southern Illinois University Press., p. 233.

[37] Poincaré, H. 1893. "Sur la généralisation d'un théorème d'Euler relatif aux polyhèdres," *Comptes rendus hebdomadaires des séances de l'Académie des Sciences*, Paris. v. 117, pp. 144-145.

[38] A tessellation, in this case, is an aggregation of polygons that cover an entire plane without overlap and without spaces or interstices among them. See Chapter 2 for examples.

Combining polygons under the rule that (i) we maintain Euclidean space, (ii) we do not distort the polygons, and (iii) that every two polygons share one edge, we can build up an indefinitely large aggregation of connected polygons satisfying Eq. 1-2. If we are aggregating pentagons, for example, when we accumulate twelve (Figure 1-3a) and connect them such that *all* edges are joined, we obtain a dodecahedron (Figure 1-3b).

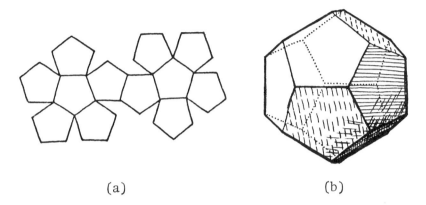

(a) (b)

Figure 1-3. (a) partial aggregation of n = 2 *entities; (b) the emergence of a single entity and a new level,* n = 3, *from the aggregation of* n = 2 *entities.*

The above conditions governing the combination rule are not violated, but the resulting single entity no longer satisfies Eq. 1-2. Instead,

$$N_0 - N_1 + N_2 = 2, \qquad \text{Eq. 1-3.}$$

where the whole right member is greater that the old sum of parts. Euler's Law was restored by introducing N_3, a new level, a new dimension, and an emergent entity.

By generalizing the three conditions above for n-dimensions, the concept can be applied to many more combinations of entities in higher spaces: (1) we maintain Euclidean space, (2) every n-dimensional entity is regular, (3) every $n-1$ dimensional entity is common to two n-dimensional entities.

In aggregating polyhedra, for example, Euler's Law becomes

$$N_0 - N_1 + N_2 - N_3 = 1 \qquad \text{Eq. 1-4.}$$

and is satisfied in all aggregations. If cubes are aggregated (Figure 1-4), when we accumulate eight and satisfy conditions (1), (2), and (3), the emergent single entity no longer satisfies Eq. 1-4. Euler's Law is again restored by introducing a new dimensional level, N_4, and so on.

25

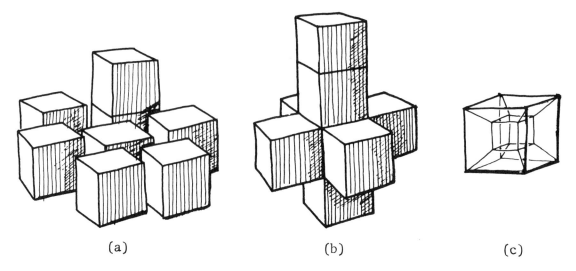

(a) (b) (c)

Figure 1-4. (a and b) partial aggregations of n = 3 *entities;*
(c) the emergence of a single entity and a new level, n = 4, *from the*
aggregation of n = 3 *entities.*

We also find it possible to achieve emergence of a new dimension
(in some cases) by relaxing either conditions (1) or (2). For exam-
ple, when four hexagons are aggregated on a plane, relaxing condition
(1) and imposing condition (3) generates a suitably curved space for
each hexagon which allows a group of them to combine into a single
emergent entity (Figure 1-5).

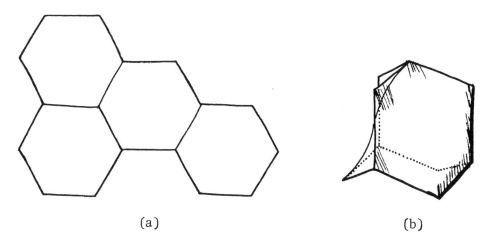

(a) (b)

Figure 1-5. (a) partial aggregation of n = 2 *entities; (b) the*
emergence of a single entity and a new level, n = 3, *from the aggre-*
gation of n = 2 *entities, where either the entities are distorted,*
or the n = 3 *space assumes non-Euclidean properties.*

Euler's Law, then is a fundamental law for relating entities within a dimension and for relating the levels of spatial dimensions.[39] As such, it is possible to use it as a fundamental law which demonstrates relational aspects of entities on the formative level of *Form Language*.

1-10. CONCLUSION

With Euler's Law as a basic tool we go to *Part Two--Geometry*. As we progress we will observe that many characteristics of the forms, as well as relationships among forms, may be described in terms of *hierarchical systems*. For example, certain hierarchical qualities are immediately apparent from characteristics inherent in the forms themselves, such as volume and packing hierarchies. Where possible, data are displayed in ways that tend to show rankings, order, etc. Other aspects of hierarchies are not immediately apparent, but emerge with the introduction of a system of relating the forms. The ordering of two-dimensional aggregations by perimeter densities, and three-dimensional aggregations by perimeter and surface densities, are examples of this emergent aspect of hierarchies. For the most part, however, properties of forms are presented as data instead of hierarchical orders of various kinds, because the presentation of one hierarchical aspect seems to require the presentation of another, *ad infinitum*.

One important assumption about *Form Language* in all of its ramifications is that before we become competent with it; that is, before we can begin to increase the probability that expectations and reality become unified, we must understand the basic elements at each level. On the formative level we should be familiar with the forms, how they combine, methods of change, and the like, in order to have a full vocabulary upon which to draw. When we operate on the purportive level we should be aware and make use of those concepts in psychology, sociology, anthropology, etc., that relate human patterns and form. We should understand concepts of how building size, color, and shape—and how partition and interior accessory placement—can enhance or restrict human emotions and behaviors. Finally, we can live in a truly rich environment only when we understand our relationship to form on the symbolic level. Though all form exists simultaneously on these three levels, independent of our awareness, our immediate universe becomes thoroughly interesting and engaging only when we understand the symbolic content of form in the environment.

[39] Williams, R. E. 1969. "Dimension as Level," *Hierarchical Structures*. (Whyte, Wilson, and Wilson, eds.). New York: American Elsevier Publishing Co., Inc., pp. 135-137.

Although the forms presented in this work are reduced to their simplest elements, their successful use requires a great deal more than a direct placement into the human environment. It is inadequate to simply build human scale dodecahedra, cubes, or any other form in order to solve a problem in which human beings are involved. The forms presented serve as a beginning point only. The designer should use them as such by adding his individual alterations and embellishments as he relates a form to human needs. A designer with an extensive vocabulary of form can literally do more interesting and meaningful work, just as the master of any language can more clearly and beautifully present complex ideas than a person with a limited vocabulary. If Whorf's conclusion that language determines perception can be applied to design, then this assumption is not unwarranted.

As we proceed through *Part Two* we will notice that the forms discussed will lend themselves to modular organizations of space, and, quite logically, can be applied to industrialized approaches to building. They can also be flexible, user-assembled structures. Although this quality is inherent in many of the forms, modular constructions are not the necessary emphasis. *Part Three*, the shortest but most important part of the work, presents methods of generating forms where static modularity is not a dominating factor; concepts of transformation are presented. Here, we can see that we are not restricted to modularity, but we can embellish the pure forms by surface changes, texture additions, and the like. In other words, forms can be changed to assume modular or organic qualities, as desired.

Form Language is not in any sense complete, and, indeed, will never be complete if it is a living and vital language. However, the geometry and the methodologies for generating form described in this work are a unified basis for the formative level. It is in this century that the sciences have been inundated with data, while scientists have not been able to formulate a *Weltanschauung* with which to deal with expanding information in any adequate sense. We can expect to be in a similar situation in the future if, indeed, we are not already there. We have a great need to develop adequate tools to deal with the new data, and a clear effort toward the development of a *Form Language* is the first step.

28

PART TWO
GEOMETRY

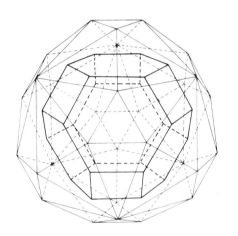

CHAPTER 2

NATURAL STRUCTURE AND THE TWO-DIMENSIONAL PLANE

Entities in nature approach two limits in manner of aggregation forming the diagrams man perceives as structure. At one limit, random aggregations define an infinite variety of beautiful networks. Liquid structures, metal crystallite and bubble clusters, and biological cell aggregations approach this limit. At the other limit, aggregated entities occupy positions in highly organized and ordered spaces. Virus structures, crystal structures, DNA structures, diatoms, and radiolaria approach this limit, at which a finite variety of configurations is possible. Although hexagonal symmetry dominates most of the continuously aggregated structures, many other symmetries are possible and appear quite often. For example, in finite structures, such as those exhibited in many plant and animal growth systems, pentagonal symmetry plays a dominant role.[1]

2-1. POLYGONS

Circles and polygons are the primary entities in two-dimensional cross-sections of natural structures.

A *circle* is defined as the locus of points in a plane, having a given fixed distance from a point within called the center.

A *polygon* is a plane figure bounded by edges and vertices. It is considered *simple* when its edges can be continuously deformed into a circle without changing its topological properties. A polygon may be concave or convex: *concave* if at least one vertex angle, α, is > π; *convex* when every α is < π. When every α is congruent

[1] Thompson, D. W. 1963. *On Growth and Form*. Cambridge: Cambridge University Press., pp. 749-993. For a theory of five-fold symmetry in animals see: Nichols, D. 1967. "The Rule of Five in Animals," *New Scientist*. v. 35, no. 562, pp. 546-549.

a polygon is *equiangular*; when every edge is congruent a polygon is *equilateral*. If both equiangular and equilateral conditions hold a polygon is *regular*, and it has the symbol {p}.[2] The sum of the vertex angles in a polygon is $\pi(p-2)$. The vertex angle, α, of a regular polygon is $\pi(p-2)/p$ and its center angle, A, is $2\pi/p$. The metamorphosis of regular polygons from {3} through {12} is shown in Figure 2-1.

Figure 2-1. The metamorphosis of regular polygons from {3} through {12}.

Two kinds of circles are common to a regular polygon (Figure 2-2): an *in-circle* tangent to the mid-edge; a *circum-circle* passing through the vertices. The radius, $_0R$, of an in-circle is $e \cot \pi/p$; the radius, $_1R$, of a circum-circle is $e \csc \pi/p$, where e is half of the edge, E, of the polygon. The radii of these circles generate *2p enantiomorphic*[3] right triangles. From these we find the area of regular polygons to be $pe^3 \cot \pi/p$.

[2] Star polygons are an extension of the concept of regularity to include polygons that are not simple; i.e., they have re-entrant angles at their vertices. These polygons are briefly discussed in Chapter 3. See: Coxeter, H. S. M. 1963. *Regular Polytopes*. New York: Dover, pp. 93-94; Fejes Tóth, L. 1964. *Regular Figures*. Oxford: Pergamon Press., pp. 102-103.

[3] *Enantiomorphic* means: having right- and left-handed forms.

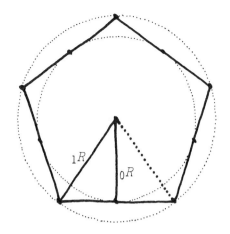

Figure 2-2. The in-circle, circum-circle, and enantiomorphic triangles of {5}.

Only seven of the infinite number of regular polygons are of principal importance to this work: {3}, {4}, {5}, {6}, {8}, {10}, and {12}. Their properties are given in Table 2-1.

Table 2-1. PROPERTIES OF REGULAR POLYGONS

POLYGON	CENTRAL ANGLE (A)	VERTEX ANGLE (α)	IN-CIRCLE RADIUS*	CIRCUM-CIRCLE RADIUS*	AREA †
{3}	$2\pi/3 = 120°$	$\pi/3 = 60°$	$E \cdot \sqrt{3}/6 =$ 0.2887	$E \cdot \sqrt{3}/3 =$ 0.5774	$E \cdot \sqrt{3}/4 =$ 0.4330
{4}	$\pi/2 = 90°$	$\pi/2 = 90°$	$E/2 = 0.5000$	$E \cdot \sqrt{2}/2 =$ 0.7071	$E^2 = 1$
{5}	$2\pi/5 = 72°$	$3\pi/5 = 108°$	$\dfrac{E \cdot \sqrt{25+10\sqrt{5}}}{10} =$ 0.6882	$\dfrac{E \cdot \sqrt{50+10\sqrt{5}}}{10} =$ 0.8507	$\dfrac{E \cdot \sqrt{25+10\sqrt{5}}}{4} =$ 1.7205
{6}	$\pi/3 = 60°$	$2\pi/3 = 120°$	$E \cdot \sqrt{3}/2 =$ 0.8660	$E = 1$	$E \cdot (3\sqrt{3})/2 =$ 2.5981
{7}	$2\pi/7 = 51.4286°$	$5\pi/7 = 128.5714°$	–	–	–
{8}	$\pi/4 = 45°$	$3\pi/4 = 135°$	$E \cdot (\sqrt{2}+1)/2 =$ 1.2071	$E \cdot (\sqrt{4+2\sqrt{2}})/2 =$ 1.3065	$E \cdot (2\sqrt{2}+1) =$ 3.8284
{9}	$2\pi/ = 40°$	$7\pi/9 = 140°$	–	–	–
{10}	$\pi/5 = 36°$	$4\pi/5 = 144°$	$\dfrac{E \cdot \sqrt{5+2\sqrt{5}}}{2} =$ 1.5388	$\dfrac{E \cdot 1+\sqrt{5}}{2} =$ 1.6180	$\dfrac{E \cdot 5\sqrt{5+2\sqrt{5}}}{2} =$ 7.6942
{12}	$\pi/6 = 30°$	$5\pi/6 = 150°$	$E \cdot (\sqrt{3}+2)/2 =$ 1.8660	$E \cdot \sqrt{2+\sqrt{3}} =$ 1.9319	$E \cdot (3\sqrt{3}+6) =$ 11.1961

*$E = 1$ for all calculations. † Area is in E^2 units.

33

2-2. SKEW POLYGONS (saddle polygons)

A polygon, $\{p\}$, can be decomposed into p isoceles triangles where the angles at the center of $\{p\}$ are $2\pi/p$; those at the vertices are $\pi(p-2)/2p$. In $\{p\}$, where p is even, a *skew polygon* is generated by altering the angular relationships in the decomposing triangles such that the angles at the center of $\{p\}$ are $> 2\pi/p$, and the angles at the vertices of $\{p\}$ are $< \pi(p-2)/2p$. The alteration pulls every other vertex of $\{p\}$ out of the existing plane, and the skew polygon is generated. For example, $\{6\}$ is decomposed into six triangles, each with three angles of $\pi/3$. If each of the six angles meeting at the center of $\{6\}$ becomes $> \pi/3$ (Figure 2-3a), while the angles at the vertices of $\{6\}$ become $< \pi/3$, three alternating vertices of $\{6\}$ move out of the plane. If the decomposing triangles are replaced by a single surface (Figure 2-3b), the surface has the constant negative curvature found in hyperbolic space.[4] The surface is considered *minimal* when it has the least possible area required to define the corresponding skew polygon. These *saddle polygons* are used to generate *saddle solids* in Chapter 6.

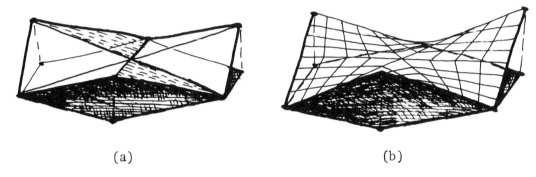

(a) (b)

Figure 2-3. (a) the skew polygon generated from $\{6\}$; (b) the saddle polygon generated from $\{6\}$.

2-3. CIRCLE PACKINGS, PLANE TESSELLATIONS, AND NETWORKS

Geometric conditions. A *circle packing* is an assemblage of contiguous circles such that each circle contacts more than two

[4] Hyperbolic space has negative curvature because the sum of the angles of a triangle is $< \pi$, while in elliptic space the sum of the angles of a triangle is $> \pi$. See Hilbert, D. and Cohn-Vossen, S. 1952. *Geometry and the Imagination*. New York: Chelsea Publishing Co., for an introduction to these concepts.

other circles.[5]

A *tessellation* is an assemblage of polygons that cover the plane without overlap and without interstices.

Consider the following limiting conditions:

(1) all polygons in a tessellation are congruent;

(2) all polygons in a tessellation are regular;

(3) all vertices in a tessellation are congruent (i.e., all vertices are n-connected and make an *n-connected network*.

Given these conditions, only three arrangements of circles yield tessellations of polygons,[6] shown in Figures 2-4a, 2-5a, and 2-6a.

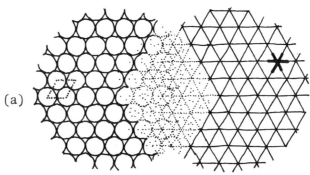

(a)

Figure 2-4. (a) a circle packing and its {3,6} tessellation; (b) {3,6} and its dual tessellation

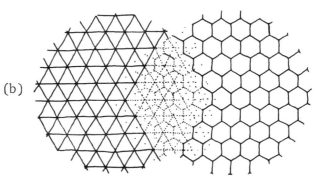

(b)

[5] It should be noted that we are referring to circles packed where each circle is tangent to the same number of circles ranging from a minimum of three to a maximum of six contacts. It would be possible to string out circles indefinitely so that some have two contacts, while others have three or more. Very open packings could be made in this way.

[6] Fejes Tóth, L. 1960/61. "On the Stability of a Circle Packing," *Ann. Univ. Sci. Budapestinensis, Sect. Math.* v. 3-4, pp. 63-66, calls a packing *stable* "...if each circle is fixed by the other circles; i.e., if on each circle the greatest 'free' arc, which contains no point of contact, is smaller than a semicircle." The central angle (λ) of the free arc is called the *lability* and the stability (σ) of a circle is determined by subtracting λ from π.

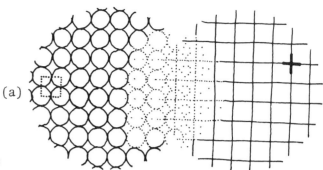

Figure 2-5. (a) a circle packing and its {4,4} tessellation; (b) {4,4} and its dual tessellation.

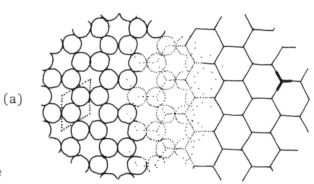

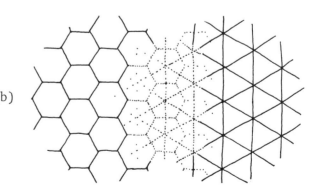

Figure 2-6. (a) a circle packing and its {6,3} tessellation; (b) {6,3} and its dual tessellation.

36

These are the *regular tessellations*, and they are assigned the Schläfli symbols {3,6}, {4,4}, and {6,3}, respectively. (The symbol {p,q} means: p-gons, q at a vertex.)

A necessary and sufficient condition for tessellations of regular congruent polygons is that the sum of the angles at each vertex must be an integer sub-multiple of 2π. The only polygons that satisfy this condition are {3}, {4}, and {6}. Since it is not possible to pack more than six regular polygons at a vertex in the plane, we are strictly bound by $2 < p < 7$.

The *dual tessellations* of {3,6}, {4,4}, and {6,3} are generated by interconnecting polygon centers with new edges as in Figures 2-4b, 2-5b, and 2-6b. The edges of the duals are perpendicular to the edges of the original tessellations. These duals are also regular tessellations: {3,6} yields {6,3}; {6,3} yields {3,6}; and {4,4} yields another {4,4}.

By relaxing condition (1)—the congruency of polygons—eight additional circle packings yield tessellations. These are the *semi-regular* or *Archimedean tessellations*: $3^3.4^2$, Figure 2-7a, $3^2.4.3.4$, Figure 2-8a; 3.6.3.6, Figure 2-9a; $3^4.6$, Figure 2-10a; 3.12^2, Figure 2-11a; 4.8^2, Figure 2-12a; 3.4.6.4, Figure 2-13a; and 4.6.12, Figure 2-14a. Of these, only $3^2.4.3.4$ is enantiomorphic.

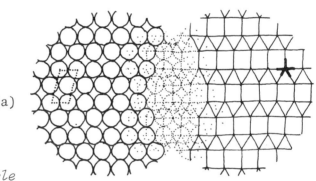

(a)

Figure 2-7. (a) a circle packing and its $3^3.4^2$ tessellation; (b) $3^3.4^2$ and its dual tessellation.

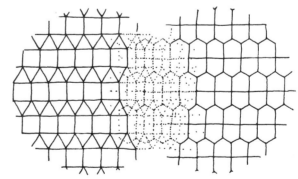

(b)

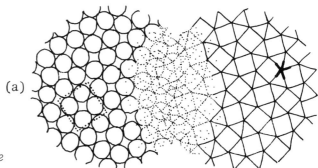

(a)

Figure 2-8. (a) a circle
packing and its $3^2.4.3.4$ tes-
sellation; (b) $3^2.4.3.4$ and
its dual tessellation

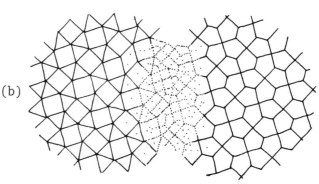

(b)

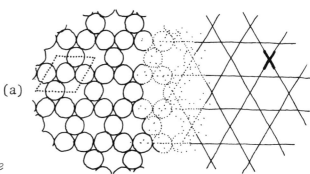

(a)

Figure 2-9. (a) a circle
packing and its 3.6.3.6 tes-
sellation; (b) 3.6.3.6 and
its dual tessellation.

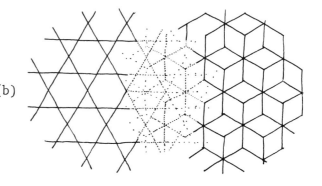

(b)

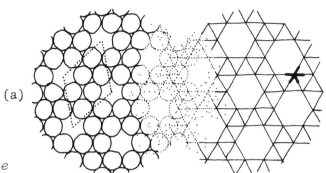

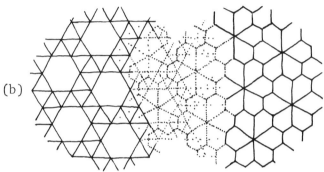

Figure 2-10. (a) a circle packing and its $3^4.6$ tessellation; (b) $3^4.6$ and its dual tessellation.

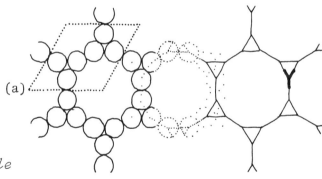

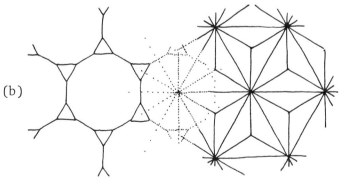

Figure 2-11. (a) a circle packing and its 3.12^2 tessellation; (b) 3.12^2 and its dual tessellation.

39

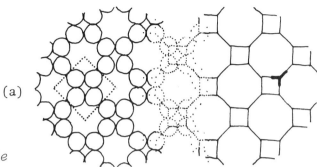

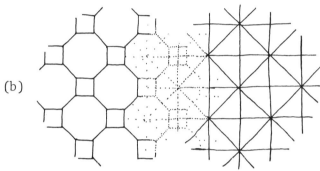

Figure 2-12. (a) a circle packing and its 4.8² tessellation; (b) 4.8² and its dual tessellation.

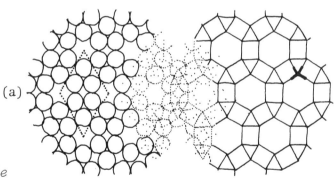

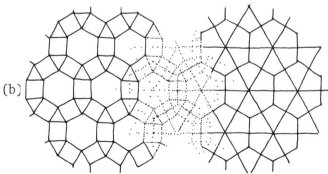

Figure 2-13. (a) a circle packing and its 3.4.6.4 tessellation; (b) 3.4.6.4 and its dual tessellation.

40

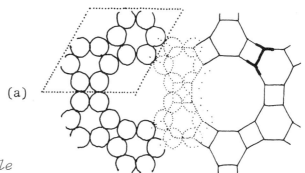

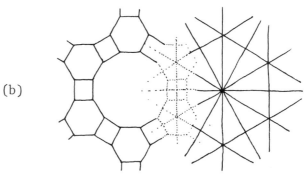

Figure 2-14. (a) a circle
packing and its 4.6.12 tes-
sellation; (b) 4.6.12 and
its dual tessellation.

The tessellations can also be derived in the following manner:
The sum of the angles around a vertex equals 2π, or

$$\Sigma\pi\frac{p-2}{p} = 2\pi;$$

Eq. 2-1.

then,

$$\pi\left(\frac{p_1-2}{p_1} + \frac{p_2-2}{p_2} + \ldots \frac{p_n-2}{p_n}\right) = 2\pi;$$

Eq. 2-2.

Simplifying for each case:
for a 3-connected network,

$$\frac{1}{p_1} + \frac{1}{p_2} + \frac{1}{p_3} = \frac{1}{2} \,;$$

Eq. 2-3.

for a 4-connected network,

$$\frac{1}{p_1} + \frac{1}{p_2} + \frac{1}{p_3} + \frac{1}{p_4} = 1 \,;$$

Eq. 2-4.

41

for a 5-connected network,

$$\frac{1}{p_1} + \frac{1}{p_2} + \frac{1}{p_3} + \frac{1}{p_4} + \frac{1}{p_5} = \frac{3}{2} \ ; \qquad\qquad \text{Eq. 2-5.}$$

for a 6-connected network,

$$\frac{1}{p_1} + \frac{1}{p_2} + \frac{1}{p_3} + \frac{1}{p_4} + \frac{1}{p_5} + \frac{1}{p_6} = 2 \ ; \qquad\qquad \text{Eq. 2-6.}$$

where p_1, p_2, ...p_6 is a count of the number of p-gons at each vertex. Eq. 2-3 gives four tessellations: {6,3}; 4.8^2; 3.12^2; and 4.6.12. (Six solutions do not tessellate, but give only one vertex with an integer sub-multiple of polygons: 3.7.42; 3.8.24; 3.9.18; 3.10.15; and 5.5.10.) Eq. 2-4 gives three tessellations: {4,4}; 3.6.3.6, and 3.4.6.4. (The combination 3^2.4.12 also comes from Eq. 2-4, but does not tessellate without the addition of another species of vertex.) Eq. 4-5 gives three tessellations: 3^3.4^2; 3^2.4.3.4; and 3^4.6. Eq. 2-6 gives one tessellation: {3,6}.

Tessellations such as those shown in Figure 2-15 are not strictly in the above group; they are generated by removing specific vertices and edges from the regular and semi-regular tessellations. In the examples, {4,4} generates Figure 2-15a; {3,6} generates Figure 2-15b; and 3^4.6 generates Figure 2-15c.

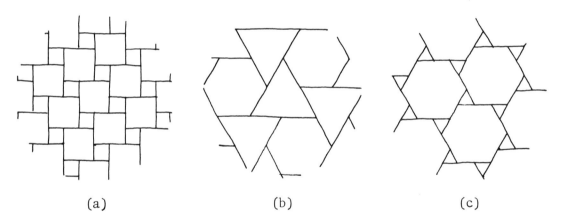

| (a) | (b) | (c) |

Figure 2-15. Plane tessellations with regular polygons of non-equivalent edges.

The tessellations which are duals to the semi-regular tessellations are shown in Figures 2-7b through 2-14b.[7] If circles are inscribed

[7] Figure 2-8b shows an interesting tessellation of pentagons. {5} will not tessellate because its vertex angle is not an integer sub-multiple of 2π. The pentagonal tessellation in Figure 2-8b does

in the polygons which make up the dual tessellations we return to the original packings in Figures 2-4a through 2-14a. The dual tessellations corresponding to a circle packing are called *Dirichlet regions*[8] or *Voronoi polytopes*:[9] the area in which all points are closer to a certain circle center than to any other.

If conditions (1) and (3) are relaxed, the number of possible combinations of polygons is substantially increased. In addition to many random packings, some of which are shown in Figure 2-16, there are fourteen *polymorph* or *demi-regular tessellations*: orderly composits of the three regular and eight semi-regular tessellations.[10]

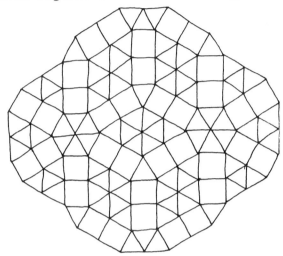

Figure 2-16. Random packings of regular polygons.

not have congruent angles or edges. Wood, D. G. 1967. "Space Enclosure Systems," *Bulletin 203*. Columbus, Ohio: Engineering Experiment Station, The Ohio State University, describes a tessellation of the plane with equal edge pentagons and vertex angles of 131°24'; 90°; 114°18'; 114°18'; and 90°.

[8] Dirichlet, G. L. 1850. "Über die Reduktion der positiven quadratischen Formen mit drei unbestimmten ganzen Zahlen," *J. Reine. Agnew. Math.* v. 40, pp. 209-227.

[9] Voronoi, G. 1908. "Recherches sur les paralléloèdres Primitives," *J. Reine. Agnew. Math.* v. 134, pp. 198-287.

[10] For drawings of these tessellations see: Ghyka, M. 1946. *The Geometry of Art and Life*. New York: Dover Publications, Inc., pp. 78-80; Steinhaus, H. 1950. *Mathematical Snapshots*. New York: Oxford University Press., pp. 66-67; and Critchlow, K. 1970. *Order in Space*. New York: Viking Press., pp. 62-67.

<u>Topological Conditions</u>. When conditions (1), (2), and (3) are relaxed the number of possible configurations of polygon packings goes to infinity. However, there are certain topological rules (specifically, Euler's Law) to which any network must conform. For the two-dimensional case this law takes the form of Eq. 1-2.

Consider the arrangement of circles in the plant stem in Figure 2-17. Also consider each circle center as a point on the plane. The points are of two kinds: those on the perimeter, p_e; and those within, p_i. Interconnect all of the points so that the network defines a system of triangles. The sum of the vertex angles of the exterior polygon is $\pi(p_e-2)$. Since the sum of the angles about each interior point is 2π, the sum of all of the angles within the polygon, p_e, is $\pi(p_e + 2p_i - 2)$. The sum of the vertex angles of a triangle is π; therefore, the number of triangles is $p_e + 2p_i - 2$.

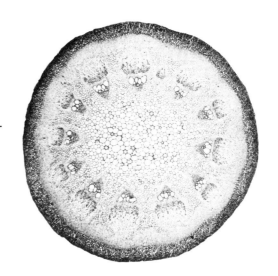

Figure 2-17. A cross-section of a plant stem.

In any large network of triangles, as p_i approaches ∞, p_e/p_i tends to zero, and p_e-2 can be neglected. The number of triangles, then, is $2p$. In a triangular network, each triangle has three edges, and each edge is common to two triangles. For a network of triangles, then:

(A) p vertices
 $3p$ edges
 $2p$ triangles.

44

As bubbles aggregate (Figure 2-18), their circular cross-sections deform to define polygons. Stable aggregations of bubbles viewed in two-dimensional cross-section have three interfaces or polygonal boundaries meeting at vertex angles of $2\pi/3.= 120°$. Bubbles can be added indefinitely, and they always join the others in the same fashion.[11] Because of surface tension each body strives toward the greatest area with the least amount of perimeter, given the special circumstances (such as random size and sequence of aggregation) that determine the form of each body. This is predominantly true of biological cell aggregations, metal crystallites, and some ceramic-ware cracks (Figure 2-19). However, since these aggregations are not quite as free as bubbles to adjust themselves in relation to one another, four or more interfaces sometime meet at a vertex.[12] In all

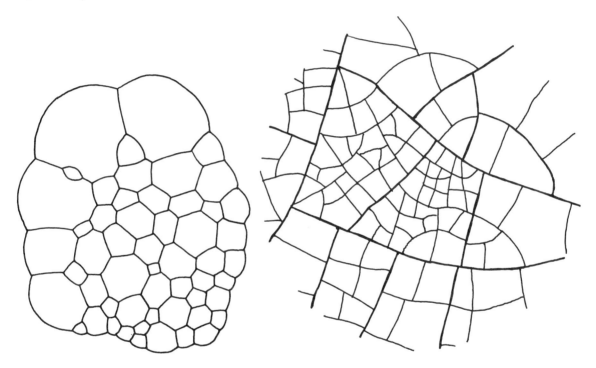

Figure 2-18. A random aggregation of bubbles.

Figure 2-19. Crack formations on a ceramic surface.

[11] Smith, C.S. 1965. "Structure, Substructure, Superstructure," *Structure in Art and Science*. (ed. G. Kepes). New York: George Braziller, Inc., pp. 29-41.

[12] We must remember that we are considering only two-dimensional cross-sections of bubbles. In the actual three-dimensional world aggregated bubbles are stable when four interfaces meet at a vertex. See: Thompson. *op. cit.*, pp. 465-525.

of these cases the average number of edges per polygon approaches
six, and the average vertex angle is $2\pi/3$, such that if there is a 7-
gon in the aggregation it will be balanced by a 5-gon, and so on.
Of the regular tessellations, only {6,3} satisfies the conditions for
both stability and aggregation configuration found in natural struc-
tures where surface tension plays a dominant role.

To determine the proportional relationship among vertices, edges,
and faces for any assembly of polygons (not necessarily regular),
consider the following: Three edges meet at a vertex, and each edge
connects two points. There must be $3p/2$ edges. When an edge is
removed the number of polygons diminishes by one. To change from a
network of triangles with $3p$ edges to a network with $3p/2$ edges, $3p/2$
edges must be removed. The number of polygons diminishes by $2p/2$, then
the number of polygons is $p/2$. Then a 3-connected network contains

(B)
p vertices
$3p/2$ edges
$p/2$ faces.

In structures of 4- and 5-connected networks, topological prop-
erties can be determined in a manner analogous to the above. Then,
for a 4-connected network,

(C)
p vertices
$2p$ edges
p faces;

for a 5-connected network,

(D)
p vertices
$5p/2$ edges
$3p/2$ faces.

From Euler's Law, the equation for any n-connected network is

$$\frac{F_p\left(\Sigma p f_p\right)}{2} = E_p$$

Eq. 2-7.

or

$$F_p\left(3f_3 + 4f_4 + 5f_5 + \ldots pf_p\right) = 2E_p$$

Eq. 2-8.

where f_p is the fraction of the total number of faces which are
p-gons; F_p, the number of faces expressed in terms of p; and E_p,
the number of edges expressed in terms of p.

By substituting (A), (B), (C), and (D) into Eq. 2-8 we have:
for a 3-connected network,

46

$$3f_3 + 4f_4 + \ldots pf_p = 6;$$ Eq. 2-9.

for a 4-connected network,

$$3f_3 + 4f_4 + \ldots pf_p = 4;$$ Eq. 2-10.

for a 5-connected network,

$$3f_3 + 4f_4 + \ldots pf_p = 10/3;$$ Eq. 2-11.

for a 6-connected network,

$$3f_3 + 4f_4 + \ldots pf_p = 3.$$ Eq. 2-12.

There is no limit to the number of solutions to Eq. 2-9, and only one solution, the triangle, to Eq. 2-12. Through these equations one can determine what networks are possible as well as the proportion of each kind of polygon that must be contained in the network, without having a visual concept of the geometric properties of the network. For example, once we know that there are x p_2-gons for each p_1-gon in an n-connected network, we can begin to play with various constructions until we arrive at the configuration we desire.[13] Figure 2-20 shows an example of a 3-connected network and an example of a 4-connected network not made of regular polygons.[14]

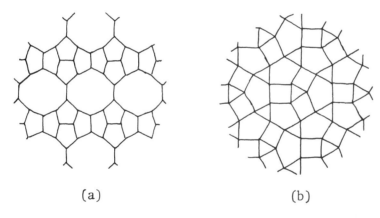

(a) (b)

Figure 2-20. *(a) a 3-connected network of 5-gons and 10-gons;* *(b) a 4-connected network of 3-gons, 4-gons, and 5-gons.*

[13] For some ideas on how one might begin to make some of these networks see: Jayne, C. F. 1962. *String Figures and How to Make Them.* New York: Dover.

[14] Eq. 2-7 is from Wells, A. F. 1968. "The Geometrical Basis of Crystal Chemistry. IX. Some Properties of Plane Nets," *Acta Cryst.* v. B24, pp. 50-57. See this paper for a thorough treatment of plane networks made of non-regular polygons.

2-4. THE UNIT CELL CONCEPT

The unit cells with which we will be concerned are of two kinds: a crystallographic unit cell and a topological unit cell. A *crystallographic unit cell* (or repeat unit) is a parallelogram containing the minimum repeatable elements of a circle packing, tessellation, or network. Its transformations, which are *translations* along the two axes of the plane, cover the entire plane just once. A *topological unit cell* is the smallest repeatable unit composed of vertices and edges that can be rotated on and translated across the plane to generate the entire network. Unit cells for the regular and semiregular tessellations are shown in Figures 2-4a through 2-14a: The crystallographic unit cell is the dotted line parallelogram at the left; the topological unit cell is composed of the darkened lines in the right circle of the respective Figures. (These concepts will be expanded later for the three-dimensional cases. Unit cells, both in two- and three-dimensions, will assume increased importance in *Part Three* as we develop methodologies for generating polygons and polyhedra.)

Unit cells are used in: (1) calculations of area densities of circle packings; (2) calculations of packing ratios of polygons in a network; (3) calculations of perimeter densities of polygons in a network; (4) descriptions of symmetry properties; and (5) transformations. (This will be taken up in *Part Three*.)

In calculations of *area densities* of circle packings we find that the uniform circle packing corresponding to {3,6}, with each circle perimeter touching six others, is the closest and densest possible arrangement of circles.[15] The *density*, the ratio between the area of the circles in a crystallographic unit cell to the area of the unit cell itself, is $\pi/\sqrt{12} = 0.9069...$ In other words, 90.69% of the area of a plane is covered in the {3,6} circle packing. The circle packing with the least density is that corresponding to the 3.12^2 tessellation (Figure 2-11a). Its density, $3\pi/(12+7\sqrt{3}) = 0.3906...$, is the lower bound for circle packing densities. The remaining nine packings fall between these two bounds. Table 2-2 gives data on area densities of the eleven packings.

The crystallographic unit cell for a packing quite easily gives the *packing ratios* among polygons. Table 2-3 gives data on these ratios.

The number of edges required to cover a unit cell with polygons is known as the *perimeter density*. The comparison of perimeter densities requires: (a) congruency among edges in the tessellations compared; and (b) a crystallographic unit cell that is *common* to all of the tessellations. Table 2-4 compares the perimeter densities for

[15] Fejes Tóth, L. 1953. *Lagerungen in der Ebene, auf der Kugel und im Raum*. Berlin-Göttingen-Heidelberg.

Table 2-2. DENSITIES OF PLANE ARRANGEMENTS OF CIRCLES

PACKING (TESSELLATION)	DENSITY
$\{3,6\}$	$\pi/\sqrt{12} = 0.9069$
$\{4,4\}$	$\pi/4 = 0.7854$
$\{6,3\}$	$\pi/\sqrt{27} = 0.6046$
$3^3.4^2$	$\pi/(\sqrt{3}+2) = 0.8418$
$3^2.4.3.4$	$\pi/(\sqrt{3}+2) = 0.8418$
$3.6.3.6$	$3\pi/(8\sqrt{3}) = 0.6802$
$3^4.6$	$3\pi/(7\sqrt{3}) = 0.7773$
3.12^2	$3\pi/(12+7\sqrt{3}) = 0.3906$
4.8^2	$\pi/(3+\sqrt{8}) = 0.5390$
$3.4.6.4$	$3\pi/(4\sqrt{3}+6) = 0.7290$
$4.6.12$	$\pi/(3+2\sqrt{3}) = 0.4860$

Table 2-3. PACKING RATIOS OF PLANE TESSELLATIONS

TESSELLATION	NETWORK	PACKING RATIO
$\{3,6\}$	6-connected	self-packing
$\{4,4\}$	4-connected	self-packing
$\{6,3\}$	3-connected	self-packing
$3^3.4^2$	5-connected	2-$\{3\}$; 1-$\{4\}$
$3^2.4.3.4$	5-connected	2-$\{3\}$; 1-$\{4\}$
$3.6.3.6$	4-connected	2-$\{3\}$; 1-$\{6\}$
$3^4.6$	5-connected	8-$\{3\}$; 1-$\{6\}$
3.12^2	3-connected	2-$\{3\}$; 1-$\{12\}$
4.8^2	3-connected	1-$\{4\}$; 1-$\{8\}$
$3.4.6.4$	4-connected	3-$\{4\}$; 2-$\{3\}$; 1-$\{6\}$
$4.6.12$	3-connected	3-$\{4\}$; 2-$\{6\}$; 1-$\{12\}$

Table 2-4. PERIMETER DENSITIES OF PLANE TESSELLATIONS

TESSELLATION	DENSITY
$\{3,6\}$	75
$\{4,4\}$	40
$\{6,3\}$	25
$3^3.4^2$	56
$3^2.4.3.4$	56
$3.6.3.6$	38
$3^4.6$	53
3.12^2	18

Table 2-4. PERIMETER DENSITIES OF PLANE TESSELLATIONS (cont.)

TESSELLATION	DENSITY
4.8^2	24
3.4.6.4	40
4.6.12	16

the eleven tessellations; all of the edges are congruent, and the unit cell for 4.6.12 is taken as the common unit cell for the comparison. The least dense tessellation is 4.6.12; that is, it contains the least number of edges in a common cell. {3,6} has the greatest number of edges within the common cell, and it has the highest density possible.

2-5. NON-EQUIVALENT CIRCLE PACKINGS

When non-equivalent circles are aggregated, an indefinite number of packing configurations is possible resulting in increased area densities. Some of these packings are generated by the incircles of polygons in the semi-regular tessellations of Figures 2-7a through 2-14a.

Consider circles packed in the {3,6} configuration shown in Figure 2-4a. To determine the radius of the largest circle that will fit within the interstices made by these circles we use the second stanza of F. Soddy's poem, "The Kiss Precise,"

Four circles to the kissing come.
The smaller are the benter.
The bend is just the inverse of
The distance from the center.
Though their intrigue left Euclid dumb
There's now no need for rule of thumb.
Since zero bend's a dead straight line
And concave bends have minus sign,
The sum of the squares of all four bends
Is half the square of their sum.[16]

The curvature of a circle, the reciprocal of its radius, is the *bend*. The radii of any four tangent circles follow the law stated in the last two lines:

$$2(a^2 + b^2 + c^2 + d^2) = (a + b + c + d)^2 \qquad \text{Eq. 2-13.}$$

[16] Soddy, F. 1936. "The Kiss Precise," *Nature*. v. 137, p. 1021.

where a, b, c, and d are the reciprocals of the radii of the circles.

From Eq. 2-13 we can determine the radius of the largest interstitial circle that fits into the interstices of the {3,6} circle packing. Where R is the radius of three contiguous circles, the radius of the interstitial circle is $R \cdot [(2/\sqrt{3})-1] = 0.1547...$ This packing is shown in Figure 2-21a; its density is $\pi+4/\sqrt{27} = 0.9503...$

In the {4,4} circle packing, the largest circles that fit into the interstices have radii of $R \cdot (\sqrt{2}-1) = 0.4142...$ (Figure 2-21b); the circle packing has a density of $[\pi(2-\sqrt{2})]/2 = 0.9202...$ In all of these packings the addition of circles with increasingly smaller radii will increase densities to approach the unity limit.

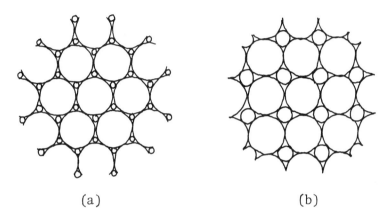

(a) (b)

Figure 2-21. Circle packings with interstices occupied by small circles.

2-6. CIRCLE COVERINGS

A *circle covering* is an arrangement of overlapping circles which cover the entire plane. The circle packing corresponding to {3,6}, having the highest density for packings of congruent circles, also gives the least dense covering (Figure 2-22a).[17] Its density is $2\pi/\sqrt{27} = 1.2093...$. Densities can, of course, be decreased in coverings of non-equivalent circles, as in Figure 2-22b. An upper bound, then, for a *packing* of equivalent circles is a density of $< \pi/\sqrt{12}$; the lower bound for a *covering* of equivalent circles is a density of $> 2\pi/\sqrt{27}$.

[17] Kershner, R. 1939. "The Number of Circles Covering a Set," *American Jour. Math.* v. 61, pp. 665-571; Fejes Tóth, L. 1950. "Some Packing and Covering Theorems," *Acta Sci. Math, (Szeged).* v. 12/A, pp. 62-67; Bambah, R. P. and Rogers, C. A. 1952. "Covering the Plane with Convex Sets," *J. London Math. Soc.* v. 22, pp. 304-314.

(a) (b)

Figure 2-22. Circle coverings.

2-7. THE GOLDEN PROPORTION[18]

The *golden proportion*, τ, is the ration useful in the description of plant symmetry properties and phyllotaxis,[19] as well as in descriptions of polygons and polyhedra.[20] τ is algebraically expressed as the positive root of the quadratic equation $\tau^2 - \tau - 1 = 0$. $\tau = (1+\sqrt{5})/2 = 1.618033...$ and is also expressed as the continued fraction,

[18] The golden proportion is the basis of the proportion system for architecture established by Le Corbusier. The system relates τ to a human figure 182 (6 feet) cm. tall and breaks up rectangular spaces according to the relationship between τ and the human proportions. See: Le Corbusier. 1968. *The Modulor* and *Modulor 2*. Cambridge, Mass.: M. I. T. Press.

[19] Thompson, D. W. *op. cit.*, pp. 749-933; Nichols, D. *op. cit.*

[20] For extensive treatments of the golden proportion in two-dimensions, as well as $\sqrt{2}$-, $\sqrt{3}$-, $\sqrt{4}$-, $\sqrt{5}$-ratio arrangements, see: Hambidge, J. 1967. *The Elements of Dynamic Symmetry*. New York: Dover. Also see: Bentley, H. E. 1970. *The Divine Proportion*. New York: Dover, and Ghyka. *op. cit.* For a discussion of the symbolic interpretations of geometric form see: Tyng, A. G. 1969. "Geometric Extensions of Consciousness," *Zodiac*. no. 19, pp. 130-162.

Geometrically τ is expressed as the relationship between the circum-circle radius and the edge of {10}, and as the relationship between the diagonal and the edge of {5}, as in Figure 2-23. Construction of

Figure 2-23. The golden proportion elements of {5}.

τ in the plane requires the bisection of an edge, AB, of {4}, and making diagonal OE = OC, as in Figure 2-24a. Then AF and AC are in the golden ratio, and ACDF is a *golden rectangle*. ACDF can be divid-ed into an infinite series of golden rectangles, as in Figure 2-24b. The logarithmic spiral, characteristic of many natural growth patterns in plants and animals is entered within this series of golden rectan-gles.[21]

(a)

(b)

Figure 2-24. (a) the construction of the golden rectangle; (b) the infinite series of golden rectangles and the logarithmic spirals.

[21] Cook, T. A. 1918. *The Curves of Life*. New York: Henry Holt & Co. Dover reprint, 1978.

CHAPTER 3

POLYHEDRA

A *polyhedron* is a finite system composed of a set of plane poly-
gons, such that every edge of a polygon also belongs to one other
polygon. The most important polyhedra are the *simple polyhedra*. A
polyhedron is simple when it is topologically equivalent to a sphere;
i.e., it can be continuously deformed into a sphere, and retain its
topological properties, as shown in Figure 3-1. Many kinds of poly-
hedra are possible; they consist of various combinations of straight

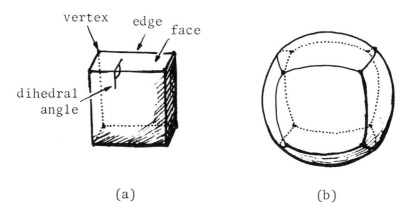

(a) (b)

*Figure 3-1. (a) the cube {4,3}, and its properties; (b) the
cube {4,3}, deformed into a sphere.*

edges, curved edges, planar faces, curved faces,[1] convex forms, and
concave forms. They may exist in curved spaces[2] and hyperspaces.[3]

[1] Burt, M. 1966. *Spacial Arrangement and Polyhedra with Curved
Faces and Their Architectural Applications*. Haifa: Israel Institute
of Technology (Technion), lists seven "Platonic" and seven "Archimed-
ean polyhedra" with curved faces. See: Chapter 6 for a discussion of
these solids.

3-1. LIMITING CONDITIONS FOR POLYHEDRA

Only five polyhedra are possible given the following five limiting conditions:

(1) all polygons are convex;

(2) all polygons are regular,

(3) all polygons in a polyhedron are congruent;

(4) all vertices are identical;

(5) all *dihedral angles* are equal (a dihedral angle, δ, is the internal angle formed by two faces that meet along a common edge).

The five polyhedra, commonly known as the *Platonic* or *regular polyhedra*, are the tetrahedron, {3,3}; the cube or hexahedron, {4,3}; the octahedron, {3,4}; the dodecahedron, {5,3}; and the icosahedron, {3,5}. (See Section 3-6 of this chapter for an explanation of the Schläfli symbols.)

If limiting condition (1) is relaxed, such that star polygons are admitted, four additional polyhedra are possible: the small stellated dodecahedron, the great stellated dodecahedron, the great dodecahedron, and the great icosahedron. They are known as *Kepler-Poinsot polyhedra*, *star polyhedra*, or *stellated polyhedra*.[4] These four, together with the five Platonic polyhedra, close the set of regular polyhedra.[5]

If limiting condition (3) is relaxed, such that a polyhedron can have non-congruent faces, two additional polyhedra, the *quasi-regular polyhedra*, are possible. They are the cuboctahedron, $(3.4)^2$,

[2] See: Coxeter, H. S. M. 1954. "Regular Honeycombs in Hyperbolic Space," *Proceedings of the International Congress of Mathematicians, Amsterdam.* v. III, pp. 155-169.

[3] See: Sommerville, D. M. Y. 1958. *An Introduction to the Geometry of N-Dimensions.* New York: Dover; Manning, H. P. 1956. *Geometry of Four Dimensions.* New York: Dover.

[4] The first two were discovered by Kepler; the remaining two were discovered by Poinsot. See: Cundy, H. M. and A. P. Rollett. 1961. *Mathematical Models.* London: Oxford University Press, pp. 90-99, for construction techniques.

[5] Only sixteen regular polytopes $\{p,q,r\}$ exist in spaces where $n > 3$. Six are convex polytopes, and ten are star polytopes. See: Coxeter, H. S. M. 1963. *Regular Polytopes.* New York: Dover: and Fejes Tóth, L. 1964. *Regular Figures.* Oxford: Pergamon Press, for discussions of these figures. For a mathematical discussion of the regular polyhedra see: Fejes Tóth, L. 1956a. "Characterizations of the Nine Regular Polyhedra by Extremum Properties," *Acta Math. Acad. Sci. Hung.* v. 7, pp. 31-48.

and the icosidodecahedron, $(3.5)^2$. If, in addition to condition (3), condition (5) is relaxed, an infinite set of polyhedra is admitted: the *Archimedean semi-regular* or *facially regular polyhedra*. They include an infinite set of prisms and anti-prisms plus eleven others: the truncated tetrahedron, 3.6^2; the truncated cube, 3.8^2; the truncated octahedron, 4.6^2; the small rhombicuboctahedron; 3.4^3; the great rhombicuboctahedron, $4.6.8$; the snub cube, $3^4.4$; the truncated dodecahedron, 3.10^2; the truncated icosahedron, 5.6^2; the small rhombicosidodecahedron, $3.4.5.4$; the great rhombicosidodecahedron, $4.6.10$; and the snub dodecahedron, $3^4.5$. Of these, two polyhedra—the snub cube, $3^4.4$, and the snub dodecahedron, $3^4.5$—are enantiomorphic. This closes the set of semi-regular polyhedra.[6]

If limiting conditions (2) and (4) are relaxed, such that a polyhedron can have non-regular faces, and more than one kind of vertex, another infinite set of polyhedra is possible. These are the *Archimedean dual* or *vertically regular polyhedra*.[7] They include an infinite set of bipyramids and trapezohedra, and a special group of thirteen polyhedra that are related to the semi-regular polyhedra through a correspondence between the faces of polyhedra in one group, and the vertices of polyhedra in the other group. This correspondence is called *duality*.

3-2. DUALITY

Two polyhedra are duals if the vertices of one can be put into a one-to-one correspondence with the centers of the faces of the other. For example, the cube, {4,3}, and the octahedron, {3,4}, are dual polyhedra (Figure 3-2a). The six vertices of {3,4} correspond to the six faces of {4,3}, and the eight vertices of {4,3} correspond to the eight faces of {3,4}.

[6] However, relaxing condition (1) in addition to (3) and (5) admits a group of stellated Archimedean semi-regular polyhedra. These fifty-three are presented in: Coxeter, H. S. M., M. S. Longuet-Higgins, and J. C. P. Miller. 1954. "Uniform Polyhedra," *Phil. Trans. Roy. Soc.* v. 264, pp. 401-450.

[7] The rhombic dodecahedron, $V(3.4)^2$, was known to the Greeks. The rhombic triacontahedron, $V(3.5)^2$, was discovered by Kepler. For an account of this see: Kepler, J. 1611. *De Nive Sexangula (On the Six-Cornered Snowflake)*. (ed. & trans. by C. Hardie.) London: Oxford University Press, 1966. The remaining dual polyhedra were discovered by: Catalan, M. E. 1865. "Mémoire sur La Théorie des Polyhèdres," *Journal de l'École Impériale Polytechnique.* v. XXIV, pp. 1-71.

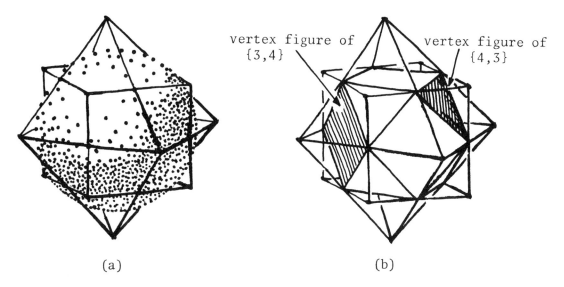

vertex figure of
{3,4}

vertex figure of
{4,3}

(a) (b)

Figure 3-2. (a) the dual properties of the cube, {4,3}, and the octahedron, {3,4}; (b) the vertex figures generated by the cube, {4,3}, and the octahedron, {3,4}.

The dual of any of the Platonic and Archimedean polyhedra can be generated as follows:

(1) Inscribe a sphere (inter-sphere) in the polyhedron such that the surface of the sphere is tangent to every edge of the polyhedron. (In the case of the Platonic and Archimedean semi-regular polyhedra, the inter-sphere is tangent to the mid-point of each edge. In the case of the Archimedean dual polyhedra, the sphere is tangent to, but not necessarily at the mid-point of each edge.)

(2) At the point of tangency of each edge to the inter-sphere, add another edge that is tangent to the sphere, and perpendicular to the edge.

(3) The added edges converge, and form the vertices and faces of the dual polyhedron.[8]

3-3. VERTEX FIGURES

A *vertex figure* is a polyhedron made by connecting the bisectors of the edges meeting at a vertex of a polyhedron. The shaded areas

[8] Catalan. *op. cit.*, derived the Archimedean duals by trigonometric methods. See: Graziotti, U. A. 1962. *Polyhedra*. San Francisco: private edition; for geometric derivations of the Archimedean dual polyhedra.

in Figure 3-2b are vertex figures of the cube, {4,3}, and the octahedron, {3,4}.

The concept of vertex figures can be substituted for limiting conditions (3), (4), and (5). Conditions for regular polyhedra then simplify to:

(1) all polygons are convex;
(2) all polygons are regular;
(3) all vertex figures are regular.

The quasi-regular polyhedra—the cuboctahedron, $(3.4)^2$, and the icosidodecahedron, $(3.5)^2$—are generated by interconnecting all of the vertex figures in a pair of dual regular polyhedra. In Figure 3-2b, for example, $(3.4)^2$ is defined by the vertex figures of the cube, {4,3}, and the octahedron, {3,4}. The vertex figures of the icosahedron, {3,5}, and the dodecahedron, {5,3}, define $(3.5)^2$; the vertex figures of the tetrahedron, {3,3}, define {3,4}. {3,4}, $(3.4)^2$, and $(3.5)^2$ have the unique property of being defined by *equatorial polygons*, {h} (or great circles); i.e., polygons (or great circles) that pass through the center of the polyhedron. In {3,4}, {h} is a {4}; in $(3.4)^2$, {h} is a {6}; and in $(3.5)^2$, {h} is a {10}, as shown in Figure 3-3.

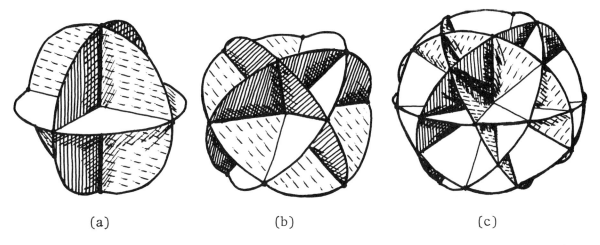

(a)	(b)	(c)

Figure 3-3. (a) three great circles defining an octahedron, {3.4}; (b) four great circles defining a cuboctahedron, $(3.4)^2$; (c) six great circles defining an icosidodecahedron, $(3.5)^2$.

3-4. THE ORTHOSCHEME

Schläfli[9] pointed out that a polyhedron, {p,q}, can be decomposed (or build up) into one or more kinds of oppositely congruent tetra-

[9] Schläfli, L. 1901. "Theorie der vielfachen Kontinuität," *Denkschriften der Schweizerischen Naturforschenden Gesellschaft*. v. 38, pp. 1-237.

hedra. He called such a tetrahedron an *orthoscheme* (Figure 3-4).
They are generally termed *quadrirectangular tetrahedra* because each
is composed of four right-angled triangles.

Figure 3-4. The orthoscheme
for the cube, {4,3}.

The quadrirectangular tetrahedron facilitates calculations of
the radii of *in-spheres* (spheres tangent to face centroids), *inter-*
spheres (spheres tangent to mid-edges), and *circum-spheres* (spheres
tangent to vertices); dihedral angles; surface areas; and volumes of
polyhedra. By using plane trigonometry and the values of p, q, and
h, these quantities can be determined.

Consider the orthoscheme, $O_1O_2O_3O_4$, for a cube; where $_0R$ is the
radius of the circum-sphere; $_1R$, the radius of the inter-sphere; and
$_2R$, the radius of the in-sphere, as in Figure 3-5.

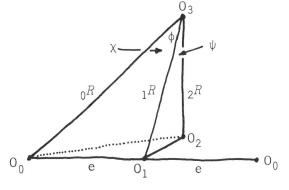

Figure 3-5. The orthoscheme
for the cube, {4,3}.

We must first determine $O_0O_3O_1 = \phi$; $O_1O_3O_2 = \lambda$; and $O_0O_3O_2 = \chi$.

$$\cos\phi = \frac{O_1O_3}{O_0O_3} = \frac{_1R}{_0R} = \cos\frac{\pi}{p}\,\csc\frac{\pi}{q} \qquad\qquad \text{Eq. 3-1.}$$

$$\cos\lambda = \frac{O_2O_3}{O_1O_3} = \frac{_2R}{_1R} = \csc\frac{\pi}{p}\,\cos\frac{\pi}{q} \qquad\qquad \text{Eq. 3-2.}$$

$$\cos\chi = \frac{O_2 O_3}{O_0 O_3} = \frac{{}_2 R}{{}_0 R} = \cot\frac{\pi}{p} \cot\frac{\pi}{q}$$

Eq. 3-3.

Since the complement ($O_2 O_1 O_3$) of ψ is half of the dihedral angle, δ; then,

$$\delta = \pi - 2\psi.$$

Eq. 3-4.

$$_0 R = e \sin\frac{\pi}{q} \csc\frac{\pi}{h}$$

Eq. 3-5.

$$_1 R = e \cos\frac{\pi}{p} \csc\frac{\pi}{h}$$

Eq. 3-6.

$$_2 R = e \cot\frac{\pi}{p} \cos\frac{\pi}{q} \csc\frac{\pi}{h}$$

Eq. 3-7.

The surface area of $\{p,q\}$ is,

$$2N_1 \; e^2 \; \cot\frac{\pi}{p}$$

Eq. 3-8.

The volume of $\{p,q\}$ is,

$$\frac{2}{3}N_1 \; e^3 \; \cot\frac{\pi}{p} \cos\frac{\pi}{q} \csc\frac{\pi}{h}$$

Eq. 3-9.

where N_1 is the number of edges in $\{p,q\}$.

Through the use of the orthoscheme, properties of the semi-regular polyhedra may also be calculated, but with more difficulty.[10]

3-5. DESCARTES' FORMULA

The sum of the angles surrounding a vertex in a convex polyhedron is always $< 2\pi$. This angular deficiency, ω, at a vertex decreases as a polyhedron increases the number of faces in its total composition. Descartes[11] demonstrated that if face angles at a vertex are $2\pi - \omega$; then,

[10] From: Coxeter, H. S. M. 1961. *Introduction to Geometry*. New York: Wiley and Sons, Inc., pp. 155-157.

[11] Coxeter, H. S. M. 1963. *op. cit.*, pp. 23-24.

$$\Sigma\omega = 4\pi \qquad\qquad\qquad\qquad \text{Eq. 3-10.}$$

for all of the vertices of the polyhedron.[12]

3-6. DESCRIPTIVE PROPERTIES OF POLYHEDRA

Properties of the Platonic, Archimedean semi-regular, and Archimedean dual polyhedra are presented in the following pages. The drawings at the top of each page include one view of the polyhedron, and the *net* for its construction. The name of the polyhedron is below the drawing.

The notation (Schläfli symbol) that follows the name designates the kinds of faces that compose the polyhedron, and the number of each kind that meet at a vertex for the Platonic and Archimedean semi-regular polyhedra. For example, Tetrahedron {3,3}, means: triangles, three at a vertex. Truncated Tetrahedron 3.6^2, means: triangles and hexagons, one triangle and two hexagons at a vertex.

For the Archimedean dual polyhedra, the notation designates the number of edges which meet at each species of vertex on the polyhedron, and the number of times that each kind of vertex is associated with a face. This notation is prefixed by a V. Rhombic Dodecahedron $V(3.4)^2$, means: two vertices with three edges, and two vertices with four edges are associated with each face.

Next to this notation are the quantity and species of faces (F), vertices (V), and edges (E) in the polyhedron. For example, the truncated tetrahedron, 3.6^2, contains:

F_3	F_6	V_3	E_{6-6}	E_{6-3}
4	4	12	6	12

i.e., the truncated tetrahedron has four triangle faces, four hexagonal faces, twelve vertices with three edges, six edges common to hexagonal faces, and twelve edges common to hexagonal and triangle faces. The topological relationship among faces, vertices, and edges is given by Euler's Law, Eq. 1-3.

The additional information that follows on each page is:
- DUAL (The name of the polyhedron that is the dual of the polyhedron described on the page.)
- DIHEDRAL ANGLE (The value of the internal angle at which two faces meet at a common edge.)
- ANGLE SUBTENDED BY AN EDGE AT THE CENTER OF THE POLYHEDRON

[12] See: Fuller, R. B. 1965. "Omnidirectional Halo," *World Design Sci. Decade. 1956-1975. Phase I, Document 3.* Carbondale, Ill.: World Resources Inventory, pp. 7-26, for a discussion of Descartes' formula.

- E/ρ This represents the relationship between the length of the edge, E, and the distance from the polyhedron center to its mid-edge, ρ. (This ratio is important because ρ represents the radius of the inter-sphere that is common to any dual polyhedra.)
- EDGE (The edge of each polyhedron will be taken as unity.)
- CENTER OF POLYHEDRON TO CENTER OF FACE (The radius of the in-sphere.)
- CENTER OF POLYHEDRON TO MID-EDGE (The radius of the inter-sphere, ρ.)
- CENTER OF POLYHEDRON TO VERTEX (The radius of the circum-sphere.)
- SURFACE AREA (in edge-squared units; eg., if edge = 1 cm, area is in cm^2.)
- VOLUME (in edge-cubed units; e.g., if edge = 1 cm, volume is in cm^3.)
- FACE ANGLES (for the Archimedean dual polyhedra.)

Figure 3-6.

Tetrahedron {3,3}

Faces	Vertices	Edges
F_3	V_3	E_{3-3}
4	4	6

Dual: Tetrahedron (self)

Dihedral Angle: 3-3: $2 \sin \sqrt{3}/3 = 70°31'44''$

Angle Subtended by an
Edge at Center of Polyhedron: $\cos - 1/3 = 109°28'16''$

E/ρ: $2\sqrt{2} = 2.8284$

Edge: 1

Center of Polyhedron to Center of Face: Triangle: $\sqrt{6}/12 = 0.2041$

Center of Polyhedron to Mid-Edge: $\sqrt{2}/4 = 0.3536$

Center of Polyhedron to Vertex: $\sqrt{6}/4 = 0.6124$

Vertex to Center of Face: $\sqrt{3}/3 = 0.5774$

Mid-Edge to Center of Face: $\sqrt{3}/6 = 0.2887$

Surface Area: $\sqrt{3} = 1.732$

Volume: $\sqrt{2}/12 = 0.1178$

 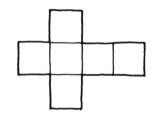

Figure 3-7.

Cube (Hexahedron) {4,3}

Faces	Vertices	Edges
F_4	V_3	E_{4-4}
6	8	12

Dual: Octahedron

Dihedral Angle: 4-4: 90°

Angle Subtended by an
Edge at Center of Polyhedron: cos 1/3 = 70° 31' 44"

E/ρ: $\sqrt{2}$ = 1.4142

Edge: 1

Center of Polyhedron to Center of Face: 1/2

Center of Polyhedron to Mid-Edge: $\sqrt{2}/2$ = 0.7071

Center of Polyhedron to Vertex: $\sqrt{3}/2$ = 0.8660

Vertex to Center of Face: $\sqrt{2}/2$ = 0.7071

Mid-Edge to Center of Face: 1/2 = 0.5000

Surface Area: 6.0000

Volume: 1.0000

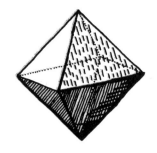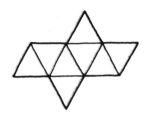

Figure 3-8.

Octahedron {3,4}

Faces	Vertices	Edges
F_3	V_4	E_{3-3}
8	6	12

Dual: Cube

Dihedral Angle: 3-3: 109°28' 16"

Angle Subtended by an
Edge at Center of Polyhedron: 90°

E/ρ: 2

Edge: 1

Center of Polyhedron to Center of Face: $\sqrt{6}/6 = 0.4083$

Center of Polyhedron to Mid-Edge: $1/2 = 0.5000$

Center of Polyhedron to Vertex: $\sqrt{2}/2 = 0.7071$

Vertex to Center of Face: $\sqrt{3}/3 = 0.5774$

Mid-Edge to Center of Face: $\sqrt{3}/6 = 0.2887$

Surface Area: $2\sqrt{3} = 3.4641$

Volume: $\sqrt{2}/3 = 0.4714$

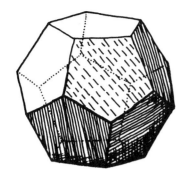 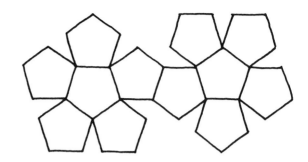

Figure 3-9.

Dodecahedron {5,3}

Faces	Vertices	Edges
F_5	V_3	E_{5-5}
12	20	30

Dual: Icosahedron

Dihedral Angle: 5-5: $\pi - (\tan^{-1})^2 = 116°33'54''$

Angle Subtended by an
Edge at Center of Polyhedron: $41°28'$

E/ρ: $3 - \sqrt{5} = 0.7639$

Edge: 1

Center of Polyhedron to Center of Face:

$$\tau^{5/2}\big/2(5^{1/4}) = 1.1135 \quad \left[\tau = (1 + \sqrt{5})/2 = 1.6180\right]$$

Center of Polyhedron to Mid-Edge: $\tau^2/2 = 1.3090$

Center of Polyhedron to Vertex: $\tau\sqrt{3}/2 = 1.4013$

Vertex to Center of Face: $\sqrt{\tau}/5^{1/4} = 0.8507$

Mid-Edge to Center of Face: $(\sqrt{25 + 10\sqrt{5}})/10 = 0.6882$

Surface Area: $3\sqrt{5(5 + 2\sqrt{5})} = 20.6458$

Volume: $(15 + 7\sqrt{5})/4 = 7.6632$

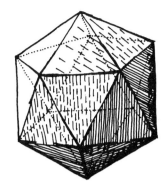

Figure 3-10.

Icosahedron {3,5}

Faces	Vertices	Edges
F_3	V_5	E_{3-3}
20	12	30

Dual: Dodecahedron

Dihedral Angle: 3-3: $\pi - (\sin^{-1})^{2/2} = 138°11'22''$

Angle Subtended by an
Edge at Center of Polyhedron: $\cos(\sqrt{5}/5) = 63°26'$

E/ρ: $\sqrt{5} - 1 = 1.2361$

Edge: 1

Center of Polyhedron to Center of Face:

$$\tau^2/2\sqrt{3} = 0.7558 \left[\tau = (1 + \sqrt{5})/2 = 1.6180\right]$$

Center of Polyhedron to Mid-Edge: $\tau/2 = 0.8090$

Center of Polyhedron to Vertex: $(5^{1/4}\sqrt{\tau})/2 = 0.9511$

Vertex to Center of Face: $\sqrt{3}/3 = 0.5774$

Mid-Edge to Center of Face: $\sqrt{3}/6 = 0.2887$

Surface Area: $5\sqrt{3} = 8.6603$

Volume: $5\tau^2/6 = 2.1817$

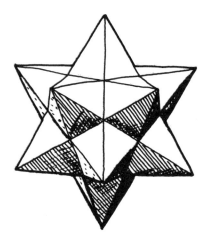

Figure 3-11.

Small Stellated Dodecahedron $\left\{\frac{5}{2}, 5\right\}$

Faces	Vertices	Edges
12	12	30

Dual: Great Dodecahedron

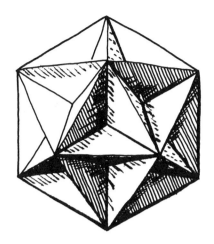

Figure 3-12.

Great Dodecahedron $\left\{5,\frac{5}{2}\right\}$

Faces	Vertices	Edges
12	12	30

Dual: Small Stellated Dodecahedron

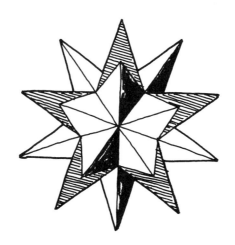

Figure 3-13.

Great Stellated Dodecahedron $\left\{\frac{5}{2}, 3\right\}$

Faces	Vertices	Edges
12	20	30

Dual: Great Icosahedron

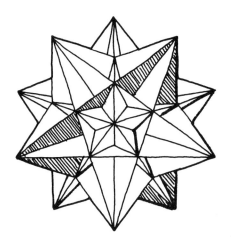

Figure 3-14.

Great Icosahedron $\left\{3,\frac{5}{2}\right\}$

Faces	Vertices	Edges
20	12	30

Dual: Great Stellated Dodecahedron

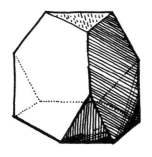

Figure 3-15.

Truncated Tetrahedron 3.6^2

Faces		Vertices	Edges	
F_3	F_6	V_3	E_{6-6}	E_{6-3}
4	4	12	6	12

Dual: Triakis Tetrahedron

Dihedral Angle: 3-6: 109° 28' 16"
6-6: 70° 31' 44"

Angle Subtended by an
Edge at Center of Polyhedron: 50° 28'

E/ρ: $\sqrt{8}/3 = 0.9428$

Edge: 1

Center of Polyhedron to Center of Face: Triangle: $5\sqrt{6}/12 = 1.0207$
Hexagon: $\sqrt{6}/4 = 0.6124$

Center of Polyhedron to Mid-Edge: $3\sqrt{2}/4 = 1.0607$

Center of Polyhedron to Vertex: $\sqrt{22}/4 = 1.1726$

Vertex to Center of Face: Triangle: $\sqrt{3}/3 = 0.5744$
Hexagon: 1

Mid-Edge to Center of Face: Triangle: $\sqrt{3}/6 = 0.2887$
Hexagon: $\sqrt{3}/2 = 0.8660$

Surface Area: 12.124

Volume: 2.7102

Figure 3-16.

Triakis Tetrahedron V3.6^2

Faces	Vertices		Edges
F_3	V_6	V_3	E
12	4	4	18

Dual: Truncated Tetrahedron

Dihedral Angle: cos – 7/11 = 129°31' 16"

E/ρ: 3, 3, 5 × 0. 5657

Face Angles: 33°33'26"; 112°53'08"

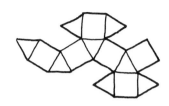

Figure 3-17.

Cuboctahedron $(3.4)^2$

Faces	Vertices	Edges
F_3 \quad F_4	V_4	E_{3-4}
8 \quad 6	12	24

Dual: Rhombic Dodecahedron

Dihedral Angle: 3-4: $\cos - (\sqrt{3}/3) = 125°15'51''$

Angle Subtended by an
Edge at Center of Polyhedron: 60°

E/ρ: $2\sqrt{3}/3 = 1.1547$

Edge: 1

Center of Polyhedron to Center of Face: Triangle: $\sqrt{6}/3 = 0.8165$
Square: $\sqrt{2}/2 = 0.7071$

Center of Polyhedron to Mid-Edge: $\sqrt{3}/2 = 0.8660$

Center of Polyhedron to Vertex: 1

Vertex to Center of Face: Triangle: $\sqrt{3}/3 = 0.5774$
Square: $\sqrt{2}/2 = 0.7071$

Mid-Edge to Center of Face: Triangle: $\sqrt{3}/6 = 0.2887$
Square: $1/2 = 0.5000$

Surface Area: 9.4641

Volume: 2.3570

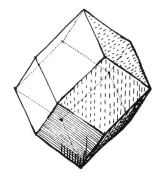 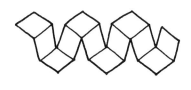

Figure 3-18.

Rhombic Dodecahedron V(3.4)2

Faces	Vertices		Edges
F_4	V_3	V_4	E_{4-4}
12	8	6	24

Dual: Cuboctahedron

Dihedral Angle: 120°

Angle Subtended by an
Edge at Center of Polyhedron: To two tri-edge vertices: 70°31'44"
To a tri-edge and a
tetra-edge vertex: 54°44'08"

E/ρ: $3\sqrt{2}/4 = 1.0607$

Edge: 1

Center of Polyhedron to Center of Face: $\sqrt{6}/3 = 0.8165$

Center of Polyhedron to Vertex: To tetra-edge vertex: $2\sqrt{3}/3 = 1.1547$
To tri-edge vertex: 1

Vertex to Center of Face: Tetra-edge vertex: $\sqrt{6}/3 = 0.8165$
Tri-edge vertex: $\sqrt{3}/3 = 0.5774$

Surface Area: 11.3137

Volume: 3.0792

Face Angles: 70°31'44"; 109°28'16"

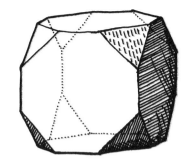

Figure 3-19.

Truncated Cube 3.8^2

Faces		Vertices	Edges	
F_3	F_8	V_3	E_{3-8}	E_{8-8}
8	6	24	24	12

Dual: Triakis Octahedron

Dihedral Angle: 3-8: 125° 15' 51"
 8-8: 90°

Angle Subtended by an
Edge at Center of Polyhedron: 32° 39'

E/ρ: $2 - \sqrt{2} = 0.5858$

Edge: 1

Center of Polyhedron to Center of Face:

 Triangle: $\sqrt{6}/12 \times (3\sqrt{2} + 4) = 1.6825$
 Octagon: $(\sqrt{2} + 1)/2 = 1.2071$

Center of Polyhedron to Mid-Edge: $(\sqrt{2} + 2)/2 = 1.7071$

Center of Polyhedron to Vertex: $\sqrt{7/4 + \sqrt{2}} = 1.7787$

Vertex to Center of Face: Triangle: $\sqrt{3}/3 = 0.5774$
 Octagon: $1/2\sqrt{4 + 2\sqrt{2}} = 1.3066$

Mid-Edge to Center of Face: Triangle: $\sqrt{3}/6 = 0.2887$
 Octagon: $(\sqrt{2} + 1)/2 = 1.2071$

Surface Area: 32.432

Volume: 13.5988

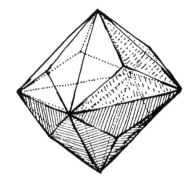 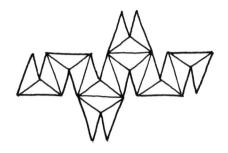

Figure 3-20.

Triakis Octahedron V3.8^2

Faces	Vertices		Edges
F_3	V_3	V_8	E_{3-3}
24	8	6	36

Dual: Truncated Cube

Dihedral Angle: $\sin - \left[2/17 \times (16 - \sqrt{2}) \right] = 147°21'0''$

E/ρ: 1.1716
 1.1716
 2.0000

Face Angles: 31°22'21''; 117°15'18''

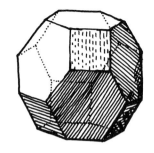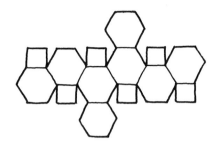

Figure 3-21.

Truncated Octahedron 4.6^2

	Faces		Vertices		Edges	
	F_4	F_6	V_3		E_{4-6}	E_{6-6}
	6	8	24		24	12

Dual: Tetrakis Hexahedron

Dihedral Angle: 4-6: cos − $\sqrt{3}/3$ = 125° 15' 51"
6-6: cos − 1/3 = 109° 28' 16"

Angle Subtended by an
Edge at Center of Polyhedron: 36° 52'

E/ρ: 2/3 = 0.6667

Edge: 1

Center of Polyhedron to Center of Face: Square: $\sqrt{2}$ = 1.4142
Hexagon: $\sqrt{6}/2$ = 1.2247

Center of Polyhedron to Mid-Edge: 1.5

Center of Polyhedron to Vertex: $\sqrt{10}/2$ = 1.5811

Vertex to Center of Face: Square: $\sqrt{2}/2$ = 0.7071
Hexagon: 1

Mid-Edge to Center of Face: Square: 1/2 = 0.5000
Hexagon: $\sqrt{3}/2$ = 0.8660

Surface Area: 26.7846

Volume: 11.3137

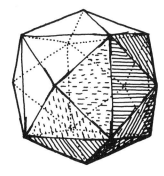 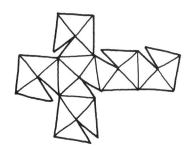

Figure 3-22.

Tetrakis Hexahedron V4.6^2

Faces	Vertices		Edges
F$_3$	V$_4$	V$_6$	E$_3$
24	6	8	36

Dual: Truncated Octahedron

Dihedral Angle: 143°7'48"

E/ρ: 3, 3, 4 × 0.3536

Face Angles: 48°11'30"; 83°37'

79

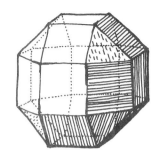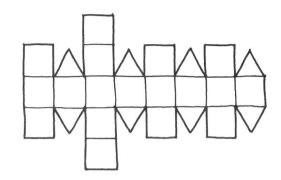

Figure 3-23.

Small Rhombicuboctahedron 3.4^3

Faces		Vertices	Edges	
F_3	F_4	V_4	E_{3-4}	E_{4-4}
8	18	24	24	24

Dual: Trapezoidal Icositetrahedron

Dihedral Angle: 3-4: $\cos - \sqrt{6}/3 = 144°44'08''$
4-4: $\cos - \sqrt{2}/2 = 135°$

Angle Subtended by an
Edge at Center of Polyhedron: $2\cos\left[(12 - 2\sqrt{2})/17\right]^{1/2} = 41°53'$

E/ρ: $(2 - \sqrt{2})^{1/2} = 0.7654$

Edge: 1

Center of Polyhedron to Center of Face:

Triangle: $\sqrt{6}\left[(3\sqrt{2} + 2)/12\right] = 1.2743$
Square: $1/2(1 + \sqrt{2}) = 1.2071$

Center of Polyhedron to Mid-Edge: $\sqrt{1 + 1/\sqrt{2}} = 1.3065$

Center of Polyhedron to Vertex: $\sqrt{5/4 + 1/\sqrt{2}} = 1.3989$

Vertex to Center of Face: Triangle: $\sqrt{3}/3 = 0.5774$
Square: $\sqrt{2}/2 = 0.7071$

Mid-Edge to Center of Face: Triangle: $\sqrt{3}/6 = 0.2887$
Square: $1/2 = 0.5000$

Surface Area: 21.4641

Volume: 8.7133

80

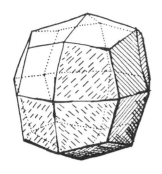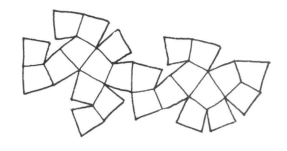

Figure 3-24.

Trapezoidal Icositetrahedron V3.4^3

Faces	Vertices		Edges
F_4	V_3	V_4	E_{4-4}
24	8	18	48

Dual: Small Rhombicuboctahedron

Dihedral Angle: 138° 6' 34"

E/ρ: 0.6408(3-4)
0.8284(4-4)

Face Angles: 81° 34' 44"; 115° 15' 48"

81

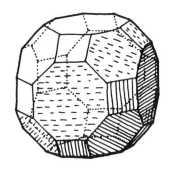

Figure 3-25.

Great Rhombicuboctahedron 4.6.8

Faces			Vertices	Edges		
F_4	F_6	F_8	V_3	E_{4-6}	E_{4-8}	E_{6-8}
12	8	6	48	24	24	24

Dual: Hexakis Octahedron

Dihedral Angle: 4-6: $\cos - \sqrt{6}/3 = 144°44'08''$
4-8: $\cos - \sqrt{2}/2 = 135°$
6-8: $\cos - \sqrt{3}/3 = 125°15'51''$

Angle Subtended by an
Edge at Center of Polyhedron: $24°55'$

E/ρ: $\sqrt{(2 - \sqrt{2})/3} = 0.4419$

Edge: 1

Center of Polyhedron to Center of Face:

Square: $(3 + \sqrt{2})/2 = 2.2071$
Hexagon: $\sqrt{6}/4 \times (2 + \sqrt{2}) = 2.0908$
Octagon: $(1 + 2\sqrt{2})/2 = 1.9142$

Center of Polyhedron to Mid-Edge: $1/2\sqrt{12 + 6\sqrt{2})} = 2.2630$

Center of Polyhedron to Vertex: $1/2\sqrt{13 + 6\sqrt{2}} = 2.3176$

Vertex to Center of Face: Square: $\sqrt{2}/2 = 0.7071$
Hexagon: 1
Octagon: $1/2\sqrt{4 + 2\sqrt{2}} = 1.3066$

Mid-Edge to Center of Face: Square: $1/2 = 0.5000$
Hexagon: $\sqrt{3}/2 = 0.8660$
Octagon: $(\sqrt{2} + 1)/2 = 1.2071$

Surface Area: 61.7551

Volume: 41.7942

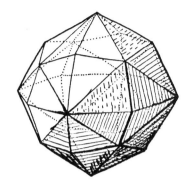 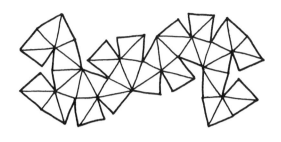

Figure 3-26.

Hexakis Octahedron V4.6.8

Faces	Vertices			Edges
F_3	V_4	V_6	V_8	E_{3-3}
48	12	8	6	72

Dual: Great Rhombicuboctahedron

Dihedral Angle: 155°04'56"

E/ρ: 0.6408
0.8571
1.0448

Face Angles: 37°46'24"; 55°01'29"; 87°12'07"

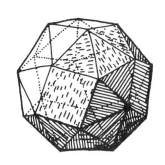

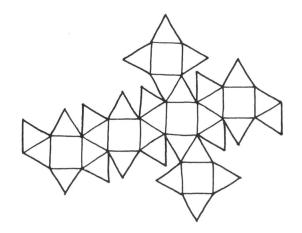

Figure 3-27.

Snub Cube $3^4.4$*

Faces		Vertices	Edges	
F_3	F_4	V_5	E_{3-3}	E_{3-4}
32	6	24	36	24

Dual: Pentagonal Icositetrahedron

Dihedral Angle: 3-3: 153° 14' 04"
 3-4: 142° 59'

Angle Subtended by an
Edge at Center of Polyhedron: 43° 41'

E/ρ: 0.8018

Edge: 1

Center of Polyhedron to Center of Face: Triangle: 1.2132
 Square: 1.1425

Center of Polyhedron to Mid-Edge: 1.2472

Center of Polyhedron to Vertex: 1.3436

Vertex to Center of Face: Triangle: $\sqrt{3}/3 = 0.5774$
 Square: $\sqrt{2}/2 = 0.7071$

Mid-Edge to Center of Face: Triangle: $\sqrt{3}/6 = 0.2887$
 Square: $1/2 = 0.5000$

Surface Area: 19.856

Volume: 7.8885

*Enantiomorphic: exists in right and left handed forms

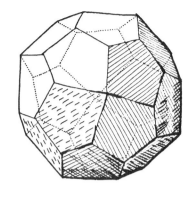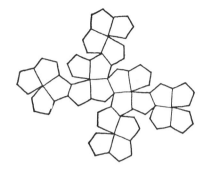

Figure 3-28.

Pentagonal Icositetrahedron V3⁴.4*

Faces	Vertices		Edges
F_5	V_3	V_4	E_{5-5}
24	32	6	60

Dual: Snub Cube

Dihedral Angle: 136°20'

E/ρ: 0.4758(3-3)
 0.6755(3-4)

Face Angles: 80°45'06"; 114°48'43"

*Enantiomorphic: exists in right and left handed forms

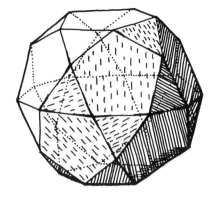

Figure 3-29.

Icosidodecahedron $(3.5)^2$

Faces		Vertices	Edges
F_3	F_5	V_4	E_{3-5}
20	12	30	60

Dual: Rhombic Triacontahedron

Dihedral Angle: 142° 37' 21"

Angle Subtended by an
Edge at Center of Polyhedron: 36°

E/ρ: $2 \tan 18° = 0.6498$

Edge: 1

Center of Polyhedron to Center of Face:

Triangle: $\sqrt{\tau^2 - (1/\sqrt{3})^2} = 1.5083$ $\left[\tau = (1 + \sqrt{5})/2 = 1.6180\right]$

Pentagon: $\sqrt{\tau^2 - (1.7613/2)^2} = 1.3764$

Center of Polyhedron to Mid-Edge: 1.5389

Center of Polyhedron to Vertex: $\tau = 1.6180$

Vertex to Center of Face: Triangle: $\sqrt{3}/3 = 0.5774$

Pentagon: $\sqrt{\tau}/5^{1/4} = 0.8507$

Mid-Edge to Center of Face: Triangle: $\sqrt{3}/6 = 0.2887$

Pentagon: $\left(\sqrt{25 + 10\sqrt{5}}\right)/10 = 0.6882$

Surface Area: 29.3002

Volume: 13.8237

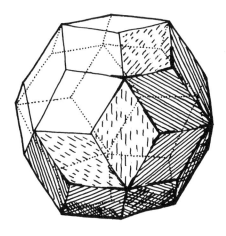

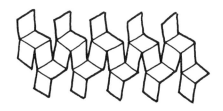

Figure 3-30.

Rhombic Triacontahedron $V(3.5)^2$

Faces	Vertices		Edges
F_4	V_3	V_5	E_{4-4}
30	20	12	60

Dual: Icosidodecahedron

Dihedral Angle: 144°

E/ρ: $(5 - \sqrt{5})/4 = 0.6910$

Face Angles: 63°26'; 116°34'

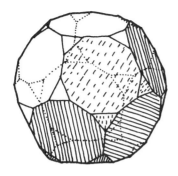 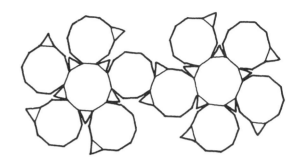

Figure 3-31.

Truncated Dodecahedron 3.10^2

Faces		Vertices	Edges	
F_3	F_{10}	V_3	E_{3-10}	E_{10-10}
20	12	60	60	30

Dual: Triakis Icosahedron

Dihedral Angle: 3-10: 142°37'21"
 10-10: 116°33'54"

Angle Subtended by an
Edge at Center of Polyhedron: 19°24'

E/ρ: $\left(3/\sqrt{5}\right) - 1 = 0.3416$

Edge: 1

Center of Polyhedron to Center of Face: Triangle: 2.9132
 Decagon: 2.4904

Center of Polyhedron to Mid-Edge: 2.9274

Center of Polyhedron to Vertex: 2.9698

Vertex to Center of Face: Triangle: $\sqrt{3}/3 = 0.5774$
 Decagon: $\tau = 1.6180$

Mid-Edge to Center of Face: Triangle: $\sqrt{3}/6 = 0.2887$

 Decagon: $1/2\sqrt{5 + 2\sqrt{5}} = 1.5388$

Surface Area: 100.9882

Volume: 85.0542

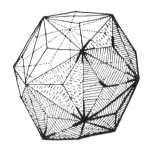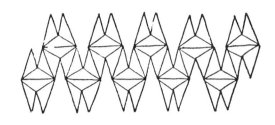

Figure 3-32.

Triakis Icosahedron V3.10^2

Faces	Vertices		Edges
F_3	V_3	V_{10}	E_{3-3}
60	20	12	90

Dual: Truncated Dodecahedron

Dihedral Angle: 160°36'45''

E/ρ: 0.7172
 0.7172
 1.2361

Face Angles: 30°28'30''; 119° 03'

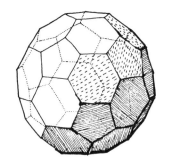

Figure 3-33.

Truncated Icosahedron 5.6^2

Faces		Vertices	Edges	
F_5	F_6	V_3	E_{5-6}	E_{6-6}
12	20	60	60	30

Dual: Pentakis Dodecahedron

Dihedral Angle: 5-6: 142°37'21"

6-6: 138°11'22"

Angle Subtended by an
Edge at Center of Polyhedron: 23°17'

E/ρ: $(\sqrt{5} - 1)/3 = 0.4120$

Edge: 1

Center of Polyhedron to Center of Face: Pentagon: 2.3276

Hexagon: $3\tau^2/2\sqrt{3} = 2.2672$

Center of Polyhedron to Mid-Edge: 2.4272

Center of Polyhedron to Vertex: 2.4782

Vertex to Center of Face: Pentagon: $\sqrt{\tau}/5^{1/4} = 0.8507$ $\left[\tau = (1 + \sqrt{5})/2\right]$

Hexagon: 1

Mid-Edge to Center of Face: Pentagon: $\left(\sqrt{25 + 10\sqrt{5}}\right)/10 = 0.6882$

Hexagon: $\sqrt{3}/2 = 0.8660$

Surface Area: 72.6000

Volume: 55.2870

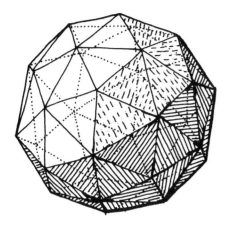 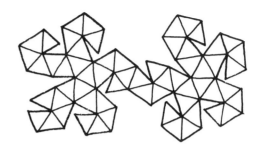

Figure 3-34.

Pentakis Dodecahedron V5.6^2

Faces	Vertices		Edges
F_3	V_5	V_6	E_{3-3}
60	12	20	90

Dual: Truncated Icosahedron

Dihedral Angle: 156°43'7"

E/ρ: 0.6776
 0.6776
 0.7639

Face Angles: 55°41'26"; 68°37'08"

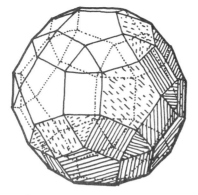 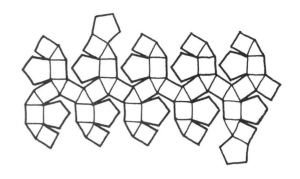

Figure 3-35.

Small Rhombicosidodecahedron 3.4.5.4

Faces			Vertices	Edges	
F_3	F_4	F_5	V_4	E_{3-4}	E_{4-5}
20	30	12	60	60	60

Dual: Trapezoidal Hexecontahedron

Dihedral Angle: 3-4: 159°05'41"
 4-5: 148°16'57"

Angle Subtended by an
Edge at Center of Polyhedron: 25°52'

E/ρ: $\sqrt{2} \tan 18° = 0.4595$

Edge: 1

Center of Polyhedron to Center of Face: Triangle: 2.1572
 Square: 2.1182
 Pentagon: 2.0647

Center of Polyhedron to Mid-Edge: 2.1763

Center of Polyhedron to Vertex: 2.2331

Vertex to Center of Face: Triangle: $\sqrt{3}/3 = 0.5774$
 Square: $\sqrt{2}/2 = 0.7071$
 Pentagon: $\sqrt{\tau}/5^{1/4} = 0.8507$ $\left[\tau = (1 + \sqrt{5})/2\right]$

Mid-Edge to Center of Face: Triangle: $\sqrt{3}/6 = 0.2887$
 Square: $1/2 = 0.5000$
 Pentagon: $\left(\sqrt{25 + 10\sqrt{5}}\right)/10 = 0.6882$

Surface Area: 59.3002

Volume: 41.6144

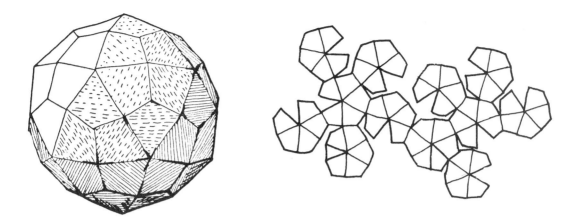

Figure 3-36.

Trapezoidal Hexecontahedron V3.4.5.4

Faces	Vertices			Edges
F_4	V_3	V_4	V_5	E_4
60	20	30	12	120

Dual: Small Rhombicosidodecahedron

Dihedral Angle: 154°8'

E/ρ: 0.3699(3-4)
 0.5694(3-5)

Face Angles: 67°46'59"; 86°58'27"; 118°16'07"

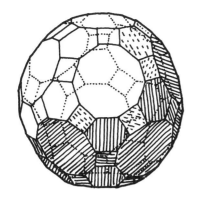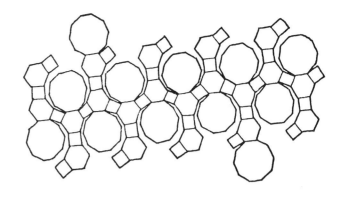

Figure 3-37.

Great Rhombicosidodecahedron 4.6.10

Faces			Vertices	Edges		
F_4	F_6	F_{10}	V_3	E_{4-6}	E_{4-10}	E_{6-10}
30	20	12	120	60	60	60

Dual: Hexakis Icosahedron

Dihedral Angle: 4-6: $\cos - (1 + \sqrt{5})/2\sqrt{3} = 159°05'41''$

4-10: $\cos - 1/2\sqrt{(10 + 2\sqrt{5})/5} = 148°16'57''$

6-10: $\cos - \sqrt{(5 + 2\sqrt{3})/5} = 142°37'21''$

Angle Subtended by an
Edge at Center of Polyhedron: $15°6'$

E/ρ: $\sqrt{6}/3 \tan 18° = 0.2653$

Edge: 1

Center of Polyhedron to Center of Face: Square: 3.7358
Hexagon: 3.6683
Decagon: 3.4407

Center of Polyhedron to Mid-Edge: 3.7693

Center of Polyhedron to Vertex: 3.8021

Vertex to Center of Face: Square: $\sqrt{2}/2 = 0.7071$
Hexagon: 1
Decagon: $\tau = 1.6180$

Mid-Edge to Center of Face: Square: $1/2 = 0.5000$
Hexagon: $\sqrt{3}/2 = 0.8660$
Decagon: $1/2\sqrt{5 + 2\sqrt{5}} = 1.5388$

Surface Area: 174.2880

Volume: 206.7839

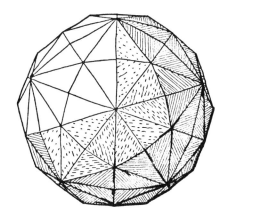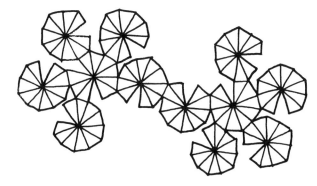

Figure 3-38.

Hexakis Icosahedron V4.6.10

Faces	Vertices			Edges
F_3	V_4	V_6	V_{10}	E_{3-3}
120	30	20	12	180

Dual: Great Rhombicosidodecahedron

Dihedral Angle: 164°53'17"

E/ρ: 0.3699
 0.5810
 0.6833

Face Angles: 32°46'12"; 58°14'17"; 88°58'31"

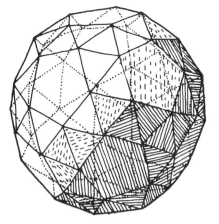

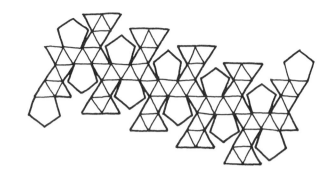

Figure 3-39.

Snub Dodecahedron $3^4.5$*

Faces		Vertices	Edges	
F_3	F_5	V_5	E_{3-3}	E_{3-5}
80	12	60	90	60

Dual: Pentagonal Hexecontahedron

Dihedral Angle: 3-3: 164°10'31"

3-5: 152°55'53"

Angle Subtended by an
Edge at Center of Polyhedron: 26°49'

E/ρ: 0.4769

Edge: 1

Center of Polyhedron to Center of Face: Triangle: 2.0768

Pentagon: 1.9806

Center of Polyhedron to Mid-Edge: 2.0969

Center of Polyhedron to Vertex: 2.1556

Vertex to Center of Face: Triangle: $\sqrt{3}/3 = 0.5774$

Pentagon: $\sqrt{\tau}/5^{1/4} = 0.8507$

Mid-Edge to Center of Face: Triangle: $\sqrt{3}/6 = 0.2887$

Pentagon: $\left(\sqrt{25 + 10\sqrt{5}}\right)/10 = 0.6882$

Surface Area: 55.2808

Volume: 37.6072

*Enantiomorphic: exists in right- and left-handed forms

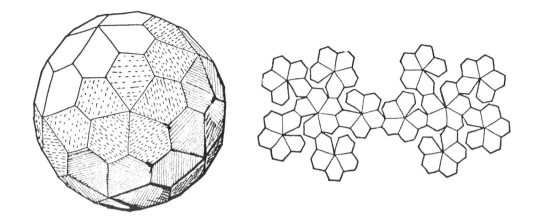

Figure 3-40.

Pentagonal Hexecontahedron V3^4.5*

Faces	Vertices		Edges
F$_5$	V$_3$	V$_5$	E$_{5-5}$
60	80	12	150

Dual: Snub Dodecahedron

Dihedral Angle: 153°10' 24"

E/ρ: 0.2779(3-3)
 0.4863(3-5)

Face Angles: 67° 28'; 118°08'

*Enantiomorphic: exists in right- and left-handed forms

3-10. ARCHIMEDEAN PRISMS AND ANTI-PRISMS; DIPYRAMIDS AND TRAPEZOHEDRA

These polyhedra complete the infinite sets of Archimedean semi-regular and Archimedean dual polyhedra.[13]

Prisms (Figure 3-41a) are composed of two {p} and p {4}. Their duals, the dipyramids (Figure 3-41b), have 2p isoceles triangles.

Anti-prisms (Figure 3-42a) are composed of two {p} and 2p {3}. Their duals, the trapezohedra (Figure 3-42b), are composed of 2p trapezoids.

(a) (b)

Figure 3-41. (a) hexagonal prism, (b) hexagonal dipyramid.

(a) (b)

Figure 3-42. (a) pentagonal anti-prism, (b) trapezohedron.

[13] Many of these polyhedra are defined by the external shape of crystals. For a detailed discussion of these crystals see: Phillips, F. C. 1963. *An Introduction to Crystallography.* New York: John Wiley & Sons. See also: Aurivillius, B. and G. Lundgren. 1965.

3-11. TWIST POLYHEDRA

Two other polyhedra can be generated from the semi-regular poly-hedra by a rotation of half of the polyhedron on an axis through its center.[14] These are the twist forms of $(3.4)^2$, with a rotation of $\pi/3$ (Figure 3-43a); and of $(3.5)^2$, with a rotation of $\pi/5$. The for-mer is the polyhedron generated by certain packings of spheres, as we shall see in Chapter 4.

An off-center rotation of $\pi/4$ in the cap of 3.4^3 generates the form shown in Figure 3-43b. Similar rotations of $\pi/5$ in 3.4.5.4 make a variety of forms.

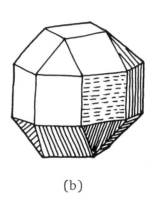

(a) (b)

Figure 3-43. (a) the twist form of $(3.4)^2$*; (b) the twist form of* 3.4^3*.*

3-12. DELTAHEDRA

A *deltahedron* is any polyhedron composed of triangles. In addition to {3,3}, {3,4}, and {3,5}, there are only five other con-vex deltahedra composed of {3}. They are shown in Figure 3-44a through e, with 6, 10, 12, 14, and 16 faces, respectively.[15] Delta-

"On the Linking of Ideal Square Archimedean Antiprisms. I.," *Arkiv. for Kemi.* v 24, pp. 133-149.

[14] These degenerate forms are considered by Cundy, *op. cit.*, p. 115, to be "isomeric forms", roughly equivalent to chemical isomers, where various molecular configurations may exist for the same chem-ical composition.

[15] Distorted forms of these polyhedra are used as models of li-quid structures. See: Bernal, J. D. 1959. "The Structure of Li-quids," *Proc. Roy. Inst.* v. 168, pp. 355-393. They are also used as

hedra with more than twenty {3} faces are non-convex, such as those in Figure 3-45a and b, composed of 60 and 140 {3}, respectively.[16]

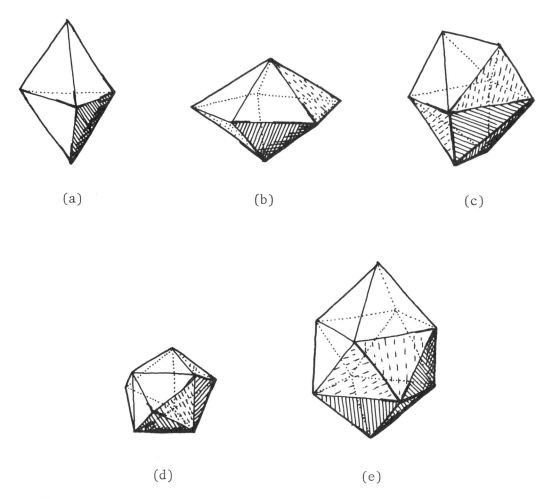

(a)

(b)

(c)

(d)

(e)

Figure 3-44. *Deltahedra: (a) six faces, (b) ten faces, (c) twelve faces; (d) fourteen faces, and (e) sixteen faces.*

models of complex alloy structures. See: Frank, F. C. and J. S. Kasper. 1958. "Complex Alloy Structures Regarded as Sphere Packings. I. Definitions and Basic Principles," *Acta Cryst.* v. 11, pp. 184-190; ————. 1959. "Complex Alloy Structures Regarded as Sphere Packings. II. Analysis and Classifications of Representative Structures," *Acta Cryst.* v. 12, pp. 483-499.

[16] These polyhedra are used as models of virus structures and are discussed in Chapter 6.

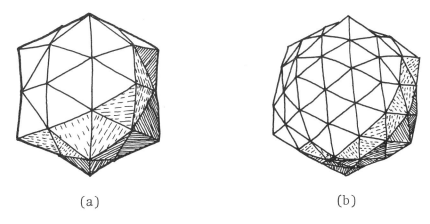

(a) (b)

Figure 3-45. Deltahedra: (a) sixty faces; (b) 140 faces.

3-13. ROTATIONAL SYMMETRY FAMILIES

The Platonic, Archimedean semi-regular, and Archimedean dual polyhedra are contained within two rotational symmetry families: 5.3.2 and 4.3.2. {3,5}, for example, belongs to the 5.3.2 symmetry family. Specifically, rotations through a pair of opposite vertices, a pair of opposite faces, and a pair of opposite edges are 5-fold, 3-fold, and 2-fold, respectively (Figure 3-46).

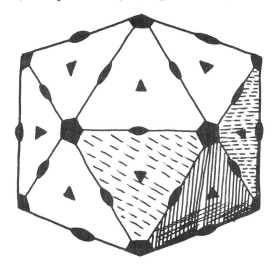

Figure 3-46. The axes of 5-fold, 3-fold, and 2-fold rotational symmetry of {3,5}.

Table 3-1 lists thirty-one polyhedra in their respective rotational symmetry families.

5.3.2 SYMMETRY FAMILIES	4.3.2 SYMMETRY FAMILIES
────	$\{3,3\}$
$\{5,3\}$	$\{4,3\}$
$\{3,5\}$	$\{3,4\}$
────	3.6^2; $V3.6^2$
$(3.5)^2$; $V(3.5)^2$	$(3.4)^2$; $V(3.4)^2$
3.10^2; $V3.10^2$	3.8^2; $V3.8^2$
5.6^2; $V5.6^2$	4.6^2; $V4.6^2$
$3.4.5.4$; $V3.4.5.4$	3.4^3; $V3.4^3$
$4.6.10$; $V4.6.10$	$4.6.8$; $V4.6.8$
$3^4.5$; $V3^4.5$	$3^4.4$; $V3^4.4$

3-14. SURFACE AREA AND VOLUME RELATIONSHIPS OF POLYHEDRA

This section presents a table to permit comparison of the
efficiency, I, of surface areas for various polyhedra with a unit
volume. A dimensionless number, I, that expresses the relation-
ship between the surface area and volume of any three-dimensional
form is obtained by dividing the surface area, S, by 2/3 power of
the volume (Vol).

$$I = \frac{S}{Vol^{2/3}}$$

Table 3-2 shows values of this number for a sphere and selected
polyhedra. By dividing the values of I for the polyhedra by the
values of I for the sphere, I_s, in the Table, we can determine how
much more polyhedral surface area is required to enclose the same
volume as the sphere. For example, dividing I for a snub dodecahedron,
$3^4.5$, that encloses the same volume as the sphere will have 1.84%
more surface area than the sphere.

Table 3-2. SURFACE AREA AND VOLUME RELATIONSHIPS FOR
VARIOUS POLYHEDRA

POLYHEDRON	$I = \dfrac{S}{Vol^{2/3}}$	I/I_s
Sphere	4.8360	1.0000
$3^4.5$	4.9248	1.0184
3.4.5.4	4.9380	1.0211
4.6.10	4.9840	1.0306
5.6^2	5.0024	1.0344
$3^4.4$	5.0106	1.0361
3.4^3	5.0690	1.0482
$(3.5)^2$	5.0869	1.0519
4.6.8	5.1275	1.0603
$\{3,5\}$	5.1480	1.0645
3.10^2	5.2216	1.0797
$\{5,3\}$	5.3126	1.0986
4.6^2	5.3146	1.0990
$(3.4)^2$	5.3437	1.1050
$V(3.4)^2$	5.3467	1.1056
3.8^2	5.6925	1.1771
$\{3,4\}$	5.7190	1.1826
$\{4,3\}$	6.0000	1.2407
3.6^2	6.2370	1.2897
$\{3,3\}$	7.2055	1.4900

CHAPTER 4

AGGREGATIONS OF SPHERES

A *sphere* is the locus of points in space having a given fixed distance from a point within, called the center.

With respect to modes of contact, aggregations of spheres can be divided into three basic types:

(1) *point contact*—where spheres touch at surface points;

(2) *perimeter contact*—where sphere surfaces overlap in a manner that their common boundary or contact perimeter is a small circle common to two spheres (a *small circle* is a circle on a sphere with a radius less than that of the sphere);

(3) *area contact*—where spheres deform at contact areas to form a planar interface.

Figure 4-1 shows the metamorphosis and degeneration of two separate spheres into a single sphere. Figure 4-1b shows the point contact mode, termed *sphere packing*. Figure 4-1c and d may be interpreted as either the perimeter contact mode or the area contact mode. Both are *sphere coverings*.

4-1. SPHERE PACKING

In crystal structures, interatomic bonds may be separated into two general catagories: *directional* and *non-directional*. Covalent bonds[1] are considered directional; while metallic,[2] ionic,[3] and van der Waals[4] bonds are non-directional. Directional bonds satisfy

[1] In covalent bonding a pair of electrons is shared by two bonded atoms. When these bonds form, atoms are crystallized at definite bonding angles.

[2] Lorentz, H. A. 1916. *The Theory of Electrons*. Leipzig: Teubner, proposed a theory of metals where metal crystals were considered as close-packed hard spheres with electrons moving freely in the inter-

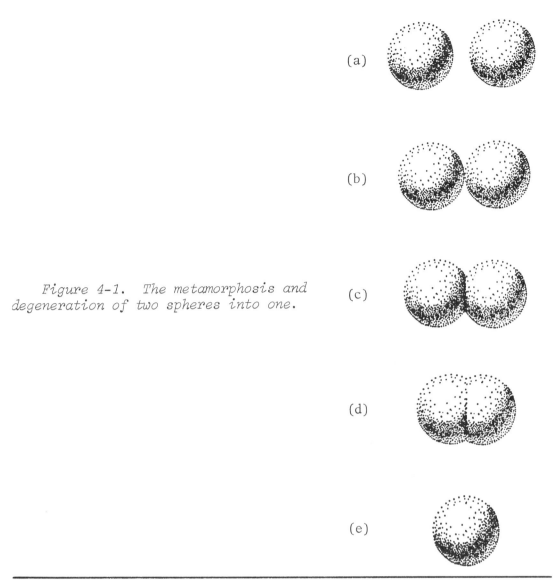

(a)

(b)

Figure 4-1. The metamorphosis and degeneration of two spheres into one.

(c)

(d)

(e)

stices. This concept has been developed in the past years through the application of quantum mechanics.

[3] In ionic bonding, atoms behave as if they are positively charged (cations) and negatively charged (anions) spheres. They aggregate, generally, such that each charged atom is surrounded by atoms of the opposite charge. In NaCl, for example, each chlorine atom (anion) is surrounded by six sodium atoms (cations) that are at the vertices of {3,4}. Each sodium atom is likewise surrounded by six chlorine atoms, also at the vertices of a {3,4}. In the lattice, the two sets of {3,4} interpenetrate one another.

[4] Van der Waals bonds are the relatively weak attractive forces which are operative among all molecules that are close together. For example, the surface molecules on a crystal are held in position by van der Waals forces.

certain bonding angles inherent in the structure of the atom. For example, carbon atoms, with bond angles of cos -1/3 = 109°28'16", define an open sphere packing: the *tetrahedral sphere pack*, shown in Figure 4-2. Each sphere is contiguous to four others, and they are arranged at the center and vertices of {3,3}. Other directionally bonded atoms, such as bismuth, with bond angles of 94°, and phosphorus, with bond angles of 99°, exhibit different geometries.[5]

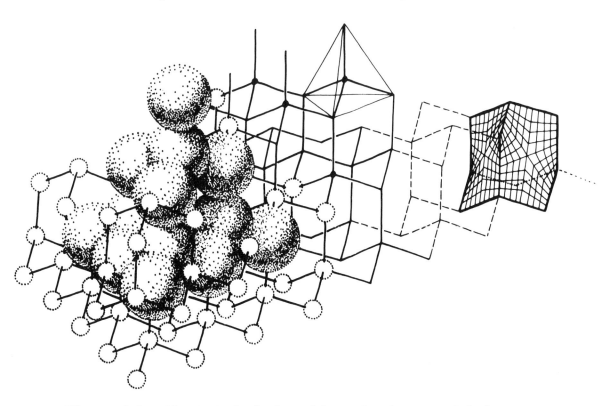

Figure 4-2. The tetrahedral packing of spheres, with its corresponding 4-connected network and saddle solid.

Because they lack strong directional bonding properties, non-directionally bonded atoms obey geometric and topological rules of sphere packings. Approximately two-thirds of the metals fall into the class of non-directional bonds, and their structure can be described by spheres in *close-packing*; i.e., packings where each sphere contacts twelve others. The remaining one-third, the alkali (Na, K, etc.) and transition metals (Fe, Cr, W, etc.), tend toward slightly more open packings. Many of the alkali metals change from slightly open packings to close-packings at low temperatures. Because bonds

[5] See: Pauling, L. 1960. *The Nature of the Chemical Bond.* New York: Cornell University Press; and Wells, A. F. 1962. *Structural Inorganic Chemistry.* London: Oxford University Press.

in the transition metals are partly covalent, they tend to have some direction in their bonding, and are slightly more open than close-packed spheres. The noble elements, on low temperature solidification, tend toward close-packed arrangements.[6]

Simple Cubic Packing. Perhaps the simplest arrangement of spheres, from the standpoint of our perceptions, is *simple cubic packing (scp)*, shown in Figure 4-3. Each sphere center is positioned at the vertex of {4,3}; each sphere contacts six others in an infinite aggregation.

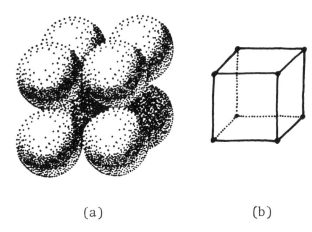

Figure 4-3. An aggregation of spheres in simple cubic packing (scp), where each sphere center is at a vertex of {4,3}.

(a) (b)

In any contiguous aggregation of spheres, a *network* is generated by interconnecting the sphere centers with lines through points (or areas) of contact. In the case of *scp*, the network is 6-connected and defines packed {4,3}. *scp* is the three-dimensional analogue of the {4,4} circle packing in the plane.

Spheres in *scp* fill about half of the total space. Specifically, their *density*, the ratio of the volume of a sphere to the volume of {4,3}, is $\pi/6 = 0.5236...$ If the spheres have a unit radius, the largest spheres that fit into their interstices have radii of $\sqrt{3}-1 = 0.7321...$ When the interstices are filled with spheres the density increases to $0.7290...$

Concave-planar faced cuboctahedra, shown in Figure 4-4, completely fill the interstices among *scp* spheres. These polyhedra are composed of six plane quadrilateral faces and eight concave triangular faces. The latter are defined by the eight spheres forming each interstice. Aggregations of these polyhedra alone have a density of $1-\pi/6 = 0.4764...$

[6] Moffatt, W. G., G. W. Pearsall, and J. Wulff. 1964. *Structure*. New York: John Wiley and Sons., pp. 29-41.

107

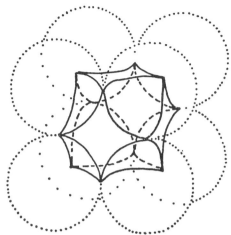

Figure 4-4. The concave-planar cuboctahedron that fills the interstice among eight spheres in simple cubic packing.

<u>Close-Packing</u>. The three-dimensional analogue of the {3,6} circle packing is *close-packing*; each sphere contacts twelve others. There are two basic kinds of close-packings; *cubic close-packing (ccp)* and *hexagonal close-packing (hcp)*.

The *ccp* can be derived in the following way: Consider a 6-connected network defining a packing of {4,3} with an edge = E. Place a sphere with a radius of E·$\sqrt{2}/2$ = 0.7141... within each alternating {4,3} of the network, as in Figure 4-5. Each sphere is the intersphere of alternating {4,3} of the network, and, in infinite aggregations, each sphere contacts twelve other spheres.

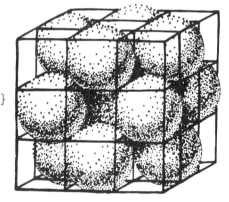

Figure 4-5. Spheres in cubic close-packing (ccp) placed in alternating {4,3} of a 6-connected network.

An alternative close-packed arrangement of spheres (*hcp*) can be determined in the following way: A single layer of spheres is packed in a manner that each sphere has six neighbor spheres contacting it. When a second layer of similarly packed spheres is placed on the first layer, each sphere in the second layer makes contact with three spheres in the first layer. When a third layer of spheres is placed on the second layer, each sphere in the third layer makes contact with three spheres in the second layer, and so on. However, the

third layer may be in one of two possible positions with respect to the first layer of spheres. If each sphere in the third layer is directly above each sphere in the first layer, as in Figure 4-6, the spheres are said to be in *hcp*. The packing arrangement of layers is A-B-A-B-A-B-A-..., where all of the spheres in the A layers are directly above one another, all of the spheres in the B layers are directly above one another, but no A-B layers are directly above one another.

The difference between *hcp* and *ccp* lies in the placement of the third layer of spheres. In *ccp* the spheres in the third layer are not placed directly above the spheres in the first, but are placed such that each sphere in the third layer lies directly above the interstice in the first layer, as in Figure 4-7. The packing arrangement of layers in *ccp* is A-B-C-A-B-C-A-B-C-A-..., where all of the spheres in the A layers are directly above one another, all of the spheres in the B layers are directly above one another, all of the spheres in the C layers are directly above one another, but none of the A-B-C layers are directly above one another.

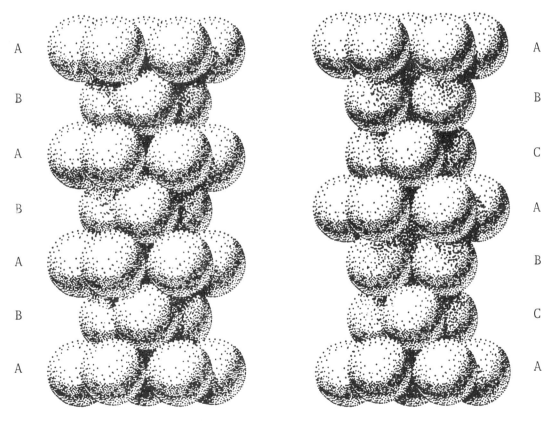

Figure 4-6. Layers of spheres in hexagonal close-packing (hcp)

Figure 4-7. Layers of spheres in cubic close-packing (ccp).

Other arrangements of layers, combining *ccp* and *hcp* systems, are also possible. For example, *double hexagonal close-packing* has a layer sequence of A-B-A-C-A-B-A-C-..., repeating after four layers.[7]

Both *ccp* and *hcp* spheres have a density of $\pi/\sqrt{18} = 0.7408...$[8]

In crystallography the *face-centered cubic lattice* (*fcc*) is equivalent to *ccp*. This lattice is defined by fourteen spheres: eight at the vertices and six at the face-centers of {4,3}, as in Figure 4-8.[8]

[7] Pauling. *op. cit.*, pp. 408-409. Probably the earliest systematic use of packings of spheres in the determination of crystal structures is found in: Barlow, W. 1883. "Probable Nature of the Internal Symmetry of Crystals," *Nature*. v. 29, pp. 186, 205, and 404; _____. 1897. "A Mechanical Cause of Homogeneity of Structure and Symmetry Geometrically Investigated; with Special Application to Crystals and to Chemical Combination," *Proc. Roy. Dublin Soc.* v. VIII, Part VI, pp. 527-620. For a description of a binary algebra useful in determining crystal structures, see: Loeb, A. L. 1958. "A Binary Algebra Describing Crystal Structures with Closely-Packed Anions," *Acta Cryst.* v. 11 pp. 469-476; Morris, I. L. and A. L. Loeb. 1960. "A Binary Algebra Describing Crystal Structures with Closely-Packed Anions. Part II: A Common System of Reference for Cubic and Hexagonal Structures," *Acta Cryst.* v. 13, pp. 434-443. Here structures are shown as interpenetrating lattice arrays denoted by a set of binary digits, from which the spatial relationships of the arrays can be derived. See also: Loeb, A. L. 1962. "A Modular Algebra for the Description of Crystal Structures," *Acta Cryst.* v. 15, pp. 219-226; _____. 1964. "The Subdivision of the Hexagonal Net and the Systematic Generation of Crystal Structures," *Acta Cryst.* v. 17, pp. 179-182, for further related work. For a closely related approach to the same problem see: Gehman, W. G. 1964. "Translation-Permutation Operator Algebra for the Description of Crystal Structures. I. Ideal Closest Packing," *Acta Cryst.* v. 17, pp. 1561-1568; Gehman, W. G. and S. B. Austerman. 1965. "Translation-Permutation Operator Algebra for the Description of Crystal Structures. II. Interstice Lattice Stacking Faults," *Acta Cryst.* v. 18, pp. 375-380. See: Shlichta, P. J. 1968. "A Contact Rule for Rigid-Sphere Models of Crystal Structures," *Techincal Report 32-1299*. Pasadena, Calif.: Jet Propulsion Laboratory, for a description of a means of calculating and displaying the parametric variations of connectivity, coordination numbers, and packing fractions of crystal structures.

[8] Although it has not been proved that this is the greatest density possible for a sphere packing, no other packing of equal spheres has shown a higher density. Rogers, C. A. 1958. "The Packing of Equal Spheres," *Proc. London Math. Soc.* (3). v. 8, pp. 609-620, has given a proof that *if* such a packing exists, it must have a density of < 0.7797...

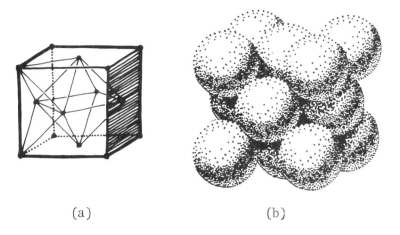

<div align="center">(a) (b)</div>

Figure 4-8. (a) the face-centered cubic lattice (fcc); (b) spheres in cubic close-packing (ccp) located at the lattice points.

In *ccp*, the *Dirichlet region* or *Voronoi polytope* is $V(3.4)^2$ (Figure 4-9a). In *hcp*, the Dirichlet region is a twist form of $V(3.4)^2$, the trapezoid-rhombic dodecahedron (Figure 4-9b and Figure 5-6). These polyhedra aggregate and completely fill space. This correspondence between a sphere packing and a polyhedra packing can be viewed in two ways: First, in a packing of spheres, planes tangent to the spheres at their points of contact will intersect one another and define polyhedral space-filling cells; second, if boundaries are formed for each sphere in an aggregation (that contain all points closer to the center of one sphere than to the center of any other),

<div align="center">(a) (b)</div>

Figure 4-9. (a) spheres in cubic close-packing (ccp) and a Dirichlet region, $V(3.4)^2$, for the center sphere; (b) spheres in hexagonal close-packing (hcp) and a Dirichlet region, the trapezoid-rhombic dodecahedron, for the center sphere. (The radii of the spheres are reduced for illustration purposes.)

<div align="center">111</div>

the boundaries define space-filling aggregations of polyhedra (Dirichlet regions or Voronoi polytopes), as in Figure 4-10.

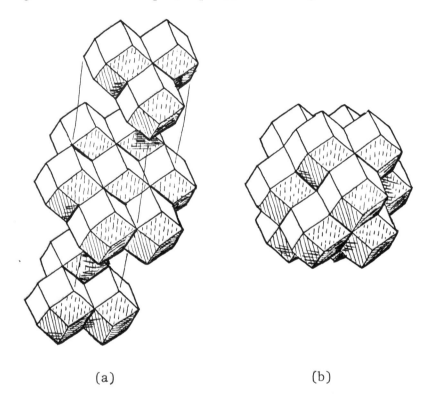

(a) (b)

Figure 4-10. (a) an exploded view, and (b) a clustering of Dirichlet regions of spheres in cubic close-packing (ccp).

Packings of Non-Congruent Spheres. In both *ccp* and *hcp*, two kinds of interstices appear. One interstice is defined by four spheres whose centers are vertices of {3,3} (Figure 4-11a). The other is defined by six spheres whose centers are vertices of {3,3} (Figure 4-12a). The maximum radius for a sphere that fills an interstice of four close-packed spheres of unit radius is $(\sqrt{6}-2)/2 = 0.2247...$ The maximum radius for a sphere that fills an interstice of six close-packed spheres of unit radius is $\sqrt{2}-1 = 0.4142...$

In an infinite *ccp* array of spheres having unit, $(\sqrt{6}-2)/2$, and $\sqrt{2}-1$ radii, the centers of the $(\sqrt{6}-2)/2$ and $\sqrt{2}-1$ spheres define vertices of packed $V(3.4)^2$, as in Figure 6-13a. Each unit radius sphere is the in-sphere of $V(3.4)^2$, because the face-centers of $V(3.4)^2$ are tangent to the sphere at twelve places.

In an infinite *hcp* array of spheres having unit, $(\sqrt{6}-2)/2$, and $\sqrt{2}-1$ radii, the centers of the $(\sqrt{6}-2)/2$ and $\sqrt{2}-1$ spheres define vertices of packed trapezoid-rhombic dodecahedra, as in Figure 4-13b.

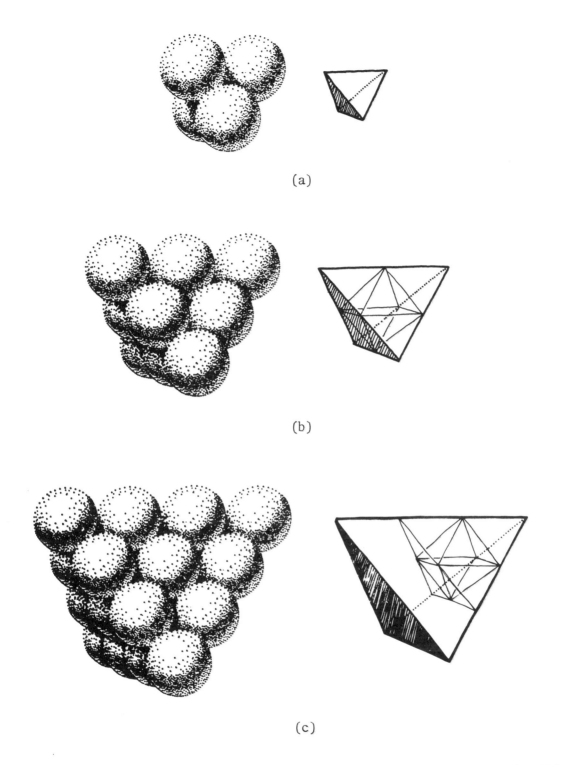

(a)

(b)

(c)

*Figure 4-11. (a) four close-packed spheres defining {3,3}; (b)
ten close-packed spheres (ccp) defining {3,3}; (c) twenty close-
packed spheres (ccp) defining {3,3}.*

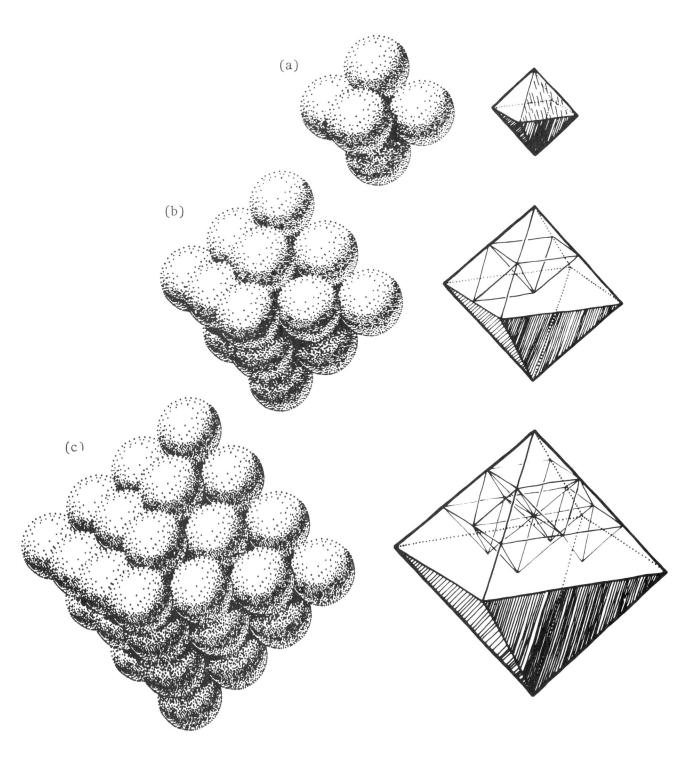

Figure 4-12. (a) six close-packed spheres defining {3,4}; (b) nineteen close-packed spheres (ccp) defining {3,4}; (c) forty-four close-packed spheres (ccp) defining {3,4}.

(a) (b)

Figure 4-13. *(a) the positions of ($\sqrt{6}$-2)/2 and $\sqrt{2}$-1 radii spheres in relation to a unit radius sphere (in ccp). The sphere centers define vertices of V(3.4)2. (b) the positions of ($\sqrt{6}$-2)/2 and $\sqrt{2}$-1 radii spheres in relation to a unit radius sphere (in ccp). The sphere centers define vertices of the trapezoid-rhombic dodecahedron.*

In either *ccp* or *hcp*, when only the interstices defined by four unit radius spheres are occupied, the density increases to 0.7574... (In *ccp*, potassium oxide exhibits this geometry, where K atoms are positioned at the unit radius sphere centers.) When only the interstices defined by six unit radius spheres are occupied, the density increases to 0.7931... (Rocksalt (NaCl) exhibits this geometry in *ccp*; nickel arsenide (NiAs) exhibits this geometry in *hcp*. Na and Ni occupy positions of the unit radius spheres; Cl and As occupy positions of the $\sqrt{2}$-1 radius spheres.)

Space Filling with Spheres and Polyhedra. Complete space filling with packed spheres requires the introduction of two types of concave-planar polyhedra. The volume of an interstice defined by four close-packed spheres can be filled by an octahedron with four planar triangular faces and four concave triangular faces, formed by openings among spheres and by the surfaces of the spheres (Figure 4-14). The volume of an interstice defined by six close-packed spheres can be filled by a cuboctahedron with six concave quadrilateral and eight planar triangular faces, as in Figure 4-15.[9]

[9] Azároff. L. V. 1960. *Introduction to Solids*. New York: McGraw-Hill Book Co., pp. 66-68.

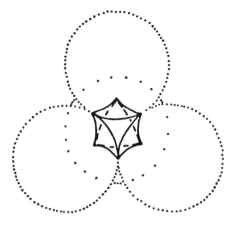

*Figure 4-14. The concave-
planar octahedron that fills the
interstice among four close-
packed spheres.*

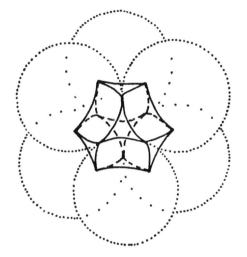

*Figure 4-15. The concave-
planar cuboctahedron that fills the
interstice among six close-packed
spheres.*

Unit radius spheres, interstice-filling cuboctahedra, and interstice-filling octahedra pack in a ratio of 1:1:2. Therefore, spheres packed with interstice-filling octahedra alone have a density of 0.827...; spheres packed with interstice-filling cuboctahedra alone have a density of 0.9135...; and packings of all three have a density of 1. Aggregations of these polyhedra alone (Figure 4-16) have a density of $1-\pi/\sqrt{18} = 0.2595...$ due to large spherical cavities.[10]

[10] In: Stewart, R. M. 1964. "Adaptable Cellular Nets," *Progress in Biocybernetics*. (eds. Wiener and Schade). v. 1 Amsterdam: Elsevier, pp. 96-105; sphere packings, polyhedra packings, and these concave-planar polyhedra are used as models for logical structures of cortical mechanisms. For detailed mathematical analysis of these structures see:_____. 1967. "Design for a Cortex," *Research Memorandum No. 25A*. Los Angeles, Calif.: Aerojet-General Corp., Center for Research and Education;_____. 1962. "Theory of Structurally Homogeneous Logic Nets," *Biological Prototypes and Synthetic Systems*. v. 1 New York: Plenum Press, pp. 370-380.

Figure 4-16. An aggregation of concave-planar octahedra and cuboctahedra.

Open Packings of Spheres. An important crystallographic lattice is the *body-centered cubic lattice (bcc)*, shown in Figure 4-17a. Spheres are placed at the center and at the vertices of {4,3} (Figure 4-17b). This packing is slightly more open than either *ccp* or *hcp*; its packing density is $\pi\sqrt{3}/8 = 0.6801...$ Each sphere contacts eight others. Figure 4-18 shows spheres concentrically packed in a *bcc* lattice. In Figure 4-18a fourteen spheres form the first shell; in Figure 4-18b fifty spheres form the second shell. Each shell defines the vertices of $V(3.4)^2$. The Dirichlet region for *bcc* sphere packings is 4.6^2, shown in Figure 4-19.

Figure 4-17. (a) the body-centered cubic lattice (bcc); (b) nine spheres in bcc packing.

(a) (b)

117

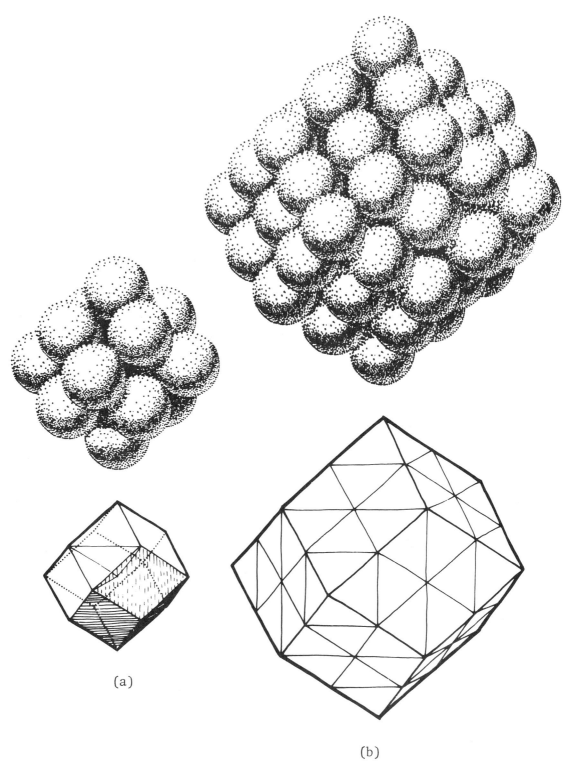

(a)

(b)

Figure 4-18. (a) a first shell of fourteen spheres packed in a bcc lattice with V(3.4)2 defined by interconnecting the sphere centers; (b) a second shell of fifty spheres packed in a bcc lattice and V(3.4)2 defined by interconnecting certain sphere centers.

118

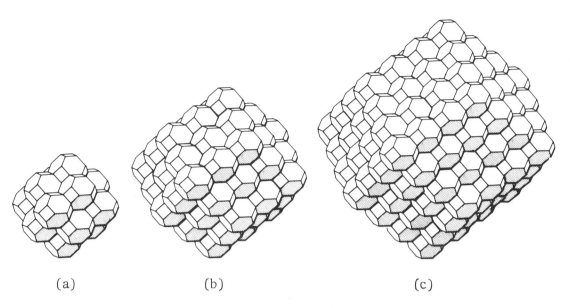

(a) (b) (c)

Figure 4-19. Concentric shell packings of Dirichlet regions
4.6² for spheres packed in the bcc lattice; (a) the first shell of
fourteen 4.6²; (b) the second shell of fifty 4.6²; (c) the third
shell of one hundred ten 4.6².

Two kinds of interstices are found in a *bcc* sphere packing. One
is located at the edge bisectors of {4,3} (Figure 4-17), and, if
spheres have a unit radius, can be occupied by smaller spheres with
radii of 0.154... The other kind of interstice is located at the
face-centers of {4,3}, and can be occupied by spheres with radii of
0.291...

Simple hexagonal packing is shown in Figure 4-20. Each sphere
contacts eight others; the packing density is $\pi/(3\sqrt{3}) = 0.6046...$

(a) (b)

Figure 4-20. (a) an aggregation of spheres in simple hexagonal
packing; (b) the polyhedron defined by connecting certain sphere centers.

The *tetrahedral sphere packing* corresponding to the arrangement of carbon atoms in the diamond crystal (Figure 4-2) has a density of $\pi\sqrt{3}/16 = 0.3401...$, half of the density of *bcc* sphere packings. The *bcc* packing of spheres, then, can be considered as two interpenetrating tetrahedral sphere packings.

A variety of sphere packings with *low* densities are possible, depending on the conditions (such as number of contacts) imposed on the structure. When each sphere touches four others, the least dense packing has a density of 0.1235... This structure is derived from the tetrahedral sphere packing (Figure 4-2) by replacing each sphere in the packing with four spheres, as in Figure 4-21. In the derived packing each sphere contacts four others, and the general network changes only slightly from that of the tetrahedral sphere pack.[11]

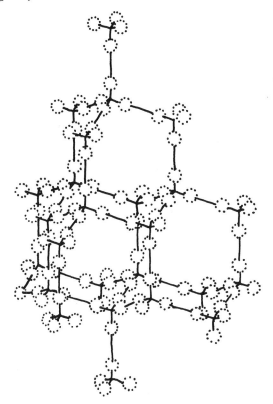

Figure 4-21. The least dense sphere packing, where each sphere contacts four others.

[11] For a 3-connected network, the most open packing has a density of 0.056... See: Heesch, H. and F. Laves. 1933. "Über dünne Kugelpackungen," *Zeitz. f. Kristallogr.* v. 85, pp. 443-453. For other open packings of spheres see: Melmore, S. 1942. "Open Packings of Spheres," *Nature.* v. 149, pp. 412 and 669; ————. 1949. "The Densest and the Least Dense Packing of Spheres," *Min. Mag.* v. 28, pp. 479-485.

Table 4-1 summarizes data on the sphere packings; Table 4-2 gives the types of sphere packings for the crystal structures of the elements.

Table 4-1. SPHERE PACKINGS[12]

PACKING	NETWORK	DENSITY
ccp	12-connected	$\pi/\sqrt{18} = 0.7405$
body-centered		
tetragonal*	10-connected	$4\pi/18 = 0.6981$
bcc	8-connected	$\pi\sqrt{3}/8 = 0.6801$
simple hexagonal	8-connected	$\pi/(3\sqrt{3}) = 0.6046$
simple cubic	6-connected	$\pi/6 = 0.5236$
tetrahedral	4-connected	$\pi\sqrt{3}/16 = 0.3401$
least dense	4-connected	$= 0.1235$

* This packing is a slight distortion of the bcc lattice packing (Figure 4-17) where the unit cell is compressed on a mirror plane parallel to the cell face until it becomes a right square prism such that each sphere contacts ten others.

Table 4-2. CRYSTAL STRUCTURES OF THE ELEMENTS[13]

LATTICE	ELEMENTS
ccp	Actinium, Aluminum, Argon, Calcium*,Cerium*, Copper, Gold, Iridium, Krypton, Lead, Neon, Nickel, Palladium, Platinium, Radon, Rhodium*, Silver, Strontium*, Thorium*, Xenon, Ytterbium*.
bcc	Barium*, Cesium, Chromium*, Europium, Francium, Iron*, Lithium, Molybdenum, Niobium, Potassium, Rubidium, Sodium, Tanalium, Tungsten, Vanadium.
hcp	Beryllium*, Cadmium*, Cobalt*, Dysprosium, Erbium, Gadolinium*, Hafnium*, Helfium, Holmium, Lutetium, Magnesium, Osmium, Rhenium, Ruthenium*, Scandium*, Technetium, Terbium, Thallium*, Thulium, Titanium*, Yttrium*, Zinc, Zirconium*.

[12] Henry, N. F. M. and K. Lonsdale (eds.) 1965. *International Tables for X-Ray Crystallography*. Birmingham, England: Kynoch Press, v. II, p. 343.

[13] Meggers, W. F. 1965. *Periodic Chart of the Atoms*. The Welch Scientific Co.

Table 4-2. CRYSTAL STRUCTURES OF THE ELEMENTS (cont.)

LATTICE	ELEMENTS
diamond cubic	Carbon*, Germanium, Silicon,
body-centered tetragonal	Indium, Protoactinium, Radium.
simple cubic	Manganese*, Oxygen*, Phosphorus*,
simple hexagonal	Americium, Hydrogen, Lanthanum*, Neodymium, Nitrogen*, Praseodymium*, Promethium, Selenium*, Tellurium.
orthorhombic	Bromine, Gallium, Iodine, Neptunium*, Sulfur*, Uranium*
rhombohedral	Antimony, Arsenic*, Bismuth, Mercury, Samarium*.
tetragonal	Boron*, Chlorine, Tin*.

* other crystal forms exist.

4-2. DEFINING POLYHEDRA BY SPHERE PACKINGS AND 12-CONNECTED NETWORKS

A simple method of defining polyhedra by spheres is to pack the spheres in a manner that allows their centers to locate vertices of polyhedra. Polyhedra in both 5.3.2 and 4.3.2 symmetry families can be generated in this manner. For example, Figure 4-22 shows thirty spheres defining vertices of $(3.5)^2$. Figure 4-23 shows spheres defining vertices of aggregated polyhedra, $\{4,3\}$, 4.6^2, and $4.6.8$, leaving large open cavities. The organization of spheres in Figure 4-23 defines positions of silicon and aluminum ions in a zeolite crystal.[14]

Structures in the 4.3.2 Symmetry Family. The connection of sphere centers in an infinite array of close-packed spheres (either *ccp* or *hcp*) by straight lines generates a network where the center of each sphere has twelve edges radiating from it. This 12-connected network defines space-filling aggregations of $\{3,3\}$ and $\{3,4\}$; where two $\{3,3\}$ and two $\{3,4\}$ meet at an edge, and eight $\{3,3\}$ and six $\{3,4\}$ meet at each vertex. This network, or its corresponding sphere planes, can

[14] Breck, D. W. and V. J. Smith. January, 1959. "Molecular Sieves," *Scientific American*. pp. 85-92.

122

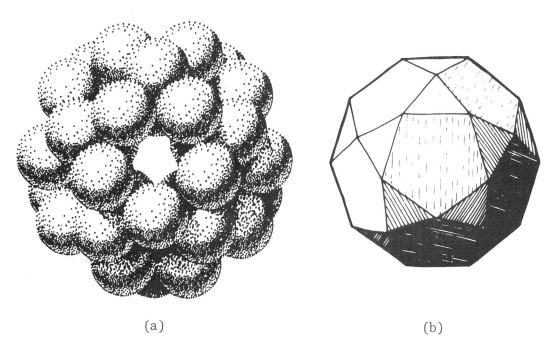

(a) (b)

Figure 4-22. An aggregation of thirty spheres with sphere
centers interconnected to define $(3.5)^2$.

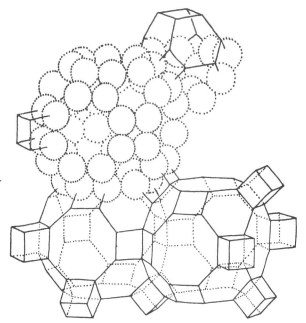

Figure 4-23. An aggre-
gation of spheres and their re-
lated polyhedra: {4,3}, 4.6^2,
and 4.6.8.

be truncated to generate polyhedra in the 4.3.2 symmetry family.

The simplest polyhedron defined is, of course, {3,3}, made from four close-packed spheres (Figure 4-11a). {3,4} is next, generated by six close-packed spheres (Figure 4-12a). These same polyhedra can also be defined again and again in larger aggregations, as shown in Figures 4-11b, c and 4-12b, c.

In addition to {3,3} and {3,4} only one other polyhedron composed of {p} can be defined by network truncations where the polyhedron is composed of whole {3,3} and {3,4}. This is 3.6^2, shown in Figure 4-24, composed of seven {3,3} and four {3,4}. All other polyhedra made of {p}, that can be defined by close-packed spheres, are composed of whole {3,3} and {3,4} plus some truncated portions of {3,3} and {3,4}.

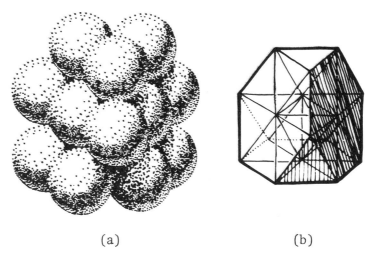

(a) (b)

Figure 4-24. Sixteen close-packed spheres with sphere centers interconnected to define 3.6^2.

For example, {4,3}, shown in Figure 4-8, is composed of a 12-connected network that is a packing of one {3,4}, eight {3,3}, and twelve 1/4-octahedra. In another example, the larger {4,3}, shown in Figure 4-25, is composed of {3,3}, {3,4}, 1/2-octahedra, and 1/4-octahedra.

Using sphere packings and their 12-connected networks, only two other Archimedean semi-regular polyhedra can be generated where the faces of the generated polyhedra are not distorted. These are 4.6^2 (Figure 4-26) and $(3.4)^2$ (Figure 4-27). The 4.6^2 is defined by thirty-eight close-packed spheres (thirty-two external and six internal); it is composed of thirty-two {3,3}, thirteen {3,4}, and six 1/2-octahedra. The $(3.4)^2$ is defined by thirteen spheres (twelve external and one internal); it is composed of eight {3,3} and six 1/2-octahedra. (The twist form of $(3.4)^2$, a polyhedron resulting from spheres in *hcp*, is shown in Figure 4-28.

124

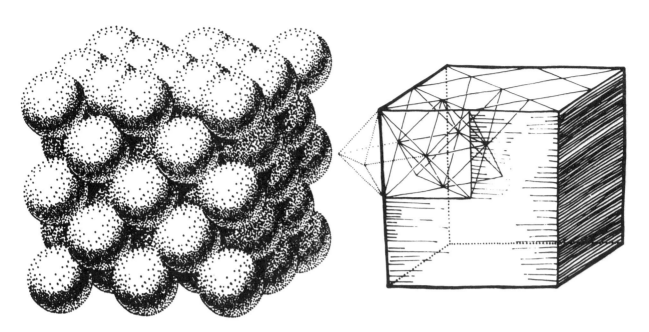

Figure 4-25. An aggregation of ccp *spheres defining* {4,3}.

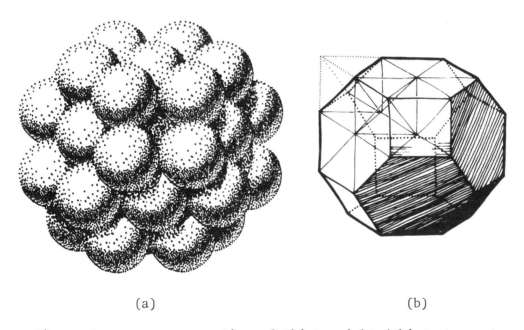

(a) (b)

Figure 4-26. An aggregation of thirty-eight (thirty-two external plus six internal) ccp *spheres with certain sphere centers interconnected to define* 4.6^2.

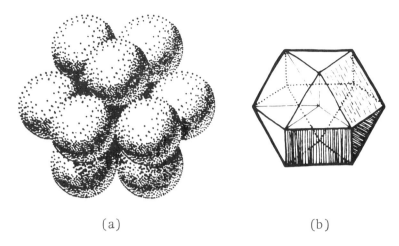

(a) (b)

Figure 4-27. An aggregation of twelve spheres surrounding one in ccp *with sphere centers interconnected to define* $(3.4)^2$.

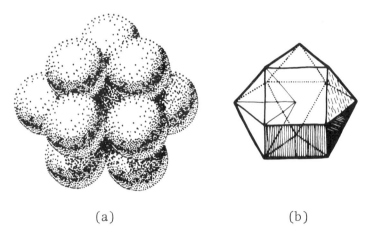

(a) (b)

Figure 4-28. An aggregation of twelve spheres surrounding one in hcp *with sphere centers interconnected to define the twist form of* $(3.4)^2$.

Larger forms of $(3.4)^2$ can be defined by concentric shell packings of spheres. The first shell of twelve spheres can be enclosed by a second shell of forty-two spheres (Figure 4-29), the second shell can be enclosed by a third shell of ninety-two spheres (Figure 4-30), and so on. Concentric shell packings can be added indefinitely, each shell defining a larger $(3.4)^2$.

An equation derived from Euler's Law gives the total number, N_t, of spheres for each shell,

$$N_t = 10s^2 + 2,$$ Eq. 4-1.

where s is the shell number 1, 2, 3,...n.[15]

The total number, A_t, of spheres in an aggregation is given by the equation,

$$A_t = (10s^3 + 15s^2 + 11s + 3)/3 \qquad \text{Eq. 4-2.}$$

where s is the shell number 1, 2, 3,...n.[16]

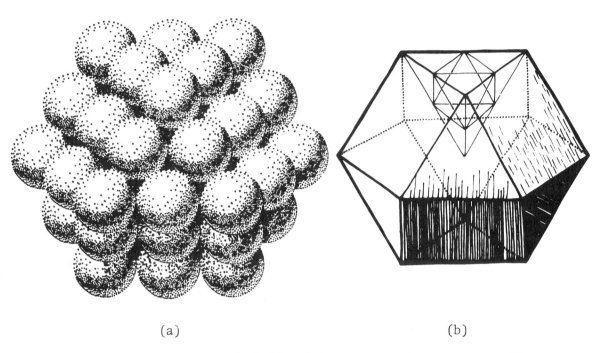

(a) (b)

Figure 4-29. A second shell of forty-two spheres surrounding a first shell of twelve spheres. Certain sphere centers are interconnected to define $(3.4)^2$.

[15] Fuller, R. B. 1965. "Omnidirectional Halo," *World Design Sci. Decade. 1965-1975. Phase I, Document 3.* Carbondale, Ill.: World Resources Inventory, pp. 7-26, uses Euler's Law to explore relationships among polyhedra.

[16] Williams, R. E. 1968. "Handbook of Structure. Part I: Polyhedra and Spheres," *Research Communication 75.* Huntington Beach, Calif.: Douglas Advanced Research Laboratories, p. 71.

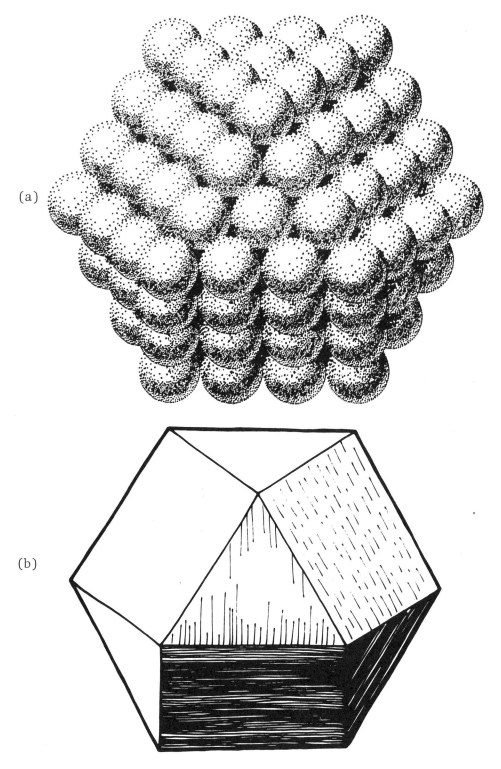

Figure 4-30. A third shell of ninety-two spheres surrounding a second shell of forty-two spheres. Certain sphere centers are interconnected to define $(3.4)^2$.

The $(3.4)^2$ in Figure 4-29 is defined by interconnecting the fifty-five sphere centers of the packing to form a 12-connected network. This network contains fifty-six {3,3}, fourteen {3,4}, and twenty-four 1/2-octahedra. If one sphere is removed from each of the twelve vertices of this $(3.4)^2$, a distorted form of 3.4^3 is generated (Figure 4-31), having edges in the ratio of $1:\sqrt{2}$.

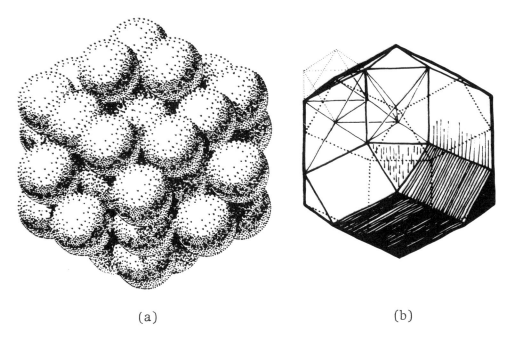

(a) (b)

Figure 4-31. Forty-three (thirty external plus thirteen internal) ccp spheres with certain sphere centers interconnected to define a distorted form of 3.4^3 having edges in the ratio of $1:\sqrt{2}$.

The $(3.4)^2$ in Figure 4-30 is defined by interconnecting the one hundred forty-seven sphere centers of the packing to form a 12-connected network. This network contains one hundred eighty-four {3,3}, sixty-two {3,4}, and fifty-four 1/2-octahedra. If a sphere is similarly removed from each of the twelve vertices of this $(3.4)^2$, a distorted form of 4.6.8 is generated (Figure 4-32): It also has edges in the ratio of $1:\sqrt{2}$.

Other polyhedra that can be defined by close-packed spheres are distorted forms of: 3.8^2 with edges in the ratio of $1:\sqrt{2}$ (Figure 4-33); the triangle prism, 3.4^2, with edges in the ratio of $1:\sqrt{2}$ (Figure 4-34); the hexagonal prism, $4^2.6$, with edges in the ratio of $1:\sqrt{2}$; (Figure 4-35); and the octagonal prism, $4^2.8$, with edges in the ratio of $1:\sqrt{2}$ (Figure 4-36).

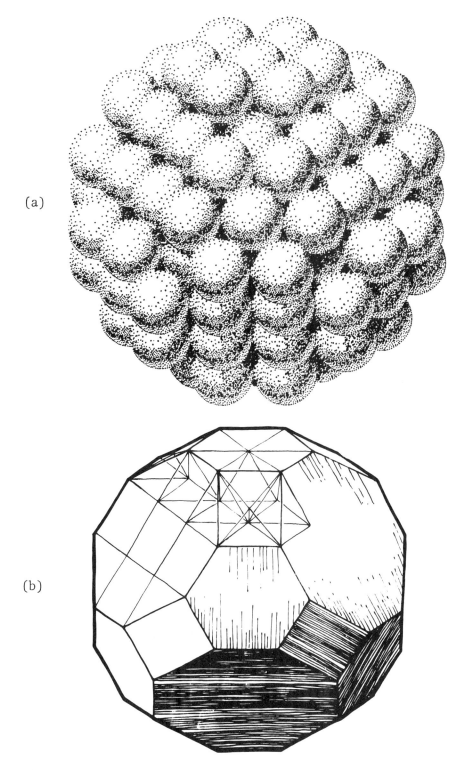

(a)

(b)

Figure 4-32. One hundred thirty-five (eighty external plus fifty-five internal) ccp spheres with certain sphere centers interconnected to define a distorted form of 4.6.8 having edges in the ratio of $1:\sqrt{2}$.

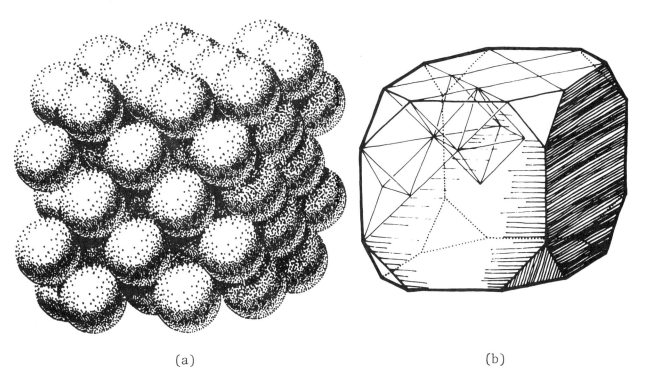

(a) (b)

Figure 4-33. Sixty-two (forty-eight external plus fourteen internal) ccp spheres with certain sphere centers interconnected to define a distorted form of 3.8^2 having edges in the ratio of $1:\sqrt{2}$.

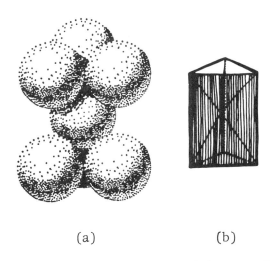

(a) (b)

Figure 4-34. Seven hcp spheres with certain sphere centers interconnected to define a distorted form of the triangle prism, 3.4^2, having edges in the ratio $1:\sqrt{2}$.

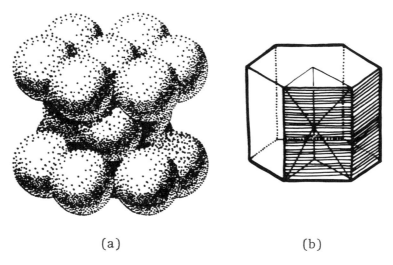

(a) (b)

Figure 4-35. Seventeen hcp *spheres with certain sphere centers interconnected to define a distorted form of the hexagonal prism,* $4^2.6$, *having edges in the ratio of 1:$\sqrt{2}$.*

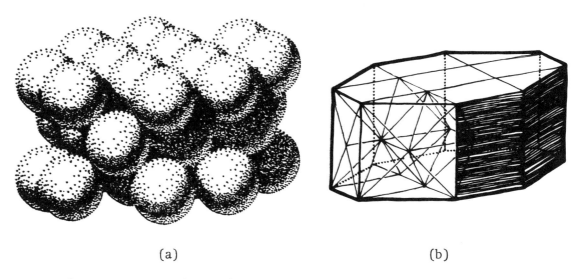

(a) (b)

Figure 4-36. Thirty-five ccp *spheres with certain sphere centers interconnected to define a distorted form of the octagonal prism,* $4^2.8$, *having edges in the ratio of 1:$\sqrt{2}$.*

A final important polyhedron, defined by eight close-packed spheres, is a rhombohedron (Figure 4-37) with face angles of 60° and 120°. This polyhedron is the *primitive cell* (the smallest possible three-dimensional cell that can fill the entire space by only translations on three axes) of the *ccp* or the *fcc* lattice.

132

(a) (b)

Figure 4-37. Eight ccp *spheres with sphere centers inter-connected to define a rhombohedron.*

Table 4-3 lists the polyhedra defined by close-packed spheres, gives the type of close-packing, and specifies the number of spheres necessary to define each polyhedron.

Table 4-3. POLYHEDRA DEFINED BY CLOSE-PACKED SPHERES[17]

POLYHEDRON	TYPE OF CLOSE-PACKING	CLOSE-PACKED SPHERES	
		MINIMUM NUMBER REQUIRED	NUMBER IN OUTER SHELL
{3,3}	*ccp* or *hcp*	4	4
{3,4}	*ccp* or *hcp*	6	6
Triangle Prism	*hcp*	7	6
Rhombohedron	*ccp*	8	8
$(3.4)^2$	*ccp*	13	12
Twist-Cuboctahedron	*hcp*	13	12
{4,3}	*ccp*	14	14
3.6^2	*ccp*	16	16
Hexagonal Prism*	*hcp*	17	14
Octagonal Prism*	*ccp*	35	28
4.6^2	*ccp*	38	32
Small Rhombicuboctahedron*	*ccp*	43	30
Truncated Cube*	*ccp*	62	48
Great Rhombicuboctahedron*	*ccp*	135	80

* This is a distorted form of the regular faced polyhedron with edge lengths in the ratio of $1:\sqrt{2}$.

[17] Pearce, P. 1966. *Synestructics*. A Report to the Graham Foundation.

133

Volumes of Polyhedra from 12-connected Networks. A simple and elegant method of determining volumes of certain polyhedra with 4.3.2 symmetry is based on two special cases of Schläfli's orthoscheme.[18] From Archimedes we know that the surface area of similar figures increases as the square, while their volume increases as the cube. Specifically, similar polygons of edges E and 2E have areas of S and S^2, respectively; similar polyhedra of edges E and 2E have volumes of C and C^3, respectively.

Consider a normalized {3,3}, ABCD (Figure 4-38a); i.e., a {3,3} with a volume, C_t, of unity. Its edge length is equal to 2.0396... = E. A similar {3,3}, A'B'C'D' (Figure 4-38b), of edge equal to 2E has a volume of $C_t^3 = 8C_t$. The six bisectors of the edges of A'B'C'D' can be connected to define {3,4}, PQRSTU (Figure 4-38c). A'B'C'D' is now composed of one {3,4} and four congruent {3,3} (Figure 4-38d).

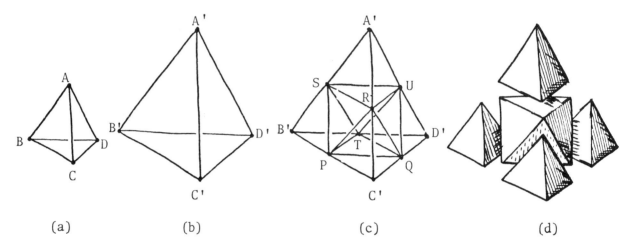

$$(a) \qquad\qquad (b) \qquad\qquad (c) \qquad\qquad (d)$$

Figure 4-38. {3,3} *subdivided into component parts of four* {3,3} *and one* {3,4}.

The four {3,3} A'RSU, B'STP, C'PQR, and D'QUT are similar to ABCD, and their combined volume equals $4C_t$. When C_T is the volume of A'B'C'D', C_t is the volume of each smaller {3,3} in A'B'C'D', and C_o is the volume of {3,4}, PQRSTU, we have

$$C_T = 4C_t + C_o$$

$$C_T = 8C_t$$

$$\therefore C_o = 4C_t$$

[18] This application of the orthoscheme was pointed out by Fuller *op. cit.*

134

We now have integer volume indicators for {3,3} and {3,4}, where the volume of {3,3} is one, and the volume of {3,4} is four.[19]

The {3,3} is composed of twenty-four oppositely congruent Schläfli orthoschemes, each with a volume of 1/24 of {3,3} (Figure 4-39). These are called 'A'. Twelve ℓ-A and twelve d-A assemble into one {3,3}. Three ℓ-A and three d-A combine to form a 1/4-tetrahedron, t/4. Six ℓ-A and six d-A form a 1/2-tetrahedron, t/2 (Figure 4-40).

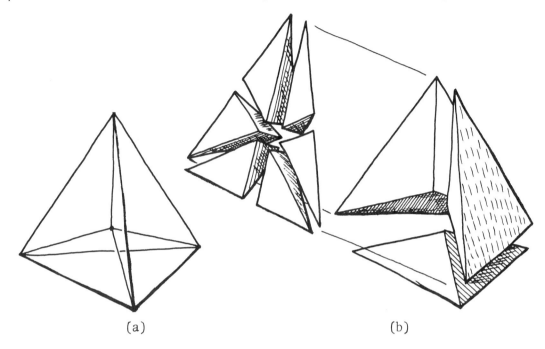

(a) (b)

Figure 4-39. (a) {3,3} divided into four t/4 units; (b) a t/4 unit divided into six 'A' orthoschemes.

Figure 4-40. {3,3} divided into two t/2 units.

[19] Loeb, A. L. 1965. "Remarks on Some Elementary Volume Relationships Between Familiar Solids," *The Math. Teacher.* v. LVIII, no. 5, pp. 417-419.

The {3,4} is composed of forty-eight oppositely congruent ortho-schemes, each with a volume of 1/12 of {3,3} (Figure 4-41). These are termed 'B'.[20] Twelve ℓ-B and twelve d-B combine to form a 1/2-octahedron, oc/2 (Figure 4-42a). Six ℓ-B and six d-B form a 1/4-octahedron, oc/4 (Figure 4-42b). Three ℓ-B and three d-B form a 1/8-octahedron, oc/8 (Figure 4-41a). Three ℓ-B and three d-B form an alternative form of the 1/8-octahedron, oc/8$_1$ (Figure 4-42c).

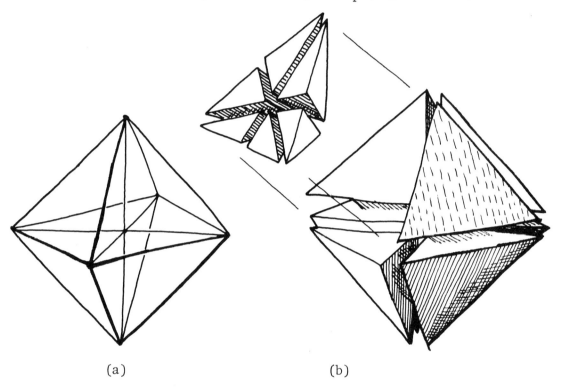

(a) (b)

Figure 4-41. (a) {3,4} *divided into eight* oc/8 *units;* (b) *an* oc/8 *unit divided into six* 'A' *orthoschemes.*

[20] Fuller, R. B. 1960. *Energetic Synergetic Geometry.* (manuscript on file at the School of Architecture Library, Washington University, St. Louis, Mo.), further divides the 'B' in half such that {3,4} is composed of forty-eight 'A' units and forty-eight other units that he called "B particles."

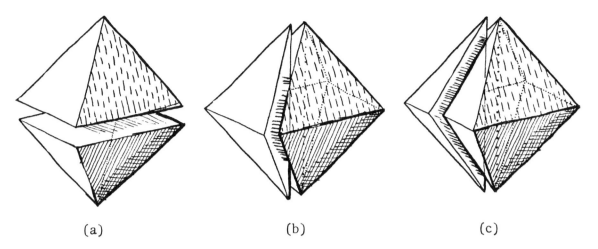

| (a) | (b) | (c) |

Figure 4-42. *(a)* {3,4} *divided into two* oc/2 *units; (b) an* oc/4 *removed from* {3,4}; *(c) an* oc/8$_1$ *removed from* {3,4}.

The volumes of polyhedra that have been defined by sphere packings and 12-connected networks can be given in terms of their composition of {3,3}, {3,4}, and their subdivisions. The volume, C_p, of a polyhedron is

$$C_p = \Sigma \frac{'A'}{24} + \Sigma \frac{'B'}{12}$$

Eq. 4-3.

Table 4-4 gives data on the polyhedral composition of the polyhedra in the 4.3.2 symmetry family. (Table 5-1 gives their respective volumes.)

Table 4-4. COMPOSITION OF 12-CONNECTED NETWORKS FOR POLYHEDRA DEFINED BY CLOSE-PACKED SPHERES

POLYHEDRON	POLYHEDRAL COMPOSITION OF 12-CONNECTED NETWORK											
	{3,3}	$\frac{t}{2}$	$\frac{t}{4}$	{3,4}	$\frac{oc}{2}$	$\frac{oc}{4}$	$\frac{oc}{8}$	$\frac{oc}{8_1}$	d-A	ℓ-A	d-B	ℓ-B
{3,3}	1	-	-	-	-	-	-	-	12	12	-	-
{3,4}	-	-	-	1	-	-	-	-	-	-	24	24
Triangle Prism*†	-	-	-	-	-	-	-	-	-	-	-	-
Rhombohedron	2	-	-	1	-	-	-	-	24	24	24	24
$(3.4)^2$	8	-	-	-	6	-	-	-	96	96	72	72
Twist-Cuboctahedron	8	-	-	-	6	-	-	-	96	96	72	72
{4,3}	8	-	-	1	-	12	-	-	96	96	96	96
3.6^2	7	-	-	4	-	-	-	-	84	84	96	96

137

POLYHEDRON	POLYHEDRAL COMPOSITION OF 12-CONNECTED NETWORK											
	$\{3,3\}$	$\frac{t}{2}$	$\frac{t}{4}$	$\{3,4\}$	$\frac{oc}{2}$	$\frac{oc}{4}$	$\frac{oc}{8}$	$\frac{oc}{8_1}$	d-A	ℓ-A	d-B	ℓ-B
Hexagonal Prism*†	-	-	-	-	-	-	-	-	-	-	-	-
Octagonal Prism*	24	8	-	4	10	16	-	8	336	336	336	336
4.6²	32	-	-	13	6	-	-	-	384	384	384	384
Small Rhombicuboctahedron*	32	24	-	14	-	24	-	24	528	528	552	552
Truncated Cube*	64	-	-	13	30	12	-	-	768	768	744	744
Great Rhombicuboctahedron*	160	24	-	62	30	24	-	24	2064	2064	2064	2064

* This is a distorted form of the regular-faced polyhedron with edge lengths in the ratio of 1:$\sqrt{2}$.

† This polyhedron cannot be subdivided into $\{3,3\}$ and $\{3,4\}$ or portions of $\{3,3\}$ and $\{3,4\}$ in this system.

Two polyhedra not accounted for in Table 4-4 can be defined by aggregations of 'A' and 'B'. The $\{4,3\}$ (Figure 4-43), with an edge of $\sqrt{2}/2\cdot E$, can be constructed from a unit $\{3,3\}$ and four oc/8 units, for a volume equivalent to three unit $\{3,3\}$. $V(3.4)^2$ (Figure 4-44) can be constructed by combining one unit $\{3,4\}$ with eight t/4 units having a total volume equivalent to six $\{3,3\}$. In this composition the E edge is the long diagonal of the faces of $V(3.4)^2$, while the edge of $V(3.4)^2$ is $\sqrt{6}/4\cdot E$.

Figure 4-43. $\{4,3\}$ built from one $\{3,3\}$ and four oc/8 units.

Figure 4-44. V(3.4)2 *built from one {3,4} and eight* t/4 *units.*

Structures in the 5.3.2 Symmetry Family. Natural structures with elements of 5.3.2 rotational symmetry include a small subset of microscopic sea animals called *Radiolaria* (Figure 4-45),[21] complex intermetallic compounds, and some virus particles.

A virus is an obligate parasite that produces diseases in living organisms. With respect to their host cells, viruses may be classified into four major groups: (1) animal viruses (man and other vertebrates), (2) insect viruses, (3) plant viruses, and (4) bacterial viruses. Of all biological structures, the virus is the smallest organism that carries all of the information necessary for reproduction. The exact reproduction process in not completely known, but it is believed to be a self-assembly process, only in a host cell where virus sub-units organize themselves into a virus particle.[22]

A virus particle is composed of a basic infective agent, a nucleic acid core of either DNA or RNA, and a protective shell called a capsid composed of protein units called capsomers. In some virus particles the shell is encased in an outer membrane or envelope.

[21] Haeckel, E. 1887. *Challenger Monograph Report on the Scientific Results of the Voyage of the H. M. S. Challenger.* v. XVIII. Also see: Moore, R. C. 1954. *Treatise on Invertebrate Paleontology. Part D-Protista.* Kansas: University of Kansas Press.

[22] Caspar, D. L. D. and A. Klug. 1962. "Physical Principles in the Construction of Regular Viruses," *Symposia on Quantitative Biology (Cold Spr. Hbr.).* v. XXVII, pp. 1-24; _____. 1963. "Structure and Assembly of Regular Virus Particles," *Viruses, Nucleic Acids, and Cancer.* Baltimore: The Williams and Wilkins Co., pp. 27-39.

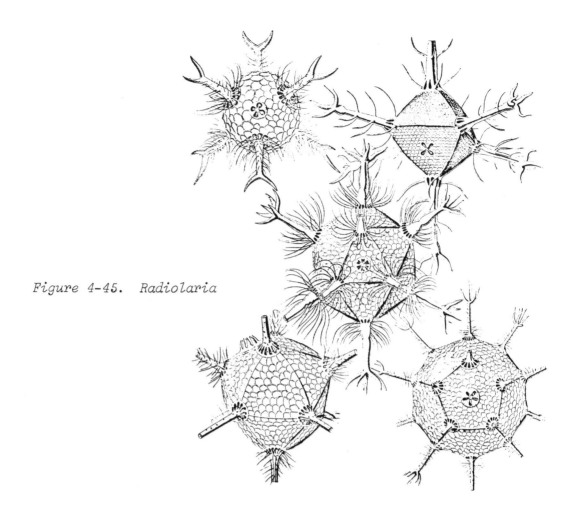

Figure 4-45. Radiolaria

On another level, individual virus particles aggregate with others to form *crystals*. These are not true crystals because the individual virus particles, though the simplest biological structures, are complex chemical structures not equivalent to atoms. However, a virus *crystal* may be visualized as close-packed spheres or as n-connected networks and lattices.

Though related viruses are often structurally similar, morphology and symmetry properties do not, in themselves, constitute adequate biological classification systems. However, because our interest is principally morphological, symmetry classifications of form are important.

Viruses fall into three basic symmetry classifications: (1) complex symmetry, (2) helical symmetry, and (3) cubic symmetry. The Contagious pustular dermatitis (orf) virus (Figure 4-46a),[23] the

[23] Nagington, J. and R. W. Horne. 1962. "Morphological Studies of Orf and Vaccina Viruses," *Virology*. v. 16, pp. 248-260.

Vaccina virus (Figure 4-46b),[24] and the T-even phages (Figure 4-46c)[25] are examples of viruses with complex symmetries. The latter virus has a head that resembles a {3,5} that has been truncated and aggregated with like forms, as shown in Figure 4-47a and b. (This

(a) (b) (c)

Figure 4-46. (a) Contagious pustular dermatitis (orf) virus; (b) Vaccina virus; (c) T-even phage.

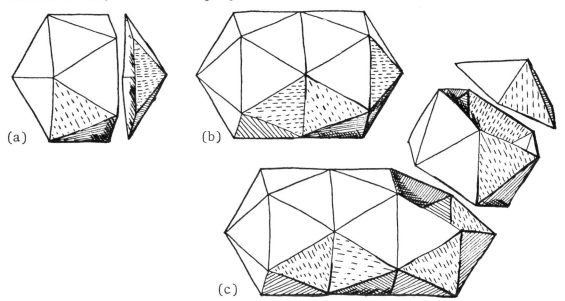

Figure 4-47. (a) a truncation plane of {3,5}; (b) two similarly truncated {3,5} joined together; (c) an aggregation of truncated {3,5}.

[24] Nagington, J. and R. W. Horne. *op. cit.*

[25] Brenner, S., G. Streisinger, R. W. Horne, S. P. Champe, L. Barnett, S. Benzer, and M. W. Rees. 1959. "Structural Components of Bacteriophages," *Jour. Mol. Biol.* v. 1, pp. 281-292.

truncation and aggregation process with {3,5} can be indefinitely continued in many directions, as shown in Figure 4-47c. The truncation planes are defined by the great dodecahedron in Figure 3-12.)

The tobacco mosaic virus (TMV),[26] shown in Figure 4-48, is an example of a virus with helical symmetry. In viruses of this kind the DNA or RNA forms a helix along a single axis, and the capsomers are located between the helical spaces.

Figure 4-48. The Tobacco mosaic virus (TMV).

The viruses with cubic symmetry comprise the group of *spherical viruses*. Virus particles in this group have 5.3.2 rotational symmetry properties, and their gross structure can be shown by sphere packings, both on the partical level and on the *crystal* level.

The basic geometry of spherical virus particles is found in {3,5}. For example, the bacteriophage, φX174, is composed of twelve capsomers arranged at the vertices of {3,5}, as shown in Figure 4-49.[27] This is the simplest formation of a spherical virus.

[26] Caspar, D. L. D. and A. Klug. *op. cit.*

[27] If a sphere is placed in the center of this cluster, its radius would be approximately five percent less than the radii of the spheres in the cluster. For a theory of the structure of the atomic nucleus based on this packing see: Pauling, L. 15 October 1965. "The Close-Packed Spheron Theory and Nuclear Fission," *Science*. v. 150, no. 3694, pp. 297-305. The theory is a refinement of the shell model and the liquid drop model. Each spheron replaces a small aggregation of nucleons. Spherons aggregate in concentric layers (mantle, outer core, inner core, innermost core) at vertices of polyhedra with 5.3.2 rotational symmetry. The theory is applied to the sequence of sub-subshells, magic numbers, the proton-neutron ratio, prolate deformation of nuclei, and symmetric and asymmetric fission.

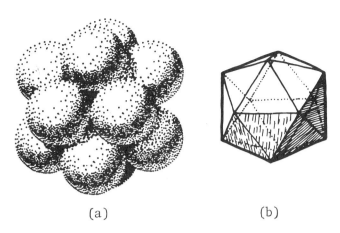

(a) (b)

Figure 4-49. A cluster of twelve spheres with sphere centers interconnected to define {3,5}.

In more complex structures, capsomer packings also define {3,5}. For example, the forty-two capsomers of the Simian virus (SV39), the K-virus, and the Polyoma virus define {3,5} with one capsomer at each vertex and one at each edge bisector, as shown in Figure 4-50. The Reovirus and the Wound tumor virus, with ninety-two capsomers, also define {3,5}. In this case, there is a capsomer at each vertex, two on the edges, and one at the center of each face, as shown in Figure 4-51. The largest known virus defining {3,5} is the Tipula iridescent virus, with 812 capsomers comprising the particle shell.

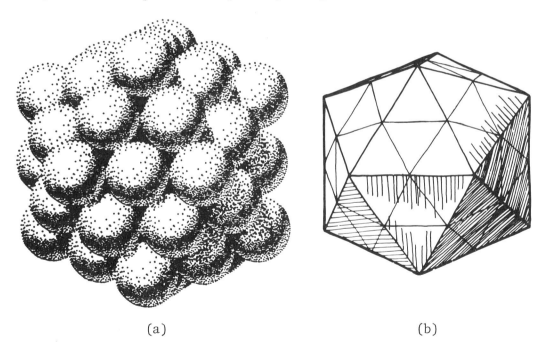

(a) (b)

Figure 4-50. A cluster of forty-two spheres with certain sphere centers interconnected to define {3,5}.

143

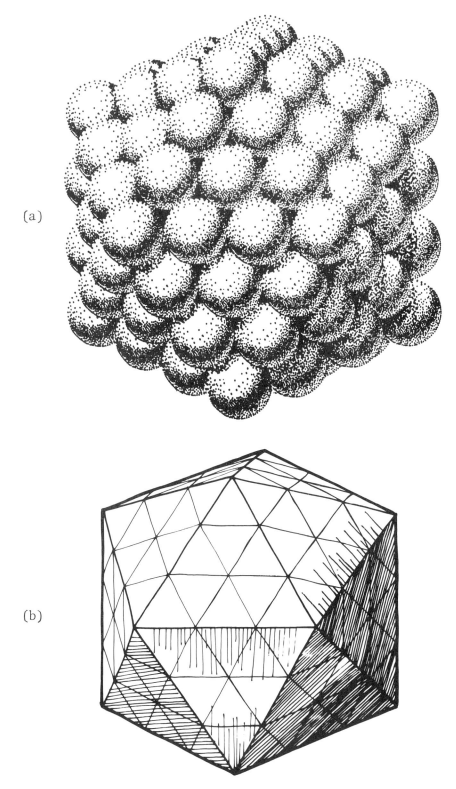

(a)

(b)

Figure 4-51. A cluster of ninety-two spheres with certain sphere centers interconnected to define {3,5}.

Other polyhedra with 5.3.2 symmetry can also be defined by capsomers. For example, the Turnip yellow mosaic virus (TYMV), with thirty-two capsomers, defines the vertices of $V(3.5)^2$, as shown in Figure 4-52. The sixty capsomers of the Poliomyelitis virus particle lie at the vertices of $3^4.5$. The Human wart virus and the Rabbit papilloma virus, each with seventy-two capsomers, define deltahedra that are right- and left-handed, respectively.

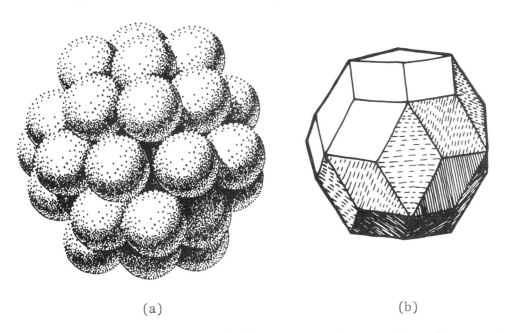

(a) (b)

Figure 4-52. A cluster of thirty-two spheres with sphere centers interconnected to define $V(3.5)^2$.

Two equations derived from Euler's Law can be used to determine the number of capsomers in a virus particle (or the number of spheres defining {3,5}). The first equation gives the total number, C_t, of capsomers in a virus particle from the number of capsomers found on an edge, C_e, of {3,5}.

$$C_t = 10(C_e-1)^2 + 2 \qquad\qquad \text{Eq. 4-4.}$$

The second equation is based on the number of triangles, T_f, on one face of {3,5}, when lines connect capsomer centers, as shown in Figures 4-49 and 4-50.

$$C_t = 10T_f + 2. \qquad\qquad \text{Eq. 4-5.}$$

Although capsomers on virus particles resemble spheres in most microphotographs, finer analysis has shown that a capsomer is made

from smaller *structure units*. These units are 5-fold (pentamer) if they fall at the vertices of {3,5}, and 6-fold (hexamer) if they fall on the edges or faces. Figure 4-53 shows the breakdown of forty-two capsomers into structure units.[28] (The shaded units locate vertices of {3,5}.) The apparent reason that structure units aggregate to generate polyhedra with 5.3.2 symmetry is because no other closed surfaces or polyhedral forms have comparable degrees of equivalent or quasi-equivalent bonding configurations, where each unit has a maximum number of bonds.[29]

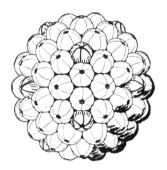

Figure 4-53. A breakdown of the capsomers on a virus particle into structure units.

In virus *crystals*, the 5-fold symmetry properties of the particles assume a role that is subordinate to the 2-fold and the 3-fold properties, such that the particles can pack indefinitely as spheres pack, usually in a *bcc* lattice (Figure 4-17). Many times the *crystals* define $V(3.4)^2$, shown in Figure 4-18 and 4-19.[30, 31]

In some ways the structure of some of the intermetallic compounds resemble the structure of virus *crystals*. In these compounds, atoms cluster about one another in a manner that define polyhedra in the 5.3.2 symmetry family. These clusters or complexes then pack as spheres in a crystallographic lattice. One of the compounds is

[28] Klug, A. and D. L. D. Caspar. 1960. "The Structure of Small Viruses," *Advan. Virus Research*. v. 7, pp. 225-325.

[29] Caspar and Klug. *op. cit.*

[30] Glaser, O. 1945. "Gener, Viruses, and Orderly Aggregation: A Reconaissance," *Am. Sci*. v. 33, pp. 175-188; Markham, R. 1959. "The Biochemistry of Plant Viruses," *The Viruses*. New York: The Academic Press, p. 97.

[31] See: Horne, R. W. 1963. "Electron Microscope Studies on the Structure and Symmetry of Virus Particles," *Viruses, Nucleic Acids, and Cancer*. Baltimore: The Williams and Wilkins Co., pp. 51-52, for a table of morphologies of virus crystals.

$Mg_{32}(Al,Zn)_{49}$.[32] As in virus *crystals*, the structure is also based on the *bcc* lattice. In this structure, the large clusters or complexes of atoms that pack with 5.3.2 symmetry properties are found at the center and vertices of the *bcc* lattice, as shown in Figure 4-54. At each lattice point there is a single atom (Figure 4-54a). Each of these atoms is surrounded by twelve atoms located at vertices of {3,5} (Figure 4-54b).[33] Twenty more atoms locate at the centers of {3,5} faces, and define vertices of {5,3} (Figure 4-54c). An additional twelve atoms are packed at the centers of the faces of {5,3}. These twelve, plus the twenty atoms at the vertices of {5,3}, define the vertices of $V(3.5)^2$ (Figure 4-54d). A further shell of sixty atoms, two at each face of $V(3.5)^2$, define vertices of 5.6^2. This polyhedron has twenty {6} faces, eight in the planes of the {6} faces of 4.6^2 (Figure 4-54f). The last twelve atoms of a complex are placed at the centers of twelve of the twenty {6} faces of 5.6^2. Each of the total of seventy-two outer atoms is shared by two complexes as they aggregate in *bcc* positions (Figure 4-54e). In all, each complex has 113 atoms, seventy-two being shared by neighboring complexes in the crystal.

We can see that the complexes with 5.3.2 symmetry properties subordinate their 5-fold symmetries to the 4- and 3-fold symmetries such that they can aggregate in crystal lattices. This happens also in virus *crystals*, although in the latter case the capsomers on each virus particle belong only to that particle, and are not shared by neighboring viruses.

[32] Bergman, G., J. L. T. Waugh, and L. Pauling. 1957. "The Crystal Structure of the Metallic Phase $Mg_{32}(Al,Zn)_{49}$," *Acta Cryst.* v. 10, pp. 254-259. See also: Samson, S. 1964. "A Method for the Determination of Complex Cubic Metal Structures and its Application to the Solution of the Structure of $NaCd_2$," *Acta Cryst.* v. 17, pp. 491-495, for a description of the use of a packing map in the solutions of these complex structures. For a description of a related structure see: Samson, S. 1967. "The Crystal Structure of the Intermetallic Compound Cu_4Cd_3," *Acta Cryst.* v. 23, pp. 586-600. In this compound, linked {3,5} at the vertices of {3,4} combine to make the crystal. For a discussion of the general topological and geometrical principles regarding the combination of polyhedra in these structures see: Frank, F. C. and J. S. Kasper. 1958. "Complex Alloy Structures Regarded as Sphere Packings. II. Definitions and Basic Principles," *Acta Cryst.* v. 11, pp. 184-190; ———. 1959. "Complex Alloy Structures Regarded as Sphere Packings. II. Analysis and Classification of Representative Structures," *Acta Cryst.* v. 12, pp. 483-499.

[33] In this crystal the spheres are in the approximate positions of the vertices of these polyhedra.

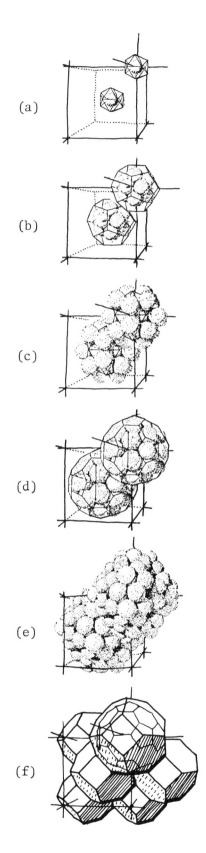

Figure 4-54. The crystal structure of $Mg_{32}(Al,Zn)_{49}$.

Mathematical Sphere Coverings. A *sphere covering* in mathematics is defined as an aggregation of overlapping spheres that cover the entire space; i.e., no interstices remain among the spheres. The spheres remain unchanged in form with the exception that their surfaces pass through one another; the contact perimeters of the spheres are small circles which intersect on each sphere.

We observed in Chapter 2 that the configuration for the circle packing with the greatest density is also the same as that for the covering with the least density. In three dimensions this is not the case. In-spheres of packed $V(3.4)^2$; i.e., spheres packed in the *fcc* lattice (*ccp*), pack with the greatest density in three dimensions. The corresponding sphere covering; i.e., a covering with circum-spheres of packed $V(3.4)^2$, has a density of $2\pi/3 = 2.0944...$, but the least dense covering has a density of $(5\sqrt{5}\pi)/24 = 1.4635...$[34] The latter covering is generated from the *bcc* lattice packing of spheres in this way: The Dirichlet region for *bcc* spheres is 4.6^2, with its eight {6} faces tangent to points of contact between spheres, and its {4} faces mid-way between the next nearest neighbors. (Each sphere has fourteen neighbor spheres—eight touching and six very close spheres.) The circumspheres of packed 4.6^2 generate the thinnest covering.

The metamorphosis from a single Dirichlet region to the geometric representation of a single sphere in the *fcc* sphere covering is shown in Figure 4-55; the related metamorphosis for the *bcc* sphere covering is shown in Figure 4-56. A number of relationships can be seen: (1) On the sphere, the vertices of $(3.4)^2$ are the polar vertices of the twelve rhombus faces of $V(3.4)^2$. Using the vertices of $(3.4)^2$, twelve intersecting small circles can be inscribed on the surface of a sphere, as shown in Figure 4-55c. These circles define the twelve planar faces of $V(3.4)^2$ (Figure 4-55b) and also the contact perimeters of spheres in the *fcc* sphere covering. (2) In a similar manner, the fourteen vertices of $V(3.4)^2$ are the polar centers of the foureeen faces of 4.6^2 (Figure 4-56a). Using these fourteen polar centers,

[34] Bambah, R. P. 1954. "On Lattice Coverings by Spheres," *Proc. Nat. Inst. Sci. India*. v. 20, pp. 25-52; Barnes, E. S. 1956. "On Coverings of Space by Spheres," *Canadian J. Math*. v. 8, pp. 293-304; Few, L. 1956. "Covering Space by Spheres," *Mathematika*. v. 3, pp. 136-139; Coxeter, H. S. M., L. Few, and C. A. Rogers. 1959. "Covering Space with Equal Spheres," *Mathematika*. v. 6, pp. 147-157; Bambah, R. P. and H. Devenport. 1957. "The Covering of *n*-Dimensional Space by Spheres," *Jour. London Math. Soc*. v. 27, pp. 224-229; Rogers, C. A. 1964. *Packing and Covering*. London: Cambridge University Press.

(a) (b) (c)

*Figure 4-55. The Dirichlet region and geometric properties of
a sphere in the* fcc *sphere covering.*

(a) (b) (c)

*Figure 4-56. The Dirichlet region and geometric properties of
a sphere in the* bcc *sphere covering.*

fourteen intersecting small circles can be inscribed on the surface
of a sphere, as shown in Figure 4-56c. These circles define the four-
teen planar faces of 4.6^2 (Figure 4-56b) and the contact perimeters
of spheres in the *bcc* sphere covering.

Natural Sphere Coverings. In natural sphere coverings—bubble
aggregations, plant and animal cell tissues—sphere surfaces deform
into two-dimensional planar or nearly planar boundaries at contact
areas. As these surfaces meet, they, in turn, form polyhedra that

150

are close-packed.[35] Metal crystallites show remarkable statistical and topological similarity to polyhedral formations of aggregated bubbles and cells, although, in isolation a crystallite is not generally spherical. Rather, the isolated form of a crystallite depends on its directional growth rate.[36]

As bubbles, cells, and crystallites aggregate to cover space, the form assumed by individual polyhedral units depends on two factors: (1) the need for stability, both in individual entities and in the aggregation as a whole; and (2) the history of the aggregation itself.[37] There is a tendency toward stability when surface tension is reduced. Reduction of surface tension occurs when each entity encloses the greatest possible volume with the least amount of surface or interface area, combined with the requirement that a minimum amount of surface area exists among the entities in the aggregation. The historical factor—the sequence of cell division, the sequence of addition or subtraction of bubbles, and the sequence and rate of crystallite nucleation—results in forms that are not symmetrical, as in crystals, but quite random in their aggregation.

In general, however, these bodies conform to at least three rules: (1) the average number of faces on aggregated bodies approaches fourteen faces per body; (2) the average number of sides per face is 5.143; and (3) the vertices are generally tetrahedral, formed by four cells whose juncture angles are $\cos^{-1} 1/3 = 109°28'$.[38] The latter restriction is always true in bubble aggregations since entities are free to glide on one another until stable conditions result.[39] Since

[35] See: Matzke, E. B. 1950. "In the Twinkling of an Eye," *Bul. Torrey Botanical Club*. v. 77, no. 3, pp. 222-232, for an interesting history of this subject.

[36] Smith, C. S. 1953. "Microstructure," *Trans. Amer. Soc. Metals*. v. 45, pp. 533-575; Harker, D. and E. R. Parker. 1945. "Grain Shape and Grain Growth," *Trans. Amer. Soc. Metals*. v. 34, pp. 156-201; Smith, C. S. 1948. "Grains, Phases, and Interfaces: An Interpretation of Microstructure," *Trans. Amer. Inst. Min. Met. Eng*. v. 175, pp. 15-51.

[37] Smith, C. S. 1964. "Some Elementary Principles of Polycrystalline Microstructure," *Metallurgical Reviews*. v. 9, no. 33, pp. 1-48.

[38] (1) and (2) are consequences of (3): Coxeter, H. S. M. 1961. *Introduction to Geometry*. New York: Wiley and Sons., p. 411.

[39] Matzke, E. B. 1946. "Three-Dimensional Shape of Bubbles in Foam—An Analysis of the Role of Surface Forces in Three-Dimensional Cell Shape Determination," *Amer. Jour. Botany*. v. 33, pp. 58-80.

this freedom is somewhat restricted in biological tissues and metal crystallites, junctures with more than four edges are occasionally present in the aggregation.[40]

In order to appreciate how the tetrahedral juncture angle is formed, consider the spherical aggregations in Figure 4-1. We see in Figure 4-1d that the interface between two spheres is a small circle half way between the sphere centers. The addition of another sphere generates two additional boundaries that meet at angles of $2\pi/3$ at an edge at the center of the cluster, as shown in figure 4-57a. An added fourth sphere (Figure 4-57b) doubles the boundaries.[41] Faces continue to meet at angles of $2\pi/3$ at four edges. The edges meet at a common point, and radiate from this point at 109° 28'. The addition

(a)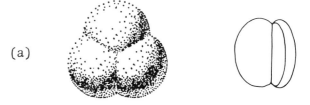

Figure 4-57. (a) a cluster of three spheres and their interfaces; (b) a cluster of four spheres and their interfaces.

(b)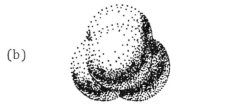

[40] Randomly aggregated compressed lead shot were first used to demonstrate these tendencies. See: Marvin, J. W. 1939. "The Shape of Compressed Lead Shot and its Relation to Cell Shape," *Amer. Jour. Botany.* v. 26, pp. 280-288; Matzke, E. B. 1939. "Volume-Shape Relationships in Lead Shot and their Bearing on Cell Shapes," *Amer. Jour. Botany.* v. 26, pp. 288-295; Marvin, J. W. 1939. "Cell Shape Studies in the Pith of Eupatorium Purpureum," *Amer. Jour. Botany.* v. 26, pp. 487-504.

[41] Thompson, D. W. 1963. *On Growth and Form.* London: Cambridge University Press, pp. 483-499.

process can be continued indefinitely. At some point, however, a sphere will assume a position completely enclosed by other spheres, as in Figure 4-58.

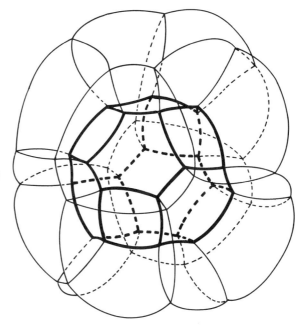

Figure 4-58. The inter-faces defined by fifteen spheres; the center polyhedron is the α-tetrakaidecahedron.

The process can be seen in actual aggregations of bubbles. (To retain control of positions of bubbles, they are resting on a glass plate.) They aggregate in a plane until six bubbles surround one, as in Figure 4-59a through g. (This can be continued indefinitely in the plane, as we have seen in Chapter 2.) As bubbles are packed on top of the planar aggregation, the spherical caps begin to assume polygonal form until a bubble is completely surrounded by others (Figure 4-59g through l). Under ideal conditions of symmetry and uniformity of entities, the polyhedral form assumed by these packed structures is the *tetrakaidecahedron* of Lord Kelvin,[42] shown in Figures 4-58, 4-59 l, and 4-60. It is closely related to 4.6^2 in that both polyhedra have eight hexagonal and six square faces. However, no planar polyhedron that packs to fill space also satisfies the stability requirement that the juncture angles at vertices in an aggregation are 109°28'. By assuming doubly-curved hexagonal faces and quadrilateral faces with bowed edges, the Kelvin body (α-tetra-kaidecahedron) satisfies this requirement.

[42] Thompson, W. (Lord Kelvin). 1887. "On the Division of Space with Minimum Partitional Area," *London, Edinburgh and Dublin Phil. Mag. and Jour. Sci.* v. 24, pp. 503-514;————. 1894. "On Homogeneous Division of Space," *Proc. Roy. Soc.* v. 55, pp. 1-16.

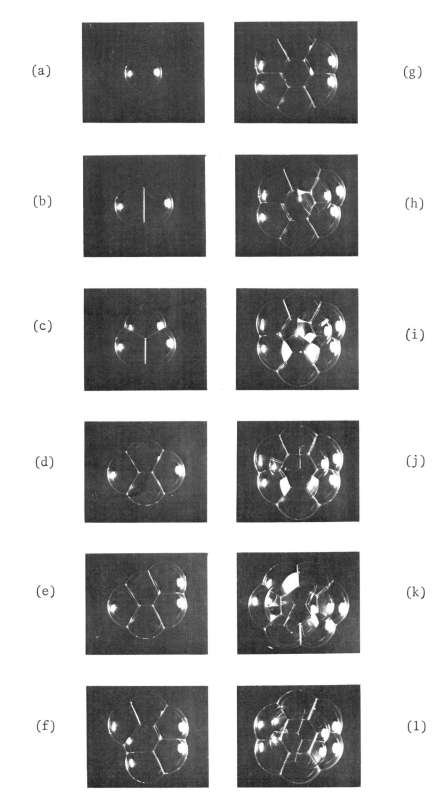

Figure 4-59. Aggregations of bubbles.

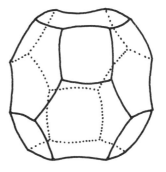

Figure 4-60. The α-tetrakaidecahedron.

Until recently the α-tetrakaidecahedron was the only polyhedron that satisfied rules (1), (2), and (3) for aggregated bodies, and also packed to fill space with identical units. Of all polyhedra that fill space with a single species uniformly oriented, this polyhedron encloses the largest volume with the least amount of surface area. However, in natural structures the α-tetrakaidecahedron is rarely, if ever, observed, due to random aggregations and sizes of entities. Examples of actual bubble forms are shown in Figure 4-61;[43] biological cells in Figure 4-62;[44] and metal crystallites in Figure 4-63.[45] The statistical distribution of polygon faces differs

Figure 4-61. Forms assumed by bubbles in an aggregation.

[43] Matzke, E. B. and J. Nestler. 1946. "Volume-Shape Relationships in Variant Foams. A Further Study of the Role of Surface Forces in Three-Dimensional Cell Shape Determination," *Amer. Jour. Botany*. v. 33, pp. 130-144.

[44] Lewis, F. T. 1925. "A Further Study of the Polyhedral Shapes of Cells," *Proc. Amer. Acad. Arts & Sci.* v. 61, pp. 1-34.

[45] Williams, M. W. and C. S. Smith. 1952. "A Study of Grain Shape in an Aluminum Alloy and Other Applications of Stereoscope Microradiography," *Jour. of Metals*. pp. 755-765.

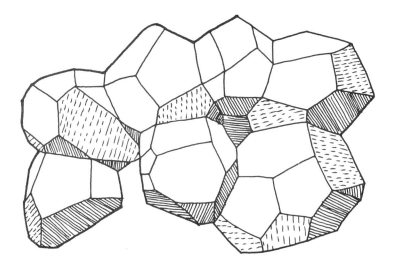

Figure 4-62. Forms assumed by biological cells in aggregation.

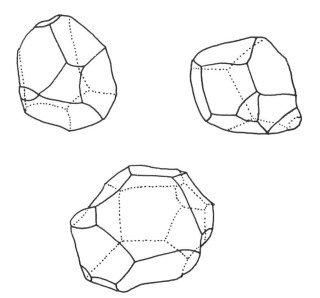

Figure 4-63. Forms assumed by metal crystallites in aggregation.

markedly from the α-tetrakaidecahedron in that bubbles show a predominance of pentagonal faces.[46] Studies of metal crystallites,[47] and vegetable cells[48] show similar distributions (Table 4-5 and Figure 4-64).

[46] Matzke, E. B. and J. Nestler. *op. cit.*

[47] Williams, M. W. and C. S. Smith. *op. cit.*

[48] Matzke, E. B. 1946. *op. cit.*

Table 4-5. SUMMARY OF DISTRIBUTION OF POLYGON FACES IN BUBBLES, VEGETABLE CELLS, AND METAL CRYSTALLITES, α-TETRAKAIDECAHEDRON (KELVIN), β-TETRAKAIDECAHEDRON

EDGES PER FACE (No.)	600 UNIFORM BUBBLES (%)	100 SMALL BUBBLES (%)	50 LARGE BUBBLES (%)	MIXTURE: 50 LARGE, 100 SMALL BUBBLES (%)	450 VEGE-TABLE CELLS (%)	30 BETA BRASS GRAINS (%)	TETRAKAI-DECAHEDRON (%)	
							α	β
3	-	-	-	-	5.1	2.5	-	-
4	10.5	32.9	11.3	22.9	27.3	20.2	42.9	14.3
5	67.0	58.1	48.1	56.1	39.7	43.6	-	57.1
6	22.1	8.9	28.3	19.8	25.4	28.7	57.1	28.6
7	0.4	-	11.2	6.0	6.3	4.6	-	-
8	-	-	5.9	0.3	0.8	0.7	-	-
9	-	-	1.1	0.05	0.1	-	-	-

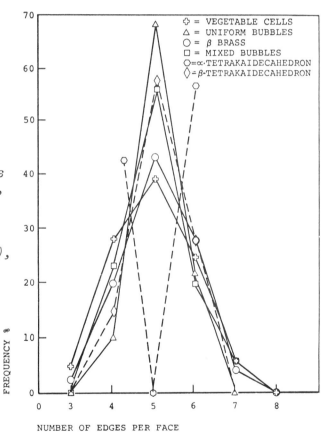

Figure 4-64. Percentage distribution of polygon faces in vegetable cells (crosses), uniform bubbles (triangles), β brass grains (circles), mixed bubbles (squares), α-tetrakaidecahedron (hexagons), and β-tetrakaidecahedron (diamonds).

⊕ = VEGETABLE CELLS
△ = UNIFORM BUBBLES
○ = β BRASS
□ = MIXED BUBBLES
⬡ = α-TETRAKAIDECAHEDRON
◇ = β-TETRAKAIDECAHEDRON

NUMBER OF EDGES PER FACE

FREQUENCY %

Another polyhedron with the appropriate distribution of kinds of faces, and with the ability to pack to fill space was recently discovered—the β-tetrakaidecahedron[49] (Figure 4-65). It can be derived from the α-tetrakaidecahedron by first locating two vertices at opposite ends of an edge that is common to two hexagons, then locating the corresponding vertices on the opposite side of the polyhedron (Figure 4-65a). Next, pairs of vertices are brought together (Figure 4-65b), then pulled apart again, such that two edges appear perpendicular to the original edges (Figure 4-65c). This transformation retains the same number of faces (14), vertices (24), and edges (36) as in the α-tetrakaidecahedron, and the vertex juncture angles remain at 109°28'. The β-tetrakaidecahedron has two quadrilateral, eight pentagonal, and four hexagonal faces; this is an average of 5.143 sides per face.

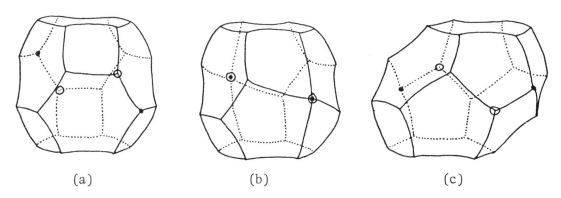

(a) (b) (c)

Figure 4-65. The transformation from the α-tetrakaidecahedron to the β-tetrakaidecahedron.

The percentage distribution of the kinds of faces on the α-tetrakaidecahedron and the β-tetrakaidecahedron, and their relationship to the distribution of faces in natural packings are shown in Table 4-5 and Figure 4-64.

A packing of a group of β-tetrakaidecahedra is shown in Figure 4-66. The packing arrangement belongs to the space group $P4_2/mnm$-D_{4h}^{14}. The centers of the polyhedra correspond to special position $2a$, the nodal points of the interstitial network correspond to positions $4d$ and $8j$ of that space group.[50]

[49] Williams, R. E. 1967. *Geometry, Structure, Environment.* Southern Illinois University., p. 20; ——. 19 July 1968. "Space-Filling Polyhedron: Its Relation to Aggregates of Soap Bubbles, Plant Cells, and Metal Crystallites," *Science.* v. 161, pp. 276-277. This polyhedron has also been identified in the clathrate hydrate $C_4N_2H_{10}\cdot6H_2O$. See: Schwarzenbach, D. 1968. "Structure of Piperazine Hexahydrate," *Jour. Chem. Phys.* v. 48, no. 9, pp. 4134-4140.

[50] Henry, N. F. M. and K. Lonsdale. (eds.). *op. cit.* v.I, p. 236.

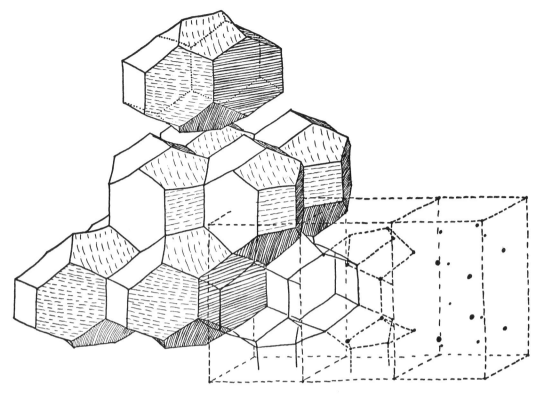

Figure 4-66. A packing of β-tetrakaidecahedra with the tetragonal lattice included.

The centers of β-tetrakaidecahedra cells form a body-centered tetragonal lattice that (if the c/a axial ratio is set at unity) is equivalent to the *bcc* lattice. Therefore, it is no suprise that the β-tetrakaidecahedron is related to the α-tetrakaidecahedron, a basic polyhedron packing in the *bcc* lattice.

Continuous topological transformations of points and bonds permit a number of other space-filling polyhedra to be derived from this polyhedron. For example, as the parameters x and z approach zero (i.e., as position $8j$ approaches position $2b$), the β-tetrakaidecahedron packing transforms to a slightly distorted form of $V(3.4)^2$ (a basic polyhedron packing in the *fcc* lattice), as shown in Figure 4-67. If z goes to zero ($8j\rightarrow4f$), the β-tetrakaidecahedron transforms to a space-filling polyhedron with eight curved pentagonal faces and four rhombus faces, as shown in Figure 4-68. Then, continuing from this polyhedron, if y ceases to equal x ($4f\rightarrow8i$), a distorted form of the α-tetrakaidecahedron is defined, as shown in Figure 4-69. This is the minimum symmetry version of the α-tetrakaidecahedron in this space group.

159

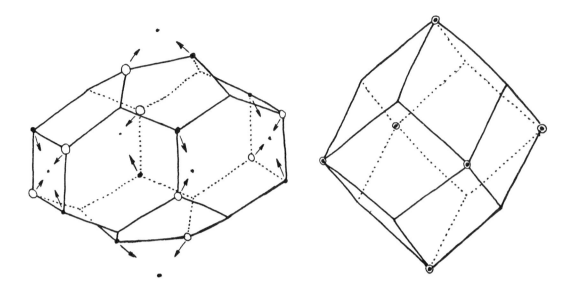

Figure 4-67. The transformation from the β-tetrakaidecahedron to V(3.4)2.

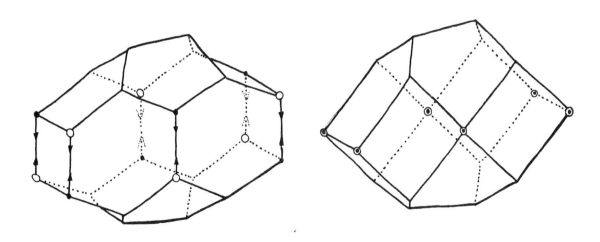

Figure 4-68. The transformation from the β-tetrakaidecahedron to a space-filling polyhedron with eight pentagonal and four rhombus faces.

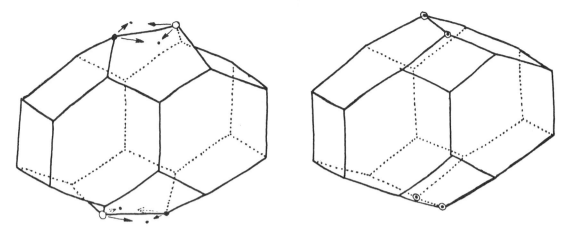

Figure 4-69. The transformation from the β-tetrakaidecahedron to a distorted form of 4.6^2.

The β-tetrakaidecahedron requires roughly 4% more surface area to enclose the same volume as the α-tetrakaidecahedron. Nonetheless, for reasons as yet unknown, natural packings of bodies seem to prefer the composition of faces exemplified in the β-tetrakaidecahedron to the more regular composition of faces on the α-tetrakaidecahedron.

4-4. EULER'S LAW AND AGGREGATIONS OF SPHERES

In addition to specifying the relationship among numbers of faces, vertices, and edges in a polyhedron, Euler's Law (Eq. 1-1) can be used to describe certain properties of sphere packings: the number of spheres in a cluster or in a shell of packed spheres, the number of bonds in a packing, and the like.

Consider, for example, Figures 4-27, 4-29, and 4-30, where spheres are packed in concentric shells; and Figures 4-49, 4-50, and 5-51, where spheres are packed not in concentric shells, but in increasingly larger clusters. In both sets of packings we find twelve, forty-two, ninety-two,... spheres in a shell or cluster; the number in each is determined by Eq. 4-1 or 4-4, respectively. In Figures 4-27, 4-29, and 4-30, $(3.4)^2$ is defined by interconnecting certain sphere centers; in Figures 4-49, 4-50, and 5-51, {3,5} is defined in a similar manner. By interconnecting all of the sphere centers in a shell or cluster with lines, triangles are inscribed on the polyhedra already defined. Whether or not the polyhedra defined by the spheres is $(3.4)^2$ or {3,5}, if the same number of spheres are interconnected by lines, then the same number of triangles are inscribed on the polyhedron. On {3,5}, the triangles are regular; on $(3.4)^2$, the triangles are both regular and isoceles. (The resulting deltahedron in each case can also be viewed as a single spherical surface covered by triangles.)

In any deltahedron, given the number of N_0, N_1, *or* N_2 entities, the number of entities in the remaining two classes can be determined,

because, from Euler's Law, the following relationships always hold among the entities:

Given N_0 (vertices):

$\qquad N_1$ (edges) $= 3(N_0 - 2)$ \hfill (A)

$\qquad N_2$ (faces) $= 2(N_0 - 2)$

Given N_1 (edges):

$\qquad N_0$ (vertices) $= N_1/3 + 2$ \hfill (B)

$\qquad N_2$ (faces) $= 2N_1/3$

Given N_2 (faces):

$\qquad N_0$ (vertices) $= N_2/2 + 2$ \hfill (C)

$\qquad N_1$ (edges) $= 3N_2/2$.

Through the use of (A), (B), or (C) many relationships among aggregated spheres can be determined. In particular, we find Eq. 4-1 and Eq. 4-4 to be special cases of Euler's Law (Eq. 1-3) for a polyhedron. From observations of Figure 4-49, 4-50, and 4-51, it is apparent that an increasingly larger cluster of spheres defining the same polyhedron is equivalent to an increasingly more dense triangulation of the polyhedron. For example, in going from Figure 4-49 to Figure 4-50, the edges of {3,5} are bisected, and interconnected to define twenty groups of four triangles each. If any triangle of edge E is so divided, and the new vertices interconnected, the number of new triangles becomes $E^2 = 2^2 = 4$. If edges are trisected and interconnected, as shown in Figure 4-51, the number of new triangles is $3^2 = 9$. Then, in any subdivision, s, of an edge of a triangle triangulated in a similar manner, the number of new triangles is s^2.

On a deltahedron of N_2 entities, when these entities are subdivided in this manner, the total number, N_{2_t}, of new N_2 entities is

$$N_{2_t} = N_2 s^2 \qquad\qquad \text{Eq. 4-5.}$$

where s denotes the subdivision of each edge, as well as the corresponding triangulation of every face of a deltahedron. From (C), the number, N_0, of zero dimensional entities expressed in terms of N_2 entities is,

$$N_0 = N_2/2 + 2 \qquad\qquad \text{Eq. 4-6.}$$

Substituting Eq. 4-5 into Eq. 4-6, we have,

$$N_{0_t} = \frac{N_2 s^2}{2} + 2 \qquad\qquad \text{Eq. 4-7.}$$

162

For $\{3,5\}$, $N_2 = 20$. Then,

$$N_{0_t} = 10s^2 + 2 \qquad\qquad \text{Eq. 4-8.}$$

Eq. 4-8 is equivalent to Eq. 4-1 and 4-4.[51] In the case of $(3.4)^2$ (Figures 4-27, 4-29, and 4-30), it is first necessary to place a diagonal on each $\{4\}$ such that $(3.4)^2$ becomes topologically equivalent to $\{3.5\}$ before we begin any further triangulation process.

Eq. 4-7 is also used in determining the number of spheres in each concentric shell of spheres packed in a *fcc* lattice (Figure 4-18). Here, $V(3.4)^2$ is defined by the sphere centers. We first divide each of the 4-gon faces into triangles by diagonal lines, before any further triangulation is done. Eq. 4-7 becomes,

$$N_{0_t} = 12s^2 + 2 \qquad\qquad \text{Eq. 4-9.}$$

Using formulae for summation of series,[52] we derive an equation for the summation of spheres in an entire aggregation of concentric shells of spheres,

$$\Sigma N_{0_t} = N_0 - 2\left(\frac{s(s+1)(2s+1)}{6}\right) + 2s + 1 \qquad\qquad \text{Eq. 4-10.}$$

where N_0 is the number of vertices in the basic deltahedron (or the number of spheres in the first shell of the packing); and s is either the shell number or the number of subdividions of an edge of a triangle on the basic deltahedron.

For the summation of spheres in concentric shells in *ccp* (Figures 4-27, 4-29, and 4-30), Eq. 4-10 becomes,

$$\Sigma N_{0_t} = (10s^3 + 15s^2 + 11s + 3)/3 \qquad\qquad \text{Eq. 4-11.}$$

For the *bcc* lattice packing of spheres, Eq. 4-10 becomes,

$$\Sigma N_{0_t} = 4s^3 + 6s^2 + 4s + 1 \qquad\qquad \text{Eq. 4-12.}$$

[51] The number of equal tangent hyperspheres in n Euclidean dimensions is given by the expression $n[(2^{n-2}/3) + n]$, where (R) is the least integer containing R and $-1 \le n \le 8$. See: Muses, C. A. 1965. "Aspects of Some Crucial Problems in Biological and Medical Cybernetics," *Progress in Biocybernetics*. (eds. Wiener and Schade). Amsterdam: Elsevier., v. 2, pp. 211-263. For $n = 4$, the number of hyperspheres in shell s (where $s \ge 2$), is given by the expression $8(2s^3 - 6s^2 + 7s - 3)$. Expressions for $n > 4$ have not been determined. (C. A. Muses, private communication, 22 February 1969.)

[52] Jolley, L. B. W. 1961. *Summation of Series*. New York: Dover., p. 5.

CHAPTER 5

POLYHEDRA PACKING AND SPACE FILLING

A model for the internal structure of crystals, serving as an alternative to sphere packing, is polyhedra packing.[1] Here, atoms can be located within a given polyhedron in a packing; as well as on faces, edges, and vertices. Atoms located within the polyhedron belong only to that polyhedron; while atoms located at faces, edges and vertices are shared between two or more polyhedra as the polyhedra pack together.

When polyhedra are packed their faces, edges, and vertices make contact. If polyhedra are packed, such that no spaces or interstices remain among them, they are said to *fill space*. Space filling is analogous to dividing or cutting space into compartments or cells that define polyhedra. We observed in Chapter 4, for example, that it is possible to generate polyhedra by slicing the networks defined by packed spheres along certain planes. In infinite packings of spheres or their corresponding n-connected networks, the polyhedra generated by the planar slices are space-filling polyhedra.

5-1. CONDITIONS FOR SPACE FILLING WITH POLYHEDRA

There is evidence that identical polyhedra can pack to fill some kind of space, whether it be curved, finite, or hyperspace.[2] In three-dimensional Euclidean space, however, not all packings of identical polyhedra will fill space, but every polyhedron in combination with assorted non-regular polyhedra can satisfy space-filling requirements. For example, $\{3,5\}$ packs with distorted forms of $\{3,3\}$ and $\{3,4\}$ to fill space, but will not fill space when packed with

[1] This method was used by the crystallographer, E. S. Federov, in the development of the 230 space groups.

[2] Coxeter, H. S. M. 1954. "Regular Honeycombs in Elliptic Space," *Proc. London Math. Soc.* (3). v. 4, pp. 471-501.

{3,3} and {3,4} themselves

For a space-filling aggregation of polyhedra either of the following two conditions are necessary and sufficient:

(1) In an infinite aggregation, the sum of the dihedral angles, δ, about each edge is equal to 2π.

$$\Sigma\delta = 2\pi \qquad\qquad\qquad\qquad \text{Eq. 5-1.}$$

(2) In an infinite aggregation, the sum of the vertex figures about each vertex must define a complete polyhedron; that is, from Eq. 3-10, when q edges meet at each vertex in an aggregation,

$$2\pi q = \Sigma(\pi p - 2) + 4\pi, \text{ or}$$

$$q = \frac{\Sigma(p - 2) + 4}{2} \qquad\qquad\qquad\qquad \text{Eq. 5-2.}$$

where p equals the number of vertices in each vertex figure (about a vertex in the polyhedra aggregation) taken separately.

5-2. PACKINGS OF POLYHEDRA HAVING 4.3.2 SYMMETRY PROPERTIES

Of the Platonic and Archimedean polyhedra, only those with 4.3.2 symmetry can be used to fill space, either singly or in combination with other regular faced polyhedra. These include three of the five Platonic polyhedra: {3,3}, {3,4}, {4,3}; and six of the Archimedean semi-regular polyhedra: 3.6^2, $(3.4)^2$, 3.8^2, 4.6^2, 3.4^3, and 4.6.8. Only one of the Archimedean dual polyhedra, $V(3.4)^2$, fills space.[3]

Packings with a Single Species. Suppose the following limiting conditions hold for a space-filling aggregation of polyhedra:
(1) all polygons are regular;
(2) the polyhedra are regular;
(3) the polyhedra are identical;
(4) the polyhedra have the same orientation.
Only a packing of {4,3} (Figure 5-1) satisfies these conditions. By relaxing condition (2), two additional polyhedra are admitted: 4.6^2 (Figure 5-2) and the hexagonal prism, $4^2.6$ (Figure 5-3). Relaxing condition (1) and (2) will admit $V(3.4)^2$ (Figure 5-4a) and the rhombo-hexagonal dodecahedron (Figure 5-5).[4] Relaxing conditions (2)

[3] These space-filling aggregations were presented by: Andreini, A. 1905. "Sulle reti di Poliedre Regolari e Semiregolari," *Memoire della Societa Italiana delle Scienze* (3). v. 14, pp. 75-129.

[4] These are the five parallelohedra of E. S. Federov.

and (4) will admit the prism equivalent to the {3,6} two-dimensional
tessellation shown in Figure 2-4. Relaxing other combinations of con-
ditions will admit many other polyhedra to the space-filling group
including: the prism equivalent of the two-dimensional dual tessell-
ations (Figures 2-7b through 2-14b), the elongated $V(3.4)^2$ (Figure 5-4b),
the trapezoid-rhombic dodecahedron (Figure 5-6), and various forms of
the rhombohedron (Figure 5-7). Other space-filling packings of single
species of polyhedra are generated by various subdivisions of the
above polyhedra, and will be discussed in Chapter 6.

Packings of Multiple Species. The simplest packings of multiple
species polyhedra are the prism equivalents of the two-dimensional
semi-regular tessellations shown in Figures 2-7 through 2-14. An
example of one of these packings is shown in Figure 5-8. Other pack-
ings of multiple species polyhedra include:
 {3,3}; {3,4} (Figure 5-9)
 {3,3}; 3.6^2 (Figure 5-10)
 {3,3}; {4,3}; 3.4^3 (Figure 5-11)
 {4,3}; $(3.4)^2$; 3.4^3 (Figure 5-12)
 {4,3}; 4.6^2; $4.6.8$ (Figure 5-13)
 {3,4}; $(3.4)^2$ (Figure 5-14)
 {3,4}; 3.8^2 (Figure 5-15)
 3.6^2; 3.8^2; $4.6.8$ (Figure 5-16)
 3.6^2; 4.6^2; $(3.4)^2$ (Figure 5-17)
 $4^2.8$; $4.6.8$ (Figure 5-18)
 {4,3}; $4^2.8$; 3.8^2; 3.4^3 (Figure 5-19).

Notes on Figures 5-1 through 5-19. With few exceptions, only one
kind of space-filling aggregation is dealt with in each Figure on the
following pages. Not all of the polyhedra discussed are composed of
regular polygons, but can be simply derived from polyhedra composed of
regular polygons. At the top of each Figure are drawings of the poly-
hedron or the aggregation of polyhedra. The following information is
contained below the drawings:
 (1) The polyhedra that make the packing configuration;
 (2) The distribution ratios of the polyhedra in the aggregation;
 (3) The number of edges that meet at each vertex in the aggrega-
 tion;
 (4) A table containing basic information on each polyhedron in a
 packing, including volumes and various subdivisions. In some
 cases the regular faced polyhedron is listed along with its
 distorted form, also a space-filling polyhedron, which has a
 volume determined by a composition of 'A' and 'B' orthoschemes.

166

Figure 5-1.

PACKING COMPONENTS: CUBES (HEXAHEDRA)
PACKING RATIO: SELF-PACKING
NETWORK: 6-CONNECTED

VOLUME FOR BASIC EDGE LENGTHS OF POLYHEDRA			POSSIBLE SUBDIVISIONS INTO EQUIVALENT POLYHEDRA									
POLYHEDRON	EDGE LENGTH	VOLUME	$\{3,3\}$	$\frac{t}{2}$	$\frac{t}{4}$	$\{3,4\}$	$\frac{oc}{2}$	$\frac{oc}{4}$	$\frac{oc}{8}$	$\frac{oc}{8_1}$	A $(d + \ell)$	B $(d + \ell)$
$\{4,3\}$	$\sqrt{2}/2$ E	3	1	–	–	–	–	–	4	–	24	24
$\{4,3\}$	$\sqrt{2}$ E	24	8	–	–	1	–	12	–	–	192	192
$\{4,3\}$	E	8.4854	–	–	–	–	–	–	–	–	–	–

Figure 5-2.

PACKING COMPONENTS: TRUNCATED OCTAHEDRA
PACKING RATIO: SELF-PACKING
NETWORK: 4-CONNECTED

VOLUME FOR BASIC EDGE LENGTHS OF POLYHEDRA			POSSIBLE SUBDIVISIONS INTO EQUIVALENT POLYHEDRA									
POLYHEDRON	EDGE LENGTH	VOLUME	$\{3,3\}$	$\frac{t}{2}$	$\frac{t}{4}$	$\{3,4\}$	$\frac{oc}{2}$	$\frac{oc}{4}$	$\frac{oc}{8}$	$\frac{oc}{8_1}$	A $(d + \ell)$	B $(d + \ell)$
4.6^2	E	96	32	–	–	13	6	–	–	–	768	768

Figure 5-3.

PACKING COMPONENTS: HEXAGONAL PRISMS
PACKING RATIO: SELF-PACKING
NETWORK: 5-CONNECTED

VOLUME FOR BASIC EDGE LENGTHS OF POLYHEDRA			POSSIBLE SUBDIVISIONS INTO EQUIVALENT POLYHEDRA									
POLYHEDRON	EDGE LENGTH	VOLUME	$\{3,3\}$	$\frac{t}{2}$	$\frac{t}{4}$	$\{3,4\}$	$\frac{oc}{2}$	$\frac{oc}{4}$	$\frac{oc}{8}$	$\frac{oc}{8_1}$	$\begin{array}{c}A\\(d+\ell)\end{array}$	$\begin{array}{c}B\\(d+\ell)\end{array}$
Hexagonal Prism	E	22.0455	-	-	-	-	-	-	-	-	-	-

(a) (b)

Figure 5-4.

PACKING COMPONENTS: RHOMBIC DODECAHEDRA
PACKING RATIO: SELF-PACKING
NETWORK: (4,8)-CONNECTED

VOLUME FOR BASIC EDGE LENGTHS OF POLYHEDRA			POSSIBLE SUBDIVISIONS INTO EQUIVALENT POLYHEDRA									
POLYHEDRON	EDGE LENGTH	VOLUME	$\{3,3\}$	$\frac{t}{2}$	$\frac{t}{4}$	$\{3,4\}$	$\frac{oc}{2}$	$\frac{oc}{4}$	$\frac{oc}{8}$	$\frac{oc}{8_1}$	$\begin{array}{c}A\\(d+\ell)\end{array}$	$\begin{array}{c}B\\(d+\ell)\end{array}$
$V(3.4)^2$	$\sqrt{6}/4$ E	6	-	-	8	1	-	-	-	-	48	48
$V(3.4)^2$	E	26.1282	-	-	-	-	-	-	-	-	-	-

REMARKS: The polyhedron in Figure 5-4b is derived by an elongation of $V(3.4)^2$ along an axis perpendicular to its hexagonal cross-section.

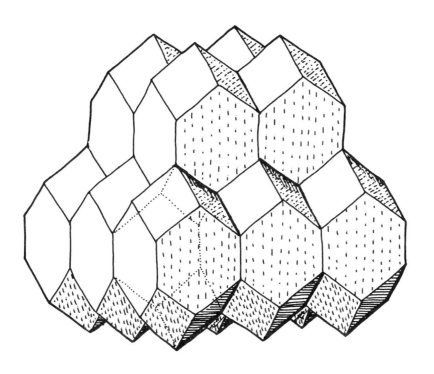

Figure 5-5.

PACKING COMPONENTS: RHOMBO-HEXAGONAL DODECAHEDRA
PACKING RATIO: SELF-PACKING
NETWORK: (4,5)-CONNECTED

VOLUME FOR BASIC EDGE LENGTHS OF POLYHEDRA			POSSIBLE SUBDIVISIONS INTO EQUIVALENT POLYHEDRA									
POLYHEDRON	EDGE LENGTH	VOLUME	{3,3}	$\frac{t}{2}$	$\frac{t}{4}$	{3,4}	$\frac{oc}{2}$	$\frac{oc}{4}$	$\frac{oc}{8}$	$\frac{oc}{8}_1$	A $(d+\ell)$	B $(d+\ell)$
Rhombo-Hexagonal Dodecahedron	$\sqrt{6}/4$ E	11.1962	-	-	-	-	-	-	-	-	-	-
Rhombo-Hexagonal Dodecahedron	E	45.7243	-	-	-	-	-	-	-	-	-	-

REMARKS: This polyhedron is derived by an elongation of $V(3.4)^2$ along an axis perpendicular to its square cross-section.

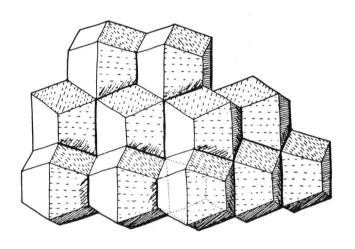

Figure 5-6.

PACKING COMPONENTS: TRAPEZOID-RHOMBIC DODECAHEDRA
PACKING RATIO: SELF-CONNECTED
NETWORK: (4,8)-CONNECTED

VOLUME FOR BASIC EDGE LENGTHS OF POLYHEDRA			POSSIBLE SUBDIVISIONS INTO EQUIVALENT POLYHEDRA									
POLYHEDRON	EDGE LENGTH	VOLUME	$\{3,3\}$	$\frac{t}{2}$	$\frac{t}{4}$	$\{3,4\}$	$\frac{oc}{2}$	$\frac{oc}{4}$	$\frac{oc}{8}$	$\frac{oc}{8_1}$	A $(d + \ell)$	B $(d + \ell)$
Trapezoid-rhombic Dodecahedron	$\sqrt{6}/4$ E, $\sqrt{6}/6$ E, $\sqrt{6}/3$ E	6	-	-	-	-	-	-	-	-	48	48
Trapezoid-rhombic Dodecahedra	E, 2/3 E, 4/3 E	26.1282	-	-	-	-	-	-	-	-	-	-

REMARKS: This polyhedron is derived by slicing $V(3.4)^2$ in half through a hexagonal cross-section, and rotating the halves 60° with respect to one another. The resulting polyhedron has six rhombic and six trapezoid faces, each with angles of 70°32' and 109°28'. The polyhedron is the Dirichlet region for spheres packed in a *hcp* lattice.

170

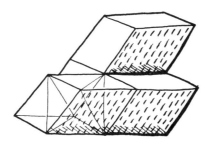

Figure 5-7.

PACKING COMPONENTS: RHOMBOHEDRA
PACKING RATIO: SELF-PACKING
NETWORK: 6-CONNECTED

| VOLUME FOR BASIC EDGE LENGTHS OF POLYHEDRA | | | POSSIBLE SUBDIVISIONS INTO EQUIVALENT POLYHEDRA | | | | | | | | | | |
|---|---|---|---|---|---|---|---|---|---|---|---|---|
| POLYHEDRON | EDGE LENGTH | VOLUME | $\{3,3\}$ | $\frac{t}{2}$ | $\frac{t}{4}$ | $\{3,4\}$ | $\frac{oc}{2}$ | $\frac{oc}{4}$ | $\frac{oc}{8}$ | $\frac{oc}{8_1}$ | A $(d + \ell)$ | B $(d + \ell)$ |
| Rhombohedron | E | 6 | 2 | - | - | 1 | - | - | - | - | 48 | 48 |

REMARKS: This polyhedron is composed of six rhombic faces with face angles of 60° and 120°. It is a composition of two $\{3,3\}$ and one $\{3,4\}$.

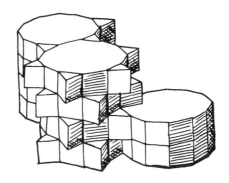

Figure 5-8.

PACKING COMPONENTS: PRISMS (see Figures 2-4 through 2-14)
PACKING RATIO: (see Table 2-3)

| VOLUME FOR BASIC EDGE LENGTHS OF POLYHEDRA | | | POSSIBLE SUBDIVISIONS INTO EQUIVALENT POLYHEDRA | | | | | | | | | | |
|---|---|---|---|---|---|---|---|---|---|---|---|---|
| POLYHEDRON | EDGE LENGTH | VOLUME | $\{3,3\}$ | $\frac{t}{2}$ | $\frac{t}{4}$ | $\{3,4\}$ | $\frac{oc}{2}$ | $\frac{oc}{4}$ | $\frac{oc}{8}$ | $\frac{oc}{8_1}$ | A $(d + \ell)$ | B $(d + \ell)$ |
| 3.4^2 | E | 3.6743 | - | - | - | - | - | - | - | - | - | - |
| $\{4,3\}$ | E | 8.4854 | - | - | - | - | - | - | - | - | - | - |
| $4^2.6$ | E | 22.0455 | - | - | - | - | - | - | - | - | - | - |
| Octagonal Prism | E, $\sqrt{2}$ E | 84 | 24 | 8 | - | 4 | 10 | 16 | - | 8 | 672 | 672 |
| $4^2.8$ | E | 40.9656 | - | - | - | - | - | - | - | - | - | - |
| $4^2.12$ | E | 95.0037 | - | - | - | - | - | - | - | - | - | - |

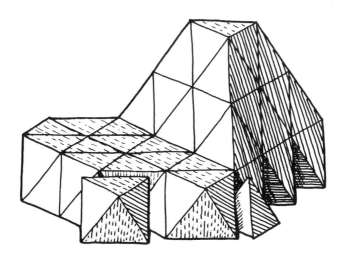

Figure 5-9.

PACKING COMPONENTS: TETRAHEDRA; OCTAHEDRA
PACKING RATIO: 2:1
NETWORK: 12-CONNECTED

VOLUME FOR BASIC EDGE LENGTHS OF POLYHEDRA			POSSIBLE SUBDIVISIONS INTO EQUIVALENT POLYHEDRA									
POLYHEDRON	EDGE LENGTH	VOLUME	{3,3}	$\frac{t}{2}$	$\frac{t}{4}$	{3,4}	$\frac{oc}{2}$	$\frac{oc}{4}$	$\frac{oc}{8}$	$\frac{oc}{8_1}$	A $(d + \ell)$	B $(d + \ell)$
{3,3}	E	1	1	-	-	-	-	-	-	-	24	-
{3,4}	E	4	-	-	-	1	-	-	-	-	-	48

REMARKS: The vertices of polyhedra in this packing are points of the *fcc* lattice.

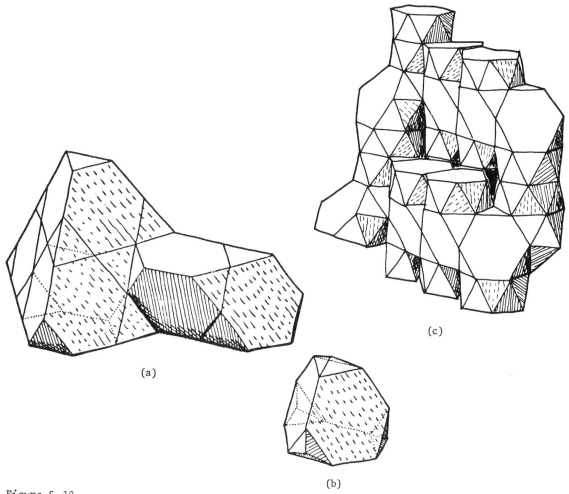

(a)

(c)

(b)

Figure 5-10.

PACKING COMPONENTS: TETRAHEDRA; TRUNCATED TETRAHEDRA
PACKING RATIO: 1:1
NETWORK: 6-CONNECTED

VOLUME FOR BASIC EDGE LENGTHS OF POLYHEDRA			POSSIBLE SUBDIVISIONS INTO EQUIVALENT POLYHEDRA									
POLYHEDRON	EDGE LENGTH	VOLUME	$\{3,3\}$	$\frac{t}{2}$	$\frac{t}{4}$	$\{3,4\}$	$\frac{oc}{2}$	$\frac{oc}{4}$	$\frac{oc}{8}$	$\frac{oc}{8_1}$	A $(d + \ell)$	B $(d + \ell)$
$\{3,3\}$	E	1	1	-	-	-	-	-	-	-	24	-
3.6^2	E	23	7	-	-	4	-	-	-	-	168	192

REMARKS: Figure 5-10b is a polyhedron made by placing a t/4 unit on each $\{3\}$ face of 3.6^2. The resulting polyhedron fills space without the use of other kinds of polyhedra. Aggregations of these polyhedra were first used to describe cleavage properties of diamond crystals. See: Zwikker, C. 1954. *Physical Properties of Solid Materials.* London: Pergamon Press, pp. 55-59. Figure 5-10c shows layers of packed $\{3,3\}$ and 3.6^2 separated by open packings of hexagonal anti-prisms. These and similar aggregations describe structures of intermetallic compounds. See: Samson, S. 1968. "The Structure of Complex Intermetallic Compounds," *Structural Chemistry and Molecular Biology.* (eds. A. Rich and N. Davidson). San Francisco: W. H. Freeman & Co., pp. 687-717.

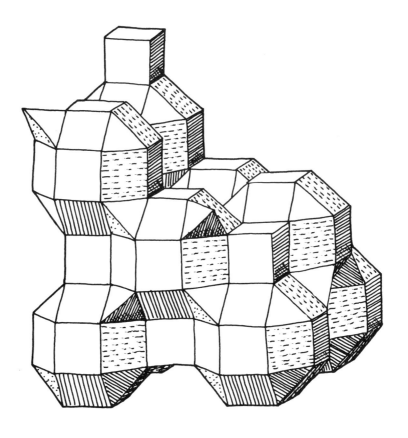

Figure 5-11.

PACKING COMPONENTS: TETRAHEDRA, CUBES; SMALL RHOMBICUBOCTAHEDRA
PACKING RATIO: 2:1:1
NETWORK: 6-CONNECTED

VOLUME FOR BASIC EDGE LENGTHS OF POLYHEDRA			POSSIBLE SUBDIVISIONS INTO EQUIVALENT POLYHEDRA									
POLYHEDRON	EDGE LENGTH	VOLUME	$\{3,3\}$	$\frac{t}{2}$	$\frac{t}{4}$	$\{3,4\}$	$\frac{oc}{2}$	$\frac{oc}{4}$	$\frac{oc}{8}$	$\frac{oc}{8_1}$	A $(d + \ell)$	B $(d + \ell)$
$\{3,3\}$	E	1	1	–	–	–	–	–	–	–	24	–
$\{4,3\}$	$\sqrt{2}\,E$	24	8	–	–	1	–	12	–	–	192	192
Small Rhombicuboctahedron	$E,\ \sqrt{2}\,E$	134	32	24	–	14	–	24	–	24	1056	1104
$\{3,3\}$	E	1	1	–	–	–	–	–	–	–	24	–
$\{4,3\}$	E	8.4854	–	–	–	–	–	–	–	–	–	–
3.4^3	E	73.9356	–	–	–	–	–	–	–	–	–	–

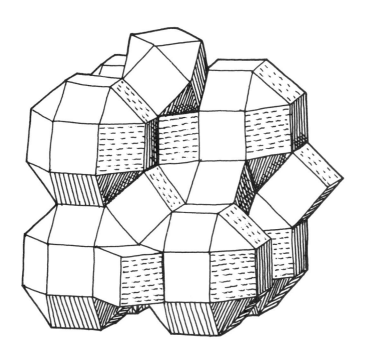

Figure 5-12.

PACKING COMPONENTS: CUBES; CUBOCTAHEDRA; SMALL RHOMBICUBOCTAHEDRA
PACKING RATIO: 3:1:1
NETWORK: 6-CONNECTED

| VOLUME FOR BASIC EDGE LENGTHS OF POLYHEDRA | | | POSSIBLE SUBDIVISIONS INTO EQUIVALENT POLYHEDRA | | | | | | | | | | |
|---|---|---|---|---|---|---|---|---|---|---|---|---|
| POLYHEDRON | EDGE LENGTH | VOLUME | $\{3,3\}$ | $\frac{t}{2}$ | $\frac{t}{4}$ | $\{3,4\}$ | $\frac{oc}{2}$ | $\frac{oc}{4}$ | $\frac{oc}{8}$ | $\frac{oc}{8_1}$ | A $(d + \ell)$ | B $(d + \ell)$ |
| $\{4,3\}$ | E | 8.4854 | - | - | - | - | - | - | - | - | - | - |
| $(3.4)^2$ | E | 20 | 8 | - | - | - | 6 | - | - | - | 192 | 144 |
| 3.4^3 | E | 73.9356 | - | - | - | - | - | - | - | - | - | - |

175

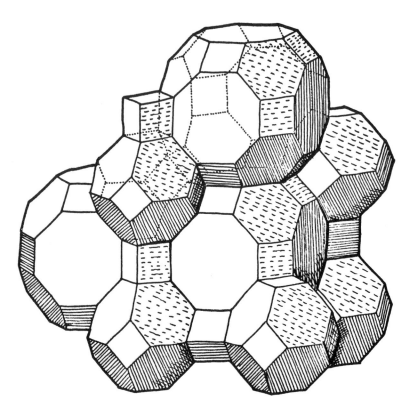

Figure 5-13.

PACKING COMPONENTS: CUBES; TRUNCATED OCTAHEDRA; GREAT RHOMBICUBOCTAHEDRA
PACKING RATIO: 3:1:1
NETWORK: 4-CONNECTED

| VOLUME FOR BASIC EDGE LENGTHS OF POLYHEDRA | | | POSSIBLE SUBDIVISIONS INTO EQUIVALENT POLYHEDRA | | | | | | | | | | |
|---|---|---|---|---|---|---|---|---|---|---|---|---|
| POLYHEDRON | EDGE LENGTH | VOLUME | $\{3,3\}$ | $\frac{t}{2}$ | $\frac{t}{4}$ | $\{3,4\}$ | $\frac{oc}{2}$ | $\frac{oc}{4}$ | $\frac{oc}{8}$ | $\frac{oc}{8_1}$ | A $(d + \ell)$ | B $(d + \ell)$ |
| $\{4,3\}$ | $\sqrt{2}$ E | 24 | 8 | - | - | 1 | - | 12 | - | - | 192 | 192 |
| 4.6^2 | E | 96 | 32 | - | - | 13 | 6 | - | - | - | 768 | 768 |
| Great Rhombicuboctahedron | E, $\sqrt{2}$ E | 516 | 160 | 24 | - | 62 | 30 | 24 | - | 24 | 4128 | 4128 |
| $\{4,3\}$ | E | 8.4854 | - | - | - | - | - | - | - | - | - | - |
| 4.6^2 | E | 96 | 32 | - | - | 13 | 6 | - | - | - | 768 | 768 |
| $4.6.8$ | E | 354.6393 | - | - | - | - | - | - | - | - | - | - |

176

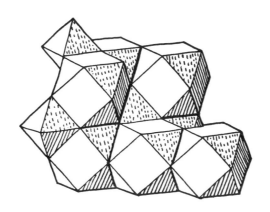

Figure 5-14.

PACKING COMPONENTS: OCTAHEDRA; CUBOCTAHEDRA
PACKING RATIO: 1:1
NETWORK: 8-CONNECTED

VOLUME FOR BASIC EDGE LENGTHS OF POLYHEDRA			POSSIBLE SUBDIVISIONS INTO EQUIVALENT POLYHEDRA									
POLYHEDRON	EDGE LENGTH	VOLUME	$\{3,3\}$	$\frac{t}{2}$	$\frac{t}{4}$	$\{3,4\}$	$\frac{oc}{2}$	$\frac{oc}{4}$	$\frac{oc}{8}$	$\frac{oc}{8_1}$	A $(d + \ell)$	B $(d + \ell)$
$\{3,4\}$	E	4	-	-	-	1	-	-	-	-	-	48
$(3.4)^2$	E	20	8	-	-	-	6	-	-	-	192	144

REMARKS: The twist form of this polyhedron is shown in Figure 4-28. It is derived by rotating half of $(3.4)^2$ through 60° at any of four hexagonal cross-sections. This twist form also packs with $\{3,4\}$ in the packing ratio given above.

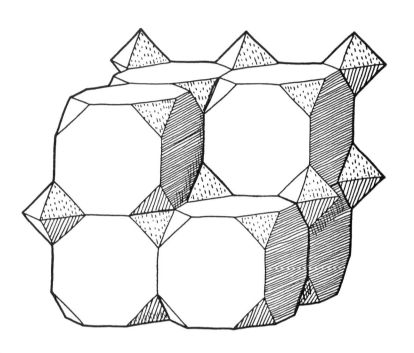

Figure 5-15.

PACKING COMPONENTS: OCTAHEDRA; TRUNCATED CUBES
PACKING RATIO: 1:1
NETWORK: 5-CONNECTED

VOLUME FOR BASIC EDGE LENGTHS OF POLYHEDRA			POSSIBLE SUBDIVISIONS INTO EQUIVALENT POLYHEDRA									
POLYHEDRON	EDGE LENGTH	VOLUME	$\{3,3\}$	$\frac{t}{2}$	$\frac{t}{4}$	$\{3,4\}$	$\frac{oc}{2}$	$\frac{oc}{4}$	$\frac{oc}{8}$	$\frac{oc}{8_1}$	A $(d + \ell)$	B $(d + \ell)$
$\{3,4\}$ Truncated Cube	E E, $\sqrt{2}$ E	4 190	- 64	- -	- -	1 13	- 30	- 12	- -	- -	- 1536	48 1536
$\{3,4\}$ 3.8^2	E E	115.3909	- -	- -	- -	1 -	- -	- -	- -	- -	- -	48 -

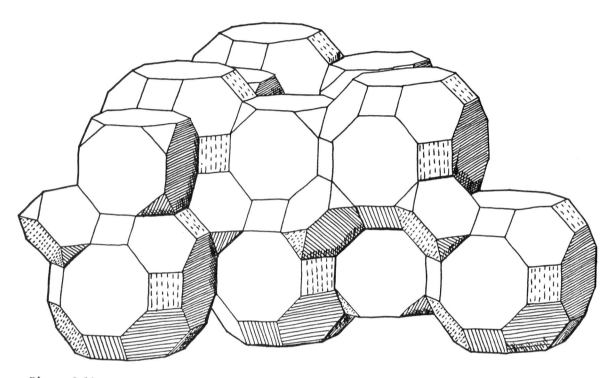

Figure 5-16.

PACKING COMPONENTS: TRUNCATED TETRAHEDRA; TRUNCATED CUBES; GREAT RHOMBICUBOCTAHEDRA
PACKING RATIO: 2:1:1
NETWORK: 4-CONNECTED

VOLUME FOR BASIC EDGE LENGTHS OF POLYHEDRA			POSSIBLE SUBDIVISIONS INTO EQUIVALENT POLYHEDRA									
POLYHEDRON	EDGE LENGTH	VOLUME	$\{3,3\}$	$\frac{t}{2}$	$\frac{t}{4}$	$\{3,4\}$	$\frac{oc}{2}$	$\frac{oc}{4}$	$\frac{oc}{8}$	$\frac{oc}{8_1}$	A $(d + \ell)$	B $(d + \ell)$
3.6^2	E	23	7	-	-	4	-	-	-	-	168	192
Truncated Cube	E, $\sqrt{2}$ E	190	64	-	-	13	30	12	-	-	1536	1488
Great Rhombicuboctahedron	E, $\sqrt{2}$ E	516	160	24	-	62	30	24	-	24	4128	4128
3.6^2	E	23	7	-	-	4	-	-	-	-	168	192
3.8^2	E	115.3909	-	-	-	-	-	-	-	-	-	-
$4.6.8$	E	354.6393	-	-	-	-	-	-	-	-	-	-

179

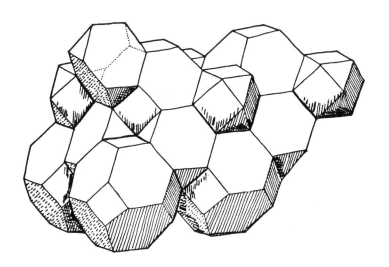

Figure 5-17.

PACKING COMPONENTS: TRUNCATED TETRAHEDRA; TRUNCATED OCTAHEDRA; CUBOCTAHEDRA
PACKING RATIO: 2:1:1
NETWORK: 5-CONNECTED

VOLUME FOR BASIC EDGE LENGTHS OF POLYHEDRA			POSSIBLE SUBDIVISIONS INTO EQUIVALENT POLYHEDRA									
POLYHEDRON	EDGE LENGTH	VOLUME	$\{3,3\}$	$\frac{t}{2}$	$\frac{t}{4}$	$\{3,4\}$	$\frac{oc}{2}$	$\frac{oc}{4}$	$\frac{oc}{8}$	$\frac{oc}{8_1}$	A $(d + \ell)$	B $(d + \ell)$
3.6^2	E	23	7	–	–	4	–	–	–	–	168	192
4.6^2	E	96	32	–	–	13	6	–	–	–	768	768
$(3.4)^2$	E	20	8	–	–	–	6	–	–	–	192	144

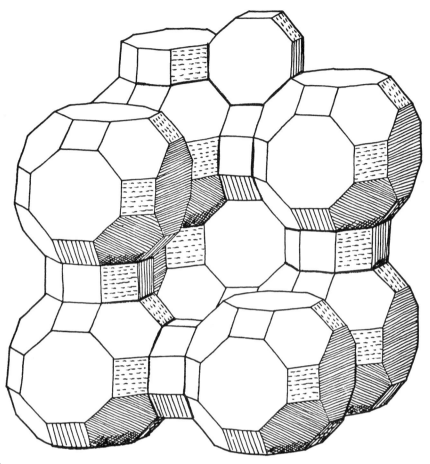

Figure 5-18.

PACKING COMPONENTS: OCTAGONAL PRISMS; GREAT RHOMBICUBOCTAHEDRA
PACKING RATIO: 3:1
NETWORK: 4-CONNECTED

VOLUME FOR BASIC EDGE LENGTHS OF POLYHEDRA			POSSIBLE SUBDIVISIONS INTO EQUIVALENT POLYHEDRA									
POLYHEDRON	EDGE LENGTH	VOLUME	$\{3,3\}$	$\frac{t}{2}$	$\frac{t}{4}$	$\{3,4\}$	$\frac{oc}{2}$	$\frac{oc}{4}$	$\frac{oc}{8}$	$\frac{oc}{8_1}$	A $(d + \ell)$	B $(d + \ell)$
Octagonal Prism	E, $\sqrt{2}$ E	84	24	8	–	4	10	16	–	8	672	672
Great Rhombicuboctahedron	E, $\sqrt{2}$ E	516	160	24	–	62	30	24	–	24	4128	4128
$4^2.8$	E	40.9656	–	–	–	–	–	–	–	–	–	–
4.6.8	E	354.6393	–	–	–	–	–	–	–	–	–	–

181

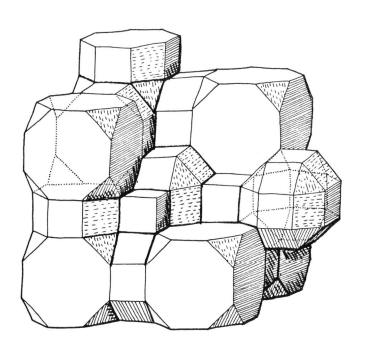

Figure 5-19.

PACKING COMPONENTS: CUBES; OCTAGONAL PRISMS; TRUNCATED CUBES; SMALL RHOMBICUBOCTAHEDRA
PACKING RATIO: 3:3:1:1
NETWORK: 5-CONNECTED

VOLUME FOR BASIC EDGE LENGTHS OF POLYHEDRA			POSSIBLE SUBDIVISIONS INTO EQUIVALENT POLYHEDRA									
POLYHEDRON	EDGE LENGTH	VOLUME	{3,3}	$\frac{t}{2}$	$\frac{t}{4}$	{3,4}	$\frac{oc}{2}$	$\frac{oc}{4}$	$\frac{oc}{8}$	$\frac{oc}{8_1}$	A $(d + \ell)$	B $(d + \ell)$
{4,3}	$\sqrt{2}$ E	24	8	–	–	1	–	12	–	–	192	192
Octagonal Prism	E, $\sqrt{2}$ E	84	24	8	–	4	10	16	–	8	672	672
Truncated Cube	E, $\sqrt{2}$ E	190	64	–	–	13	30	12	–	–	1536	1488
Small Rhombicuboctahedra	E, $\sqrt{2}$ E	134	32	24	–	14	–	24	–	24	1056	1104
{4,3}	E	8.4854	–	–	–	–	–	–	–	–	–	–
$4^2.8$	E	40.9656	–	–	–	–	–	–	–	–	–	–
3.8^2	E	115.3909	–	–	–	–	–	–	–	–	––	–
3.4^4	E	73.9356	–	–	–	–	–	–	–	–	–	–

Table 5-1 summarizes the information concerning volumes and sub-
divisions of the polyhedra discussed in Figures 5-1 through 5-19. The
Platonic and Archimedean polyhedra with 5.3.2 symmetry are also includ-
ed for comparison. The table includes the name of the polyhedron; the
number of faces (F), vertices (V), and edges (E); the basic edge
lengths; the number of 'A' and 'B' orthoschemes (where applicable);
and the volume of the polyhedron.

Table 5-1. SUMMARY OF POLYHEDRA VOLUMES AND SUBDIVISIONS[5]

POLYHEDRON	F	V	E	EDGE LENGTHS	A $(d + \ell)$	B $(d + \ell)$	VOLUME
Unitary Tetrahedron (1/24 Rhombic Dodecahedron)	4	4	6	$\sqrt{2}/2$ E, $\sqrt{6}/4$ E	2	2	.2500
{3,3}	4	4	6	E	24	–	1.0000
Unitary Octahedron (1/6 Rhombic Dodecahedron)	8	6	12	$\sqrt{2}/2$ E, $\sqrt{6}/4$ E	8	8	1.0000
Rhombohedron (face angles: 70°32' and 109°28')	6	8	12	$\sqrt{6}/4$ E	12	12	1.5000
{4,3}	6	8	12	$\sqrt{2}/2$ E	24	24	3.0000
3.4^2	5	6	9	E	–	–	3.6743
{3,4}	8	6	12	E	–	48	4.0000
$V(3.4)^2$	12	14	24	$\sqrt{6}/4$ E	48	48	6.0000
Trapezoid Rhombic Dodecahedron	12	14	24	$\sqrt{6}/4$ E, $\sqrt{6}/6$ E, $\sqrt{6}/3$ E	48	48	6.0000
Rhombohedron (face angles: 60° and 120°)	6	8	12	E	48	48	6.0000
{4,3}	6	8	12	E	–	–	8.4854
Rhombo-Hexagonal Dodecahedron	12	18	28	$\sqrt{6}/4$ E	–	–	11.1962
{3,5}	20	12	30	E	–	–	18.5125
$(3.4)^2$	14	12	24	E	192	144	20.0000
Twist-Cuboctahedron	14	12	24	E	192	144	20.0000
$4^2.6$	8	12	18	E	–	–	22.0455

[5] Part of the information in this table was compiled by: Fuller,
R. B. 1965. *World Design Science Decade 1965-1975. Phase I, Doc -
ument 3.* Carbondale, Ill.: World Resources Inventory., pp. 21-22;
part by Pearce, P. 1966. *Synestructics.* A Report to the Graham
Foundation, Table 2; and part by Williams, R. E. 1968. "Handbook
of Structure," *Research Communication 75.* Huntington Beach, Calif-
ornia: Douglas Advanced Research Laboratories., pp. 120-121.

Table 5-1. SUMMARY OF POLYHEDRA VOLUMES AND SUBDIVISIONS (cont.)

POLYHEDRON	F	V	E	EDGE LENGTHS	A $(d + \ell)$	B $(d + \ell)$	VOLUME
3.6^2	8	12	18	E	168	192	23.0000
Produced Truncated Tetrahedron	16	16	30	E, $\sqrt{6}/4$ E	192	192	24.0000
$\{4,3\}$	6	8	12	$\sqrt{2}$ E	192	192	24.0000
$V(3.4)^2$	12	14	24	E	-	-	26.1282
Hexagonal Prism	8	12	18	E, $\sqrt{2}$ E	-	-	31.1772
$4^2.8$	10	16	24	E	-	-	40.9656
Rhombo-Hexagonal Dodecahedron	12	18	28	E	-	-	45.7243
$\{5,3\}$	12	20	30	E	-	-	65.0251
$3^4.4$	38	24	60	E	-	-	66.9368
3.4^3	26	24	48	E	-	-	73.9356
Octagonal Prism	10	16	24	E, $\sqrt{2}$ E	672	672	84.0000
$4^2.12$	14	24	36	E	-	-	95.0037
4.6^2	14	24	36	E	768	768	96.0000
3.8^2	14	24	36	E	-	-	115.3909
$(3.5)^2$	32	30	60	E	-	-	117.2992
Small Rhombicuboctahedron	26	24	48	E, $\sqrt{2}$ E	1056	1104	134.0000
Truncated Cube	14	24	36	E, $\sqrt{2}$ E	1536	1488	190.0000
$3^4.5$	92	60	150	E	-	-	319.1110
$3.4.5.4$	62	60	120	E	-	-	353.1136
$4.6.8$	26	48	72	E	-	-	354.6393
5.6^2	32	60	90	E	-	-	469.1307
Great Rhombicuboctahedron	26	48	72	E, $\sqrt{2}$ E	4128	4128	516.0000
3.10^2	32	60	90	E	-	-	721.7164
$4.6.10$	62	120	180	E	-	-	1754.6379

Table 5-2 lists the relative quantities of surface areas for select-
ed packings of polyhedra required to fill a certain minimum unit of
space. The least dense packing with respect to surface area is the
$\{4,3\}$; 4.6^2; 4.6.8 packing, requiring 58 E^2 units to cover a unit space.
The surface required to cover the same space by other packing combin-
ations of edge E are given in the surface density column. By dividing
the surface densities for the various packings by the surface density
for the least dense packing, we obtain the Value I. For example, di-
viding the surface density of 4.6^2 by the surface density of the
$\{4,3\}$; 4.6^2; 4.6.8 packing gives 1.22. This number indicates that a
packing of 4.6^2 requires approximately 22% more surface area to cover
the same space as the least dense packing.

Table 5-3 is similar to Table 5-2. In Table 5-3, however, we are
concerned with perimeter density; i.e., the number of polyhedral edges
required to cover a unit space.

Table 5-2. *SURFACE DENSITIES OF SELECTED POLYHEDRA PACKINGS*

POLYHEDRA PACKING*	SURFACE DENSITY†	I
$\{4,3\}$; 4.6^2; $4.6.8$	58	1.00
3.6^2; 3.8^2; $4.6.8$	59	1.02
$4^2.8$; $4.6.8$	63	1.09
4.6^2	72	1.22
$\{3,4\}$; 3.8^2	77	1.33
$\{3,3\}$; $\{4,3\}$; 3.4^3	90	1.55
3.6^2; $(3.4)^2$; 4.6^2	96	1.66
$\{4,3\}$; $(3.4)^2$; 3.4^3	106	1.83
$V(3.4)^2$	112	1.93
$\{4,3\}$; $4^2.8$; 3.8^2; 3.4^3	127	2.19
$\{3,4\}$; $(3.4)^2$	138	2.38
$\{3,3\}$; 3.6^2	147	2.54
$\{4,3\}$	180	3.10
$\{3,3\}$; $\{3,4\}$	300	5.17

* edge = E † approximate values in E^2 units

Table 5-3. *PERIMETER DENSITIES OF SELECTED POLYHEDRA PACKINGS*

POLYHEDRA PACKING	PERIMETER DENSITY†	I
3.6^2; 3.8^2; $4.6.8$	48	1.00
$\{4,3\}$; 4.6^2; $4.6.8$	52	1.08
$4^2.8$; $4.6.8$	53	1.10
4.6^2	64	1.33
$\{3,4\}$; 3.8^2	69	1.44
$\{4,3\}$; $4^2.8$; 3.8^2; 3.4^3	100	2.08
3.6^2; $(3.4)^2$; 4.6^2	102	2.13
$\{3,3\}$; 3.6^2	129	2.69
$\{3,3\}$; $\{4,3\}$; 3.4^3	144	3.00
$\{4,3\}$; $(3.4)^2$; 3.4^3	155	3.23
$V(3.4)^2$	160	3.33
$\{4,3\}$	180	3.75
$\{3,4\}$; $(3.4)^2$	258	5.37
$\{3,3\}$; $\{3,4\}$	516	10.75

* edge = E † approximate values

5-3. PACKINGS OF POLYHEDRA WITH 5.3.2 SYMMETRY PROPERTIES

Combinations of polyhedra in the 5.3.2 symmetry family do not pack
to fill space with either regular-faced bodies in the same family or
with regular-faced bodies in the 4.3.2 symmetry family because they
cannot satisfy.either of the two conditions for space-filling (see:
Section 5-1). However, with (1) slight distortions in face and dihed-
ral angles, or (2) symmetrically subordinating the 5.3.2 symmetry
polyhedra to polyhedra in the 4.3.2 symmetry family, the 5.3.2 poly-
hedra are able to aggregate in regular formations. In some aggregations
the polyhedra fill space, while in others the polyhedra leave open
spaces among them.

Polyhedra Distortions. Although {5,3} will not fill space when
packed, it is possible (with slight distortions of face and dihedral
angles) to aggregate them such that certain faces are shared, leaving
large cavities within the aggregation. Depending on the method of
aggregation, these cavities define three kinds of polyhedra. One
type of cavity defines a polyhedron with two hexagonal and twelve
pentagonal faces (Figure 5-20a), built from two *cups*, each with one
hexagon and six pentagons. A second cavity defines a 15-hedron with
three hexagons and twelve pentagons (Figure 5-20b). A third cavity
defines a 16-hedron with four hexagons and twelve pentagons (Figure
5-20c), in which the centers of the hexagons are at the vertices of
{3,3}.[6]

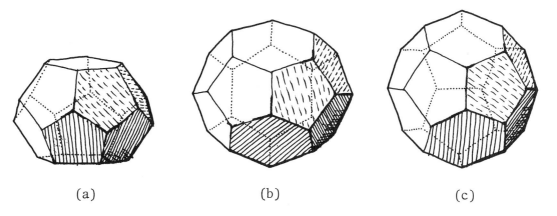

(a) (b) (c)

*Figure 5-20. (a) the 14-hedron composed of twelve pentagons and
two hexagons; (b) the 15-hedron composed of twelve pentagons and three
hexagons; (c) the 16-hedron composed of twelve pentagons and four
hexagons.*

[6] In packings of these polyhedra, their geometries can change de-
pending on specific requirements. For example, if all edges are con-
gruent, the face and dihedral angles must change; if certain angles
are congruent, edge lengths must be changed. See: Allen, K. W. 1964.

The crystal structures of gas hydrates and some related quaternary alkyl ammonium salt hydrates are defined by aggregations of {5,3}, 14-, 15-, and 16-hedra; the polyhedra are viewed as cages containing gas or other molecules. Water modecules define the cages themselves, with oxygen atoms at vertices, and hydrogen atoms along the edges of the aggregated polyhedra.

The structure of the 12 Å cubic gas hydrate[7] is shown in Figures 5-21 and 5-22. It is composed of layers of hexagonal rings of slightly distorted {5,3} with 14-hedra (Figure 5-20a) filling the cavities. This structure is a pseudo body-centered packing of {5,3} with groups of four 14-hedra in the center of the *bcc* cell (Figure 5-22).

"Polyhedral Clathrate Hydrates. VIII. The geometry of the Polyhedra," *Jour. Chem. Phys.* v. 41, no. 3, pp. 840-844.

[7] Jeffrey, G. A. 1961. "The Geometrical Approach to the Structure of Water and the Clathrate Hydrates," *Nat. Acad. Sci., Nat. Res. Council Publication 942.* See also: McMullan, R. K. and G. A. Jeffrey. 1959. "The Polyhedral Clathrate Hydrates, I. Hydrates of the Tetra-n-butyl and Tetra-i-amyl Quaternary Ammonium Salts," *Jour. Chem. Phys.* v. 31, pp. 1231-1234; Bonamico, M., G. A. Jeffrey, and R. K. McMullan. 1962. "Polyhedral Clathrate Hydrates, III. The Structure of Tetra-n-butyl Ammonium Benzoate Hydrate," *Jour. Chem. Phys.* v. 37, pp. 2219-2230; Jeffrey, G. A. and R. K. McMullan. 1962. "Polyhedral Clathrate Hydrates, IV. The Structure of the Tri-n-butyl Sulfonium Fluoride Hydrate," *Jour. Chem. Phys.* v. 37, pp. 2231-2239; McMullan, R. K., M. Bonamico, and G. A. Jeffrey. 1963. "Polyhedral Clathrate Hydrates, V. Structure of the Tetra-n-butyl Ammonium Fluoride Hydrate," *Jour. Chem. Phys.* v. 39, pp. 3295-3310; Beurskins, G., G. A. Jeffrey, and R. K. McMullan. 1963. "Polyhedral Clathrate Hydrates, VI. Lattice Type and Ion Distribution in Some New Peralkyl Ammonium, Phosphonium and Sulfonium Salt Hydrates," *Jour. Chem. Phys.* v. 39, pp. 3311-3315; McMullan, R. K. and G. A. Jeffrey. 1965. "Polyhedral Clathrate Hydrates, IX. The Structure of Ethylene Oxide Hydrate," *Jour. Chem. Phys.* v. 42, pp. 2725-2731; Mak, T. C. W. and R. K. McMullan. 1965. "Polyhedral Clathrate Hydrates, X. Structure of the Double Hydrate of Tetrahydrofuran and Hydrogen Sulfide," *Jour. Chem. Phys.* v. 42, pp. 2732-2737; McMullan, R. K., T. C. W. Mak, and G. A. Jeffrey. 1966. "Polyhedral Clathrate Hydrates, XI. Structure of Tetramethyl Ammonium Hydroxide Pentahydrate," *Jour. Chem. Phys.* v. 44, pp. 2338-2339, McMullan, R. K., T. H. Jordan, and G. A. Jeffrey. 1967. "Polyhedral Clathrate Hydrates, XII. The Crystallographic Data on Hydrates of Ethylamine, Trimethylamine, n-Propylamine (two forms), iso-Propylamine (two forms) and tetra-Butylamine," *Jour. Chem. Phys.* v. 47, pp. 1218-1222; Jordan, T. H. and T. C. W. Mak. 1967. "Polyhedral Clathrate Hydrates, XIII. The Structure of $(CH_3CH_2)_2NH \cdot 8\tfrac{3}{4}H_2O$," *Jour. Chem. Phys.* v. 47, pp. 1222-1228; McMullan, R. K., G. A. Jeffrey, and T. H. Jordan. 1967. "Polyhedral Clathrate Hydrates, XIV. The Structure of

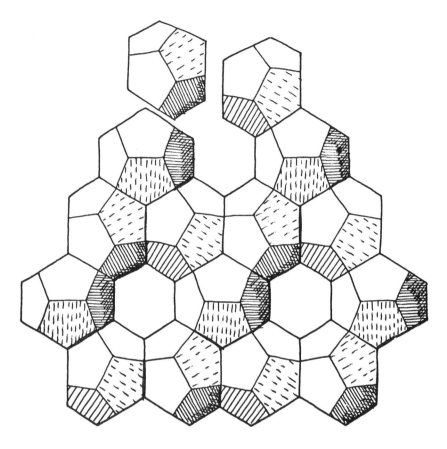

Figure 5-21. A layer of hexagonal rings of distorted {5,3}.

In the structure of the 17 Å chlorine gas hydrate,[8] the distorted {5,3} are positioned at vertices and edges of {3,3} with the 16-hedron at the center (Figure 5-23). The 16-hedra link together at their hexagonal faces (Figure 5-24), such that they define the tetrahedral sphere packing shown in Figure 4-2. The relationships among these polyhedra is most easily seen by a sphere packing analogue (Figure 5-25). Connecting the centers of {5,3} generates a network of packed {3,3} and 3.6^2. In Figure 5-25, the small spheres represent {5,3}, and the large spheres within 3.6^2 represent the 16-hedra.

$(CH_3)_3CNH_2 \cdot 93H_2O$," *Jour. Chem. Phys.* v. 47, pp. 1229-1234; and Panke, D. 1968. "Polyhedral Clathrate Hydrates, XV. The Structure of $4(CH_3)_3N \cdot 41H_2O$," *Jour. Chem. Phys.* v. 48, pp. 2990-2996.

[8] Jeffrey, G. A. 1961. *op. cit.*

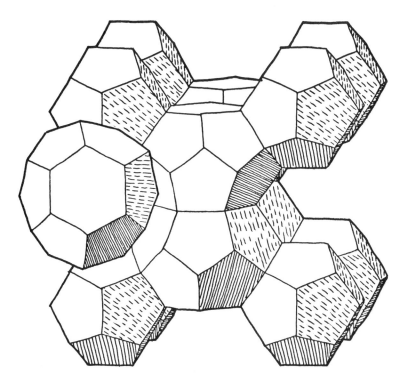

Figure 5-22. The pseudo body-centered packing of distorted {5,3} and 14-hedra. The {5,3} are at the vertices, and groups of 14-hedra are at the center of the bcc cell.

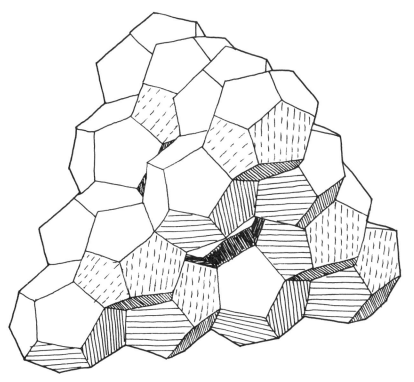

Figure 5-23. An aggregation of distorted {5,3} at vertices and edges of {3,3}. The cavity in the center of the aggregation defines a 16-hedron.

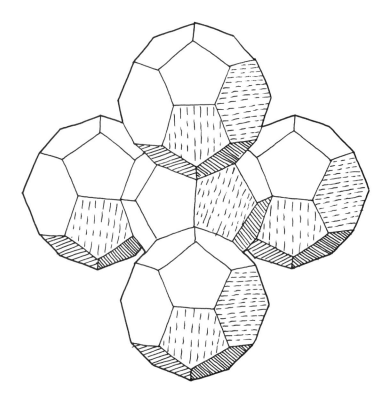

Figure 5-24. Five 16-hedra located at the center and at the vertices of {3,3}.

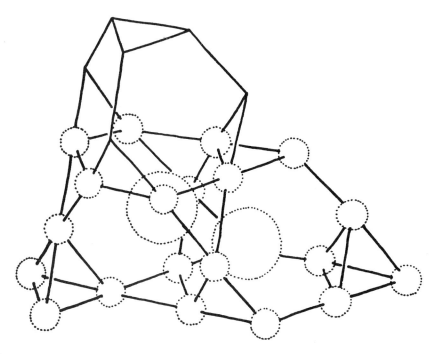

Figure 5-25. The positions of distorted {5,3} and 16-hedra demonstrated by packings of {3,3} and 3.6². The small spheres represent {5,3}, and the large spheres represent 16-hedra.

The structure of Tetra-iso-amyl ammonium fluoride hydrate[9] is an aggregation of distorted {5,3}, 14-hedra, and 15-hedra. It is composed of layers of hexagonal rings of {5,3} (Figure 5-21) with alternating layers of 15-hedra (Figure 5-26). The remaining cavities are filled with 14-hedra. In another arrangement of these polyhedra, one layer is composed of {5,3}, 14-hedra, and 15-hedra, while alternating layers have {5,3} and 15-hedra.[10]

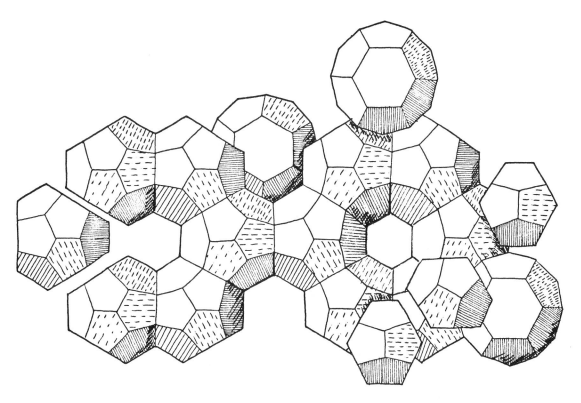

Figure 5-26. A layer of hexagonal rings of 15-hedra, with distorted {5,3} and 14-hedra beginning to cluster in alternating layers.

[9] Feil, D. and G. A. Jeffrey. 1961. "Polyhedral Clathrate Hydrates, II. Structure of the Hydrate of Tetra-iso-amyl Ammonium Fluoride," *Jour. Chem. Phys.* v. 35, pp. 1863-1873.

[10] Beurskens, P. T. and G. A. Jeffrey. 1964. "Polyhedral Clathrate Hydrates, VII. The Structure of the Monoclinic Form of the Tri-n-butyl Sulfonium Fluoride Hydrate," *Jour. Chem. Phys.* v. 40, pp. 2800-2810.

A number of structures of intermetallic compounds are defined by aggregations of 3.6^2 in 5-fold arrangements. In these aggregations, 3.6^2 are either distorted slightly, or have small openings among them. The structure of $NaCd_2$, for example, is shown in Figure 5-27. Cadmium atoms are located at the vertices of 3.6^2; sodium atoms are found at the centers of 3.6^2, as well as near the centers of {6}. In the structure, complexes of forty-seven atoms are formed; they roughly define the 5-fold aggregation of 3.6^2, shown in Figure 5-27a. These complexes then aggregate into larger complexes, such as the 234-atom complex in Figure 5-27b, in which six complexes of Figure 5-27a are at the vertices of {3,4}. Figure 5-27c shows twelve complexes aggregated at vertices of $(3.4)^2$. Six additional complexes are seen at the centers of {4} in $(3.4)^2$.[11]

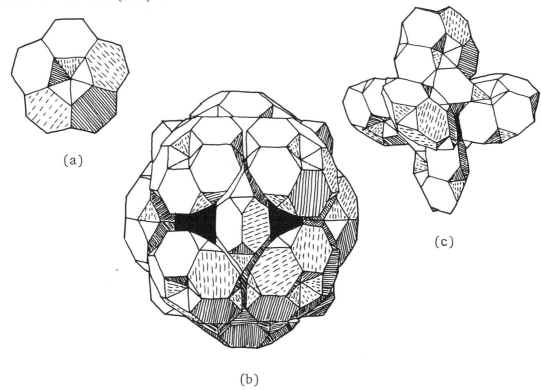

(a)

(b)

(c)

Figure 5-27. (a) a 5-fold aggregation of 3.6^2 defining complexes containing forty-seven atoms; (b) six complexes aggregated at vertices of {3,4}; (c) twelve complexes aggregated at vertices of $(3.4)^2$, with additional complexes at centers of {4} of $(3.4)^2$.

[11] Samson, S. 1962. "Crystal Structure of $NaCd_2$," *Nature.* v. 195, no. 4838, pp. 259-262. For a geometrically related structure see: Samson, S. 1965. "The Crystal Structure of the Phase $βMg_2Al_3$," *Acta Cryst.* v. 19, pp. 401-413.

The crystal structure of $Mg_{32}(Zn,Al)_{49}$, discussed in Chapter 4, can be visualized as *bcc* lattice aggregations of complexes containing 113 atoms. Each complex is formed by the aggregation of twenty distorted 3.6^2 to define a 5.6^2. Here the faces of 5.6^2 need not be distorted to be able to form the open aggregation shown in Figure 7-28.[12]

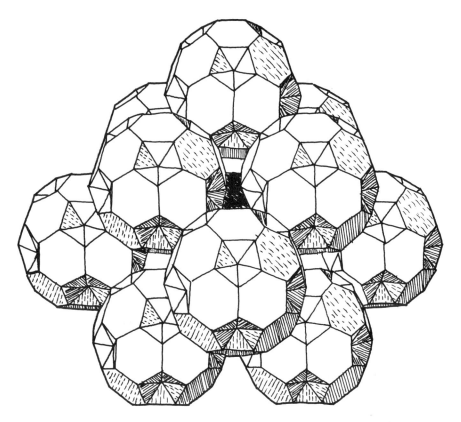

Figure 5-28. *5-fold aggregations of distorted* 3.6^2 *packed in the* bcc *lattice.*

Symmetry Relationships. The determining factor for relationships among polyhedra in the $5.3.2$ and the $4.3.2$ symmetry families is the *golden proportion*, τ. For example, three mutually perpendicular τ rectangles (Figure 5-29a) define the twelve vertices of $\{3,5\}$, as shown in Figure 5-29b, and establish the orthogonal coordinates of the polyhedron. Aggregations of $\{3,5\}$ pack orthogonally, with $\{4,3\}$ as the basis of the packing, as shown in Figure 5-30. Edges of $\{3,5\}$ are coincident with faces of $\{4,3\}$, such that in the aggregation certain edges of $\{3,5\}$ make contact. The aggregation leaves cavities that can be filled with distorted forms of $\{3,3\}$ and $\{3,4\}$.

[12] Samson, S. 1968. *op. cit.*

193

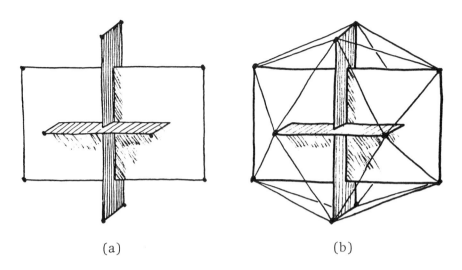

(a) (b)

Figure 5-29. (a) three mutually perpendicular τ rectangles,
(b) the vertices of the τ rectangles defining vertices of {3,5}.

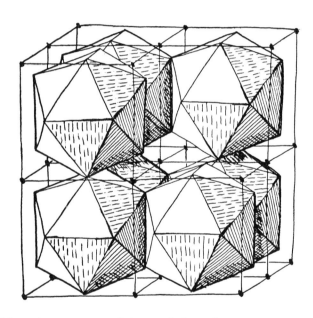

Figure 5-30. An open packing of {3,5}.

Three mutually perpendicular τ rectangles also locate the twelve
5-fold vertices of $V(3.5)^2$ (Figure 5-31a). (The diagonals across each
face of $V(3.5)^2$ are in the golden proportion, as shown in Figure 5-31b.)
5-31b.) These polyhedra can aggregate in the same manner as {3,5}
above; i.e., the center of each $V(3.5)^2$ is the vertex of {4,3}, as
shown in Figure 5-32. This is an open aggregation, but the inter-
stices can be filled with concave forms of $V(3.5)^2$, shown in Figure
5-33.

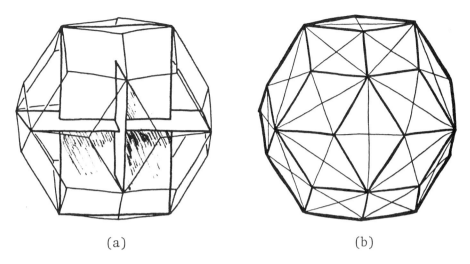

(a) (b)

Figure 5-31. (a) the vertices of τ rectangles defining the 5-fold vertices of V(3.5)2; (b) the golden proportion diagonals across each face of V(3.5)2.

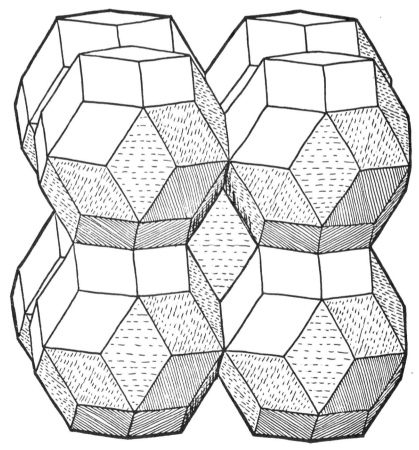

Figure 5-32. An aggregation of V(3.5)2.

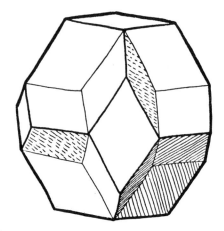

Figure 5-33. The concave polyhedron defined by the interstices among aggregated V(3.5)2.[13]

3^4.4 occupies an interesting transitional position between 5.3.2 and 4.3.2 polyhedra in that it *almost* has elements of 5-fold rotational symmetry at its vertices. The six {4} faces of 3^4.4 are on the faces of {4,3}, such that groups of these polyhedra can pack {4} to {4}, as shown in Figure 5-34. This is an open packing with large cavities among the polyhedra. Both enantiomorphic forms of 3^4.4 are required in the aggregation.[14]

Using τ, numerous other relationships among polyhedra in the 5.3.2 and the 4.3.2 symmetry families can be established.[15] However, we will show only a few characteristic examples, leaving other explorations to the reader. We observed in Chapter 2 that the ratio between the edge and the diagonal of {5} is 1:(1+√5)/2. In {5,3}, the τ diagonals define {4,3}, as shown in Figure 5-35a. This relationship

[13] Crystallized TYM viruses resemble packed V(3.5)2. However, since the virus particles are generally spherical their packing is more open, leaving place in the interstitial spaces for other virus particles. The interstitial virus particles have, at most, only a slight distortion; they do not closely resemble the concave polyhedron in Figure 5-32b. See: Finch, J. T. and A. Klug. 1966. "Arrangement of Protein Subunits in the Distribution of Nucleic Acid in Turnip Yellow Mosaic Virus," *Jour. Mol. Biol.* v. 15, pp. 344-364.

[14] See: Johnson, Q. and G. S. Smith. 1967. "The Crystal Structure of Ce$_5$Mg$_{42}$," *Acta Cryst.* v. 22, pp. 360-365, for a discussion of an open packing of 3^3.4, in which the interstitial spaces are filled with distorted forms of {3,3}, {3,4}, and {3,5}.

[15] Critchlow, K. 1970. *Order in Space.* New York: The Viking Press., p. 25.

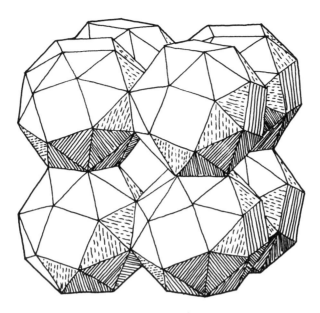

Figure 5-34. An aggregation of $3^4.4$.

allows us to generate one of the five *interpenetrating regular solids*,[16] in which five {4,3} are placed in {5,3}, as shown in Figure 5-35b. Changing the relationship slightly, such that {5,3} is contained in {4,3}, it becomes possible to aggregate groups of {5,3}, as shown in Figure 5-36.

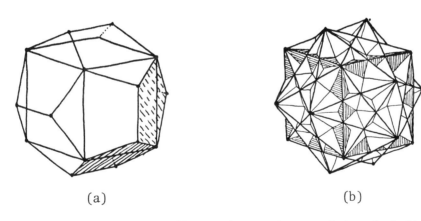

(a) (b)

Figure 5-35. (a) the τ diagonals on faces of {5,3} defining {4,3}; (b) five {4,3} contained in a {5,3}.

[16] The other four are: (1) two {3,3} in a {4,3} (stella octangula); (2) five {3,3} in a {5,3}; (3) ten {3,3} in a {5,3}; and (4) five {3,4} containing a {3,5}. See: Cundy, H. M. and A. P. Rollett. 1961. *Mathematical Models*. London: Oxford University Press, pp. 134-142.

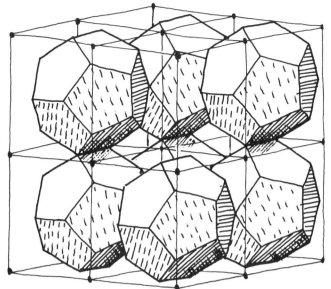

Figure 5-36. An Aggre-
gation of {5,3}.

By dividing the twelve edges of {3,4} by τ we define the twelve
vertices of {3,5} (Figure 5-37a). A 12-connected network defining
aggregations of {3,3} and {3,4}, in which each {3,4} contains {3,5},
creates the packing shown in Figure 5-37b. We also observe that

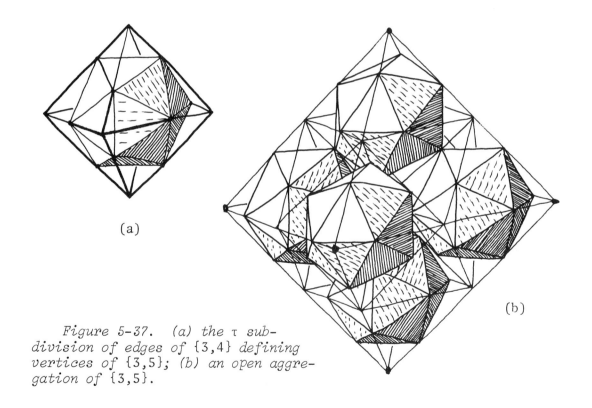

(a)

(b)

Figure 5-37. (a) the τ sub-
division of edges of {3,4} defining
vertices of {3,5}; (b) an open aggre-
gation of {3,5}.

{3,5}, linked by their vertices, define the *fcc* positions of complexes of boron atoms in the α-rhombohedral crystal, as shown in Figure 5-38.[17]

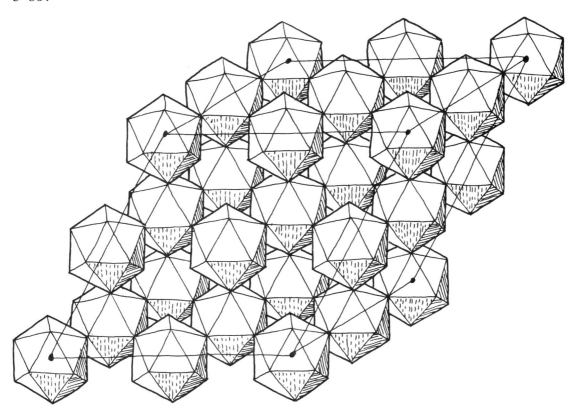

Figure 5-38. An open aggregation of {3,5}, in which the centers of {3,5} are located in fcc *positions.*

[17] Horn, F. H., E. A. Taft, and D. W. Oliver. 1965. "On the Birefringence of Simple Rhombohedral Boron," *Boron*. (ed. G. K. Gaulé). New York: Plenum Press., v. 2, pp. 231-234; Lipscomb, W. N. 1966. "Framework Rearrangement of Boranes and Carboranes," *Science*. v. 153, no. 3734, pp. 373-378; Sullenger, D. B. and C. H. L. Kennard. July, 1966. "Boron Crystals," *Scientific American*. v. 215, no. 1, pp. 96-107.

PART THREE
METHODOLOGIES

CHAPTER 6

GENERATING FORM

Polygons and polyhedra can be generated or have identity changes through ten principal methods:

(1) Vertex Motion (6) Augmentation-Deletion
(2) Fold (7) Fistulation
(3) Reciprocation (8) Distortion
(4) Truncation (9) Dissection
(5) Rotation-Translation (10) Symmetry Integration

6-1. VERTEX MOTION

Vertex Motion is one of the most fruitful operations, not only in generating new polygons and polyhedra, but in generating entirely new close-packed arrangements of polygons and polyhedra. In this operation, motions of vertices can be either symmetrical or asymmetrical. The use of the crystallographic unit cell in these transformations greatly simplifies perception of the processes involved.[1] For example, we have already observed (Chapter 4, Figures 4-65 through 4-69) transformations of the β-tetrakaidecahedron to distorted forms of $V(3.4)^2$, 4.6^2, and other space-filling polyhedra by symmetrical motions of vertices within a tetragonal unit cell. (Figure 4-66). A beautiful transformation of a two-dimensional tessellation by symmetrical vertex motion is shown in Figure 6-1.[2] Here, the {4,4}

[1] The crystallographic unit cell is the smallest rhombohedron (i.e., {4,3} or its distortion) containing all of the elements in a three-dimensional packing, network, etc.; which, when translated on the x, y, and z axes, generates the packing, network, etc. (See: Figures 6-10 and 6-11.)

[2] From: Wood, D. G. 1967. "Space Enclosure Systems," *Bulletin 203*. Columbus, Ohio: The Ohio State University, Engineering Experiment Station., pp. 6-7.

tessellation (Figure 6-1a) transforms into a tessellation of pentagons (Figure 6-1b, c, and d), and finally into a tessellation of rectangles (Figure 6-1e) by separation and symmetrical movements of vertices. (The crystallographic unit cell is the superimposed {4}.)

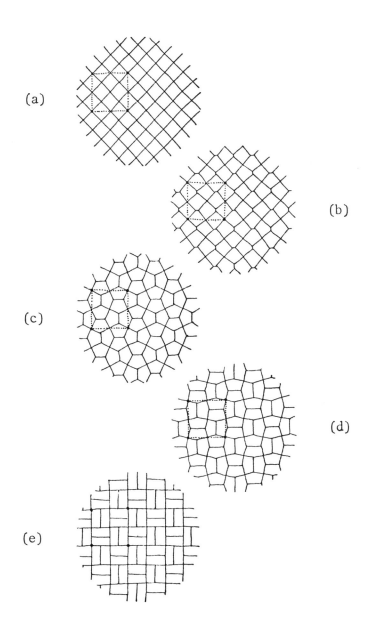

(a)

(b)

(c)

(d)

(e)

Figure 6-1. A transformation from the {4,4} tessellation (a), to a tessellation of pentagons (b,c,and d), to a tessellation of rectangles (e) by the vertex motion operation.

In a three-dimensional transformation (Figure 6-2) we see a rectangular prism (Figure 6-2a) go to (→) 4.6^2 (Figure 6-2d) → $V(3.4)^2$ (Figure 6-2f) → the rhombo-hexagonal dodecahedron (Figure 6-2g) → a rectangular prism (Figure 6-2i) by separation, motion, and fusion of vertices.[3] Every slight change in polyhedral form in Figure 6-2 is a space-filling polyhedron. The operation, therefore, can be performed on aggregated polyhedra.

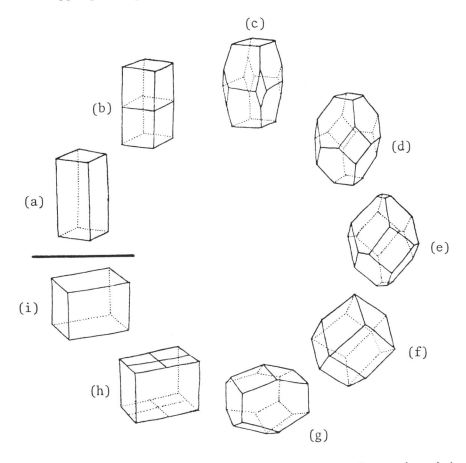

Figure 6-2. *A transformation from a rectangular prism (a) to forms of 4.6^2 (d and e), $V(3.4)^2$ (f), the rhombo-hexagonal dodecahedron (g), and a rectangular prism (h and i) by the vertex motion operation.*

[3] From: Wood, D. G. 1968. "Space Enclosure Systems," *Bulletin 205.* Columbus, Ohio: The Ohio State University, Engineering Experiment Station., pp. 6. See this and *Bulletin 203* for many other examples of polygons and polyhedra generated by vertex motion.

In these and further examples, we see edges appear and disappear, expand and contract, with the exquisite harmony reminiscent of the motions of surfaces, edges, and vertices in bubble aggregations. It will become increasingly obvious as we proceed through the chapter, that many of the operations we discuss—including Fold, Truncation, Rotation-Translation, Augmentation-Deletion, and Distortion—involve some kind of vertex motion. However, since each of these operations has separate and interesting characteristics and qualities of their own, they are presented in separate sections, with the vertex motion operation included in descriptions of each individual operation.

6-2. FOLD

In Chapter 1 we used Euler's Law as a hierarchical equation where aggregations of N_0, N_1, N_2, N_3,... entities combined and folded to generate a single emergent entity and a new dimension. Using the *fold* method in two-dimensions we simply aggregate edges, and close them to define a polyhedron. In three-dimensions, generating polyhedra by this method requires that the polygons be made in a specific pattern (net) on a two-dimensional surface, and folded or closed to form the polyhedron. A necessary condition for generating convex planar polyhedra is that, in the two-dimensional net, the total number of edges common to two polygons is one less than the number of polygons in the net. (Chapter 3 shows nets for various polyhedra.) The fold method can also be used in the sense of including folds on each of the $\{p\}$ faces of a polyhedron in arrays reminiscent of origami paper folding.[4,5] Figure 6-3 shows two examples of $\{3,4\}$ that have faces folded in this manner.

Figure 6-3. Complex folds on the faces of {3,4}.

[4,5] Arnstein, B. 1968. *Origami Polyhedra*. New York: Exposition Press, Inc.

6-3. RECIPROCATION

Polygons and polyhedra can be generated by the reciprocation oper-
ation in three principle ways:

(1) The connection of centers of packed circles or spheres gener-
ates networks that define polygons or polyhedra. Examples are shown
in Chapter 2 for the two-dimensional case, and in Chapter 4 for the
three-dimensional case.

(2) The replacement of edges on a polygon, polyhedron, or network
by vertices connected with lines generates new polygons and polyhedra.
An example of this operation for a polyhedron is shown in Figure 3-2,
where $(3.4)^2$ is generated by replacing edges of either {3,4} or {4,3}
by vertices, and connecting the vertices by edges. The operation on
networks or space-filling polyhedra generates new space-filling poly-
hedra.

(3) The creation of the dual of a polygon or polyhedron, or the
creation of the aggregated duals of aggregated polyhedra, makes new
forms. This operation for a single polyhedron is covered in Chapter
3. The duals of aggregated polyhedra are generated by connecting
face centers of the polyhedra by new edges. Many of the aggregated
duals are triangulated polyhedra. For example, the duals of packings
of distorted {5,3} and 14-hedra, shown in Figure 5-23, are space-
filling aggregations of slightly distorted {3,3}, {3,4}, {3,5}, and
24-deltahedra. An aggregation of distorted {3,5} with a 24-deltahe-
dron in the center is shown in Figure 6-4. The spaces remaining are

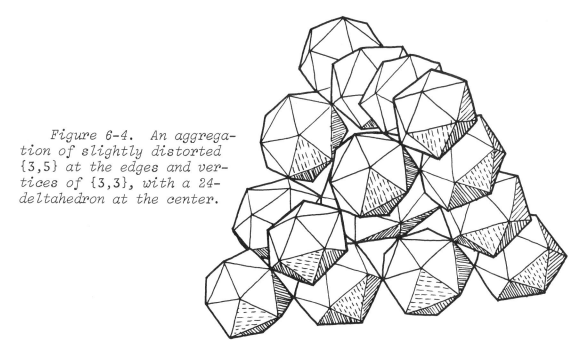

*Figure 6-4. An aggrega-
tion of slightly distorted
{3,5} at the edges and ver-
tices of {3,3}, with a 24-
deltahedron at the center.*

207

filled with distorted {3,3} and {3,4}. Similarly, the duals of aggregations of {5,3}, 14-hedra, and 15-hedra (Figure 5-26) are space-filling aggregations of distorted {3,3}, {3,4}, {3,5}, 24-deltahedra, and 26-deltahedra.

6-4. TRUNCATION

In the *Truncation* operation, N_0, N_1, and N_2 entities are sliced from polygons or polyhedra.

Individual Forms. In truncating a two-dimensional entity, vertices and all (or portions) of the edges are removed. Truncating all vertices of {6} gives a series of 12-gons and finally another {6}, as shown in Figure 6-5.

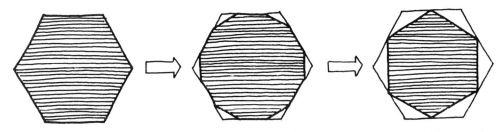

Figure 6-5. *Vertex truncations of {6}, generating {12}, and another {6}.*

Truncating a vertex or an edge of a polyhedron generates a new face, new edges, and new vertices, thereby defining a new polyhedron. Important relationships among the regular, semi-regular, and dual polyhedra are demonstrated by means of this operation. Simple truncations of the five regular polyhedra generate all of the semi-regular polyhedra except the two snub forms; truncating the thirteen Archimedean dual polyhedra generates other polyhedra which fall into the 5.3.2 or 4.3.2 symmetry families.[6]

For the truncations of polyhedra in the 5.3.2 symmetry family (Figure 6-6), {3,5} and {5,3} can be considered basic polyhedra. Truncating the twelve vertices of {3,5}, such that one-third of each edge remains, generates 5.6^2. Truncating further, such that each of the thirty edges of {3,5} becomes a vertex, generates $(3.5)^2$. Further truncations generate 3.10^2 and finally {5,3}. The process may of course be reversed; it is possible to begin with {5,3} and end with {3,5}.

[6] Fejes Tóth, L. 1964. *Regular Figures*. New York: Pergamon Press., pp. 113; Critchlow, K. December, 1965. "Universal Space Families," *Architectural Design.*, p. 516.

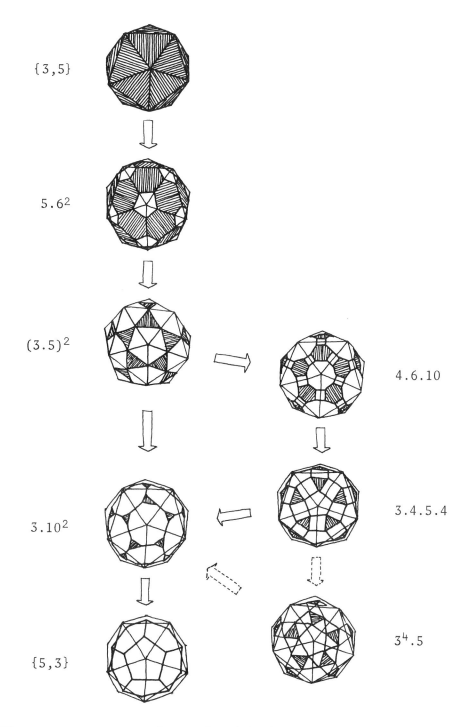

{3,5}

5.6²

(3.5)²

4.6.10

3.10²

3.4.5.4

{5,3}

3⁴.5

Figure 6-6. Truncations of polyhedra in the 5.3.2 symmetry family.

Once $(3.5)^2$ has been defined, it is possible to truncate its vertices, and generate distorted forms of 4.6.10, then 3.4.5.4. Both of these polyhedra have edges in the ratio of $1:(1+\sqrt{5})/2$. From 3.4.5.4 it is possible to continue to 3.10^2, and finally to $\{5,3\}$. The $3^4.5$ cannot be defined by these simple truncations, but it can be related to both $\{3,5\}$ and $\{5,3\}$ by a more complex truncation operation.

For truncations of polyhedra in the 4.3.2 symmetry family we begin with $\{3,3\}$ (Figure 6-7). Truncating each of the four vertices of $\{3,3\}$, such that one-third of each edge remains, generates 3.6^2.

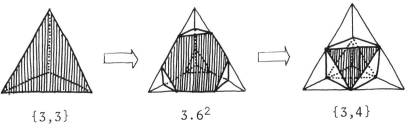

$\{3,3\}$ 3.6^2 $\{3,4\}$

Figure 6-7. Truncations of polyhedra in the 4.3.2 symmetry family.

Truncating further, such that each of the six edges of $\{3,3\}$ becomes a vertex, defines $\{3,4\}$. Then using $\{3,4\}$ as a basic polyhedron (Figure 6-8), and truncating each of its six vertices, such that one-third of each edge remains, generates 4.6^2. Truncating further, such that each of twelve edges of $\{3,4\}$ becomes a vertex, generates $(3.4)^2$. Further truncations generate 3.8^2, then $\{4,3\}$. As in truncations of polyhedra in the 5.3.2 symmetry family, this process can be reversed; it is possible to begin with $\{4,3\}$ and end with $\{3,4\}$. Once $(3.4)^2$ has been defined it is possible to truncate its vertices to generate distorted forms of 4.6.8, then 3.4^3, each with edges in the ratio $1:\sqrt{2}$. From 3.4^3 it is possible to continue to 3.8^2, and finally $\{4,3\}$. As in the case of $3^4.5$, $3^4.4$ cannot be defined by these simple truncations, but it can be related to both $\{3,4\}$ and $\{4,3\}$ through more complex truncations.

Because the Archimedean dual polyhedra have non-regular faces and more than one kind of vertex, there are no simple, consistent truncations that will generate polyhedra. Some of the dual polyhedra however, can be truncated to generate other polyhedra in their respective symmetry families. For example, if all six of the tetra-edge vertices of $V(3.4)^2$ (Figure 6-9) are truncated, the resulting polyhedron is $\{4,3\}$. If its eight tri-edge vertices are truncated, the resulting polyhedron is $\{3,4\}$.

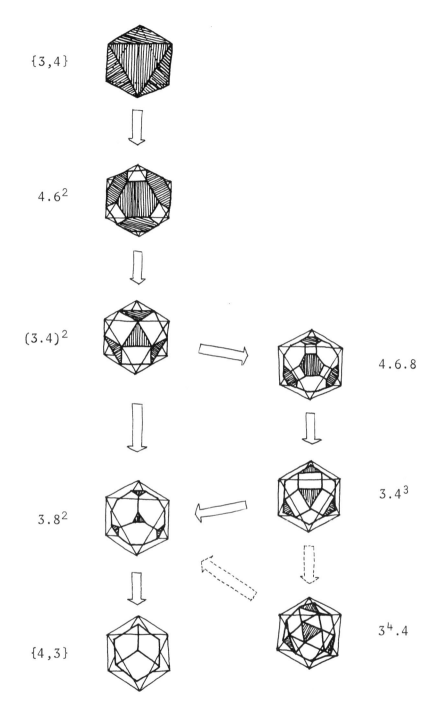

$\{3,4\}$

4.6^2

$(3.4)^2$ 4.6.8

3.8^2 3.4^3

$\{4,3\}$ $3^4.4$

Figure 6-8. Truncations of polyhedra in the 4.3.2 symmetry family.

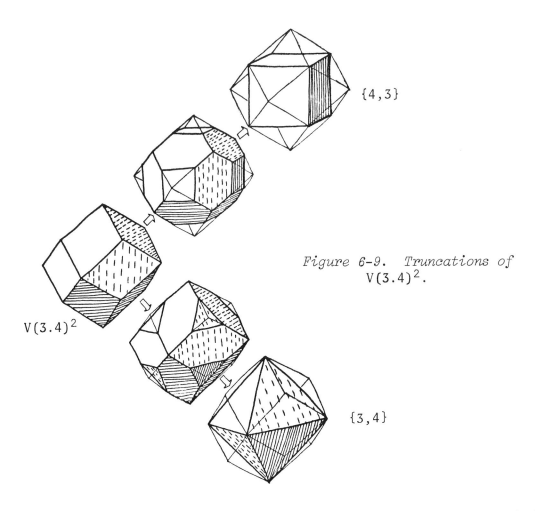

$\{4,3\}$

Figure 6-9. Truncations of
V(3.4)2.

V(3.4)2

$\{3,4\}$

Aggregated Forms. Truncations of aggregated polygons or polyhedra is equivalent to the vertex motion operation. A careful examination of the $\{6,3\}$ plane tessellation (Figure 2-6) reveals that a truncation of the vertices of every $\{6\}$ involves motions of vertices in which 3.12^2 (Figure 2-11) and finally $3.6.3.6$ (Figure 2-9) are generated.

In truncations of aggregated polyhedra, holes or interstices increase in size as the polyhedra are truncated. Because it greatly simplifies perceptions, the crystallographic unit cell is very useful in truncations of aggregated polyhedra. Consider the cubic cell shown in Figure 6-10a. Motions of points from its eight vertices toward the edge bisectors generates 3.8^2 and its distortions (Figure 6-10b and c), then $(3.4)^2$ (Figure 6-10d) as points meet at each edge. Further motions of points from the edge bisectors toward the face centers of the cubic cell generates 4.6^2 and its distortions (Figure 6-10e and f), finally $\{3,4\}$ (Figure 6-10g). Aggregations of these unit cells, combined with vertex motions, can be viewed either as polyhedra packings of various kinds, open aggregations of polyhedra, or connected networks of points. Stretching and distorting

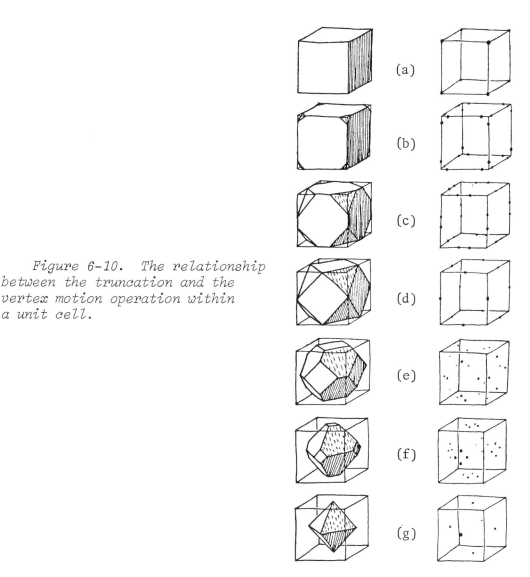

Figure 6-10. *The relationship between the truncation and the vertex motion operation within a unit cell.*

unit cells result in further modifications of form. In vertex motions identical to those in Figure 6-10, performed on aggregated unit cells (Figure 6-11), the same polyhedra are defined within the cells, but new polyhedra are created in the interstices. The first motions generate a 5-connected network of packed {3,4} and 3.8^2 (or its distortions) (Figure 6-11b and c). Continued motions generate the 8-connected network of {3,4} and $(3.4)^2$ (Figure 6-11d). The 4-connected network of 4.6^2 (and their distortions) (Figure 6-11e and f) follows next. Finally, the 8-connected network of {3,4} and $(3.4)^2$ (Figure 6-11g) is generated.

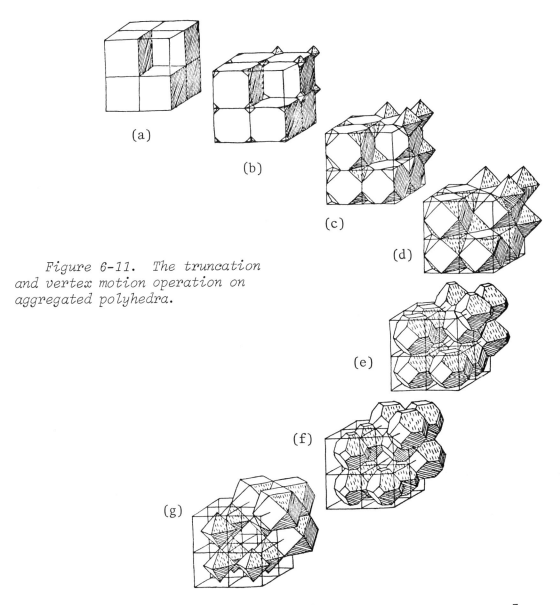

(a)

(b)

(c)

(d)

Figure 6-11. The truncation and vertex motion operation on aggregated polyhedra.

(e)

(f)

(g)

In another transformation of aggregated cells (Figure 6-12),[7] points move from the vertices to the centers of alternating unit cells (Figure 6-12b, c, d, and e). Then another set of points moves from vertices to the same alternating unit cell centers.(Figure 6-12f, g, h, and i). The transformation goes from the 6-connected network of the unit cells themselves to a 4-connected network of truncated $V(3.4)^2$ and $\{4,3\}$ (Figure 6-12c and d), to the 4,8-connected network of packed $V(3.4)^2$ (Figure 6-12e). It then goes to a 4,8-

[7] Guran, M. A. 1969. "Change in Space-Defining Systems," *General Systems*. v. XIV., Society for General Systems Research., pp. 37-49.

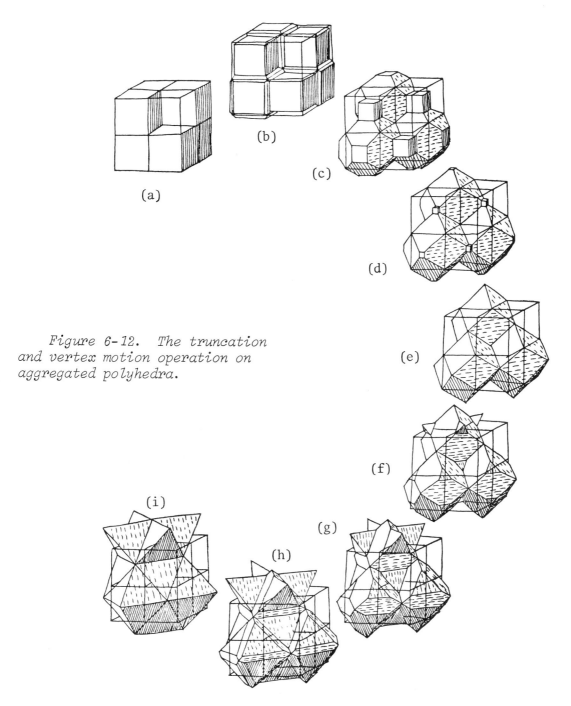

Figure 6-12. The truncation and vertex motion operation on aggregated polyhedra.

connected network of packed {3,3} and truncated $V(3.4)^2$ (Figure 6-12f, g, and h), and finally to the 12-connected network of packed {3,3} and {3,4} (Figure 6-12i).

Similar vertex motions resulting from truncations of aggregated polyhedra in the 5.3.2 symmetry family (Figures 5-30, 5-34, 5-36,

and 5-37) generate other polyhedral aggregations. Many other forms are generated by asymmetric truncations of aggregated polyhedra.[8]

6-5. ROTATION-TRANSLATION

Principles of Rotation-Translation in Two-Dimensions. Generating polygons in tessellations by the *Rotation-Translation* method involves a portion or all of the following:
 (1) Rotation of polygons about their center points.
 (2) Translation of polygons across the plane.
 (3) Maintenance of one connection between two polygons, either at their vertices or by an edge.
 (4) Creation of new faces defined by voids that appear as the polygons rotate and translate.

The operation is generally viewed as an operation on polygons, but can also be viewed as an operation on circles that are centered at vertices of polygons. Consider, for example, Figure 6-13, where the connection of circle centers defines the {4,4} tessellation.

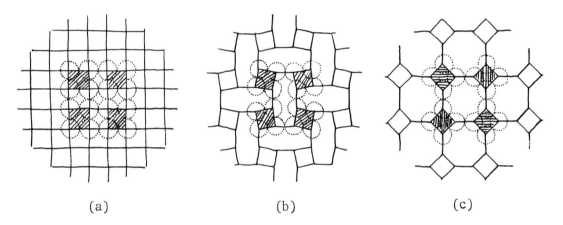

(a) (b) (c)

Figure 6-13. A transformation from the {4,4} tessellation to the 4.8² tessellation by the rotation-translation operation.

Some of the bonds or edges are released as groups of four circles rotate about points at the centers of their respective groups to define the 4.8^2 tessellation (Figure 6-13c). In these cases the crystallographic unit cell is not useful in describing the motions of points because entire tessellations are translated across the plane and the unit cells would have to stretch to accommodate the transformation. While these translations are not apparent in Figure 6-13, they are easily seen in Figure 6-14a, b, and c. Here, tessellation 3.4.6.4 goes to (→) 3.12²; groups of three spheres rotate on and translate

[8] Guran, M. A. *op. cit.*

216

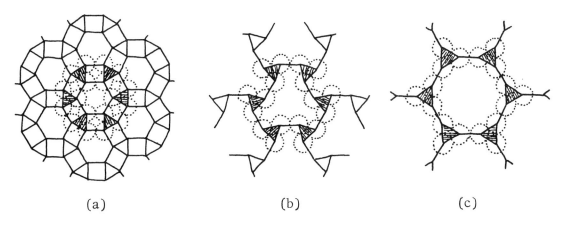

<center>(a) (b) (c)</center>

Figure 6-14. A transformation from the 3.4.6.4 tessellation to the 3.12² tessellation by the rotation-translation operation.

across the plane in a direction radiating from a central {6}. In other operations of this kind: {3,6}↔{4,4}; {3,6}↔{6,3}; {6,3}↔ 3.6.3.6; {3,6}↔3³.4²; {3,3}↔3².4.3.4; 3⁴.6↔3.4.6.4;...

In another kind of two-dimensional rotation-translation operation circles cannot be used to characterize the transformations.[9] Some vertices remain connected, while others disengage to reconnect later in the transformation, as shown in Figure 6-15, where {6,3}↔3.6.3.6.

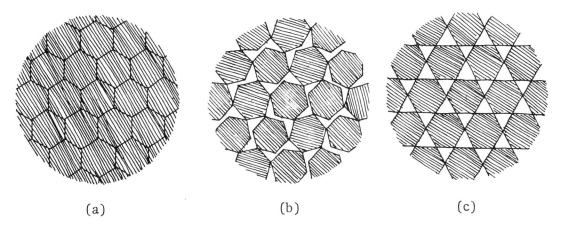

<center>(a) (b) (c)</center>

Figure 6-15. A transformation from the {6,3} tessellation to the 3.6.3.6 tessellation by the rotation-translation operation.

[9] Stuart, D. 1963. "Polyhedral and Mosaic Transformations," *Student Publications of the School of Design.* v. 12, no. 1., Raleigh: North Carolina State of the University of North Carolina., pp. 2-28.

Other transformations where some vertices remain connected include: $\{4,4\} \leftrightarrow 3^2.4.3.4$; $\{3,6\} \leftrightarrow 3.6.3.6$;... In Figure 6-16, $\{3,6\} \leftrightarrow 3^4.6 \leftrightarrow 3.12^2$; none of the vertices of the polygons remain directly connected, but new edges appear as connecting links. Other transformations of this kind include: $\{4,4\} \leftrightarrow 3^2.4.3.4 \leftrightarrow 4.8^2$; $3.6.3.6 \leftrightarrow 3^4.6 \leftrightarrow 3.4.6.4$.

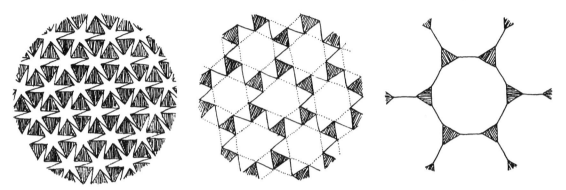

Figure 6-16. A transformation from the $\{3,6\}$ to the $3^4.6$ to the 3.12^2 tessellation by the rotation-translation operation.

Principles of Rotation-Translation in Three-Dimensions. Generating polyhedra by the rotation-translation method involves the following:

(1) Rotation of each face of a polyhedron about an axis that radiates from the center of the polyhedron and passes through the center of the faces, as shown in Figure 6-17a.

(2) Translation of each face along its axis by a motion that holds the face perpendicular to its axis, as shown in Figure 6-17b.

(3) Maintenance of one connection, whether a vertex or a new edge, between two faces.

(4) Creation of new faces defined by voids that appear as the faces rotate on and translate along their respective axes.

Although spheres can sometimes be used in this operation, it is much easier to visualize motions by using polyhedra.[10] Figure 6-18 shows $\{3,4\} \leftrightarrow \{3,5\} \leftrightarrow (3.4)^2 \leftrightarrow \{4,3\}$. In this transformation, $\{3,5\}$ (Figure 6-18d and e) appears as a mid-phase between $\{3,4\}$ (Figure 6-18a) and $(3.4)^2$ (Figure 6-18g). In the illustration, the $\{3\}$ faces

[10] This method of generating polyhedra was pointed out by R. B. Fuller. D. Stuart later formulated the complete theory, expanding it to include an infinite series of polyhedra. The series is a combination of some of the planer transformations on faces of transforming polyhedra. See: Stuart, D. *op. cit.*

Figure 6-17. (a) the rotation of a face of {4,3} on its axis,
(b) the translation of the face along its axis combined with a
rotation on its axis.

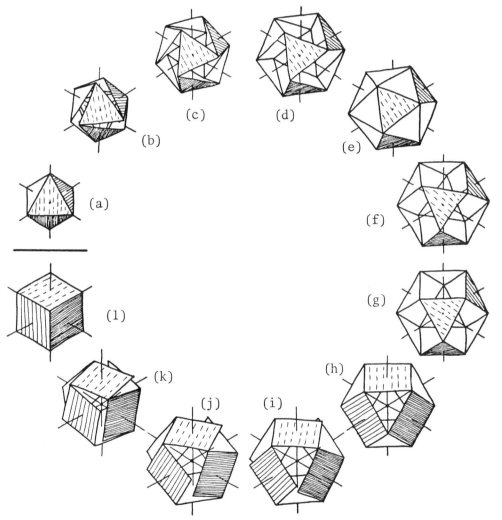

Figure 6-18. The rotation-translation operation on {3,4} (a),
to generate {3,5} (e), (3.4)2 (g and h), and {4,3} (l).

of the polyhedron are removed at the $(3.4)^2$ phase (Figure 6-18g), and {4} faces are positioned in the polyhedron (Figure 6-18h); then $(3.4)^2$ $\leftrightarrow\{4,3\}$. Figure 6-19 shows $\{4,3\}\leftrightarrow3^4.4\leftrightarrow4.6^2$. In this transformation the vertices of the six {4} faces are connected by edges which, in turn, rotate on and translate along their respective axes.

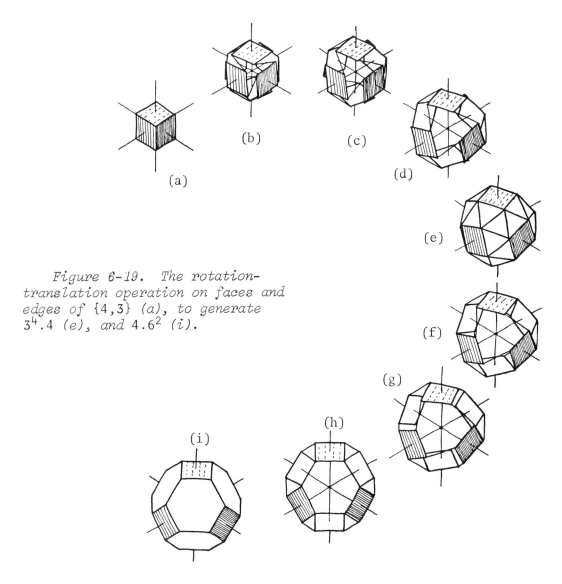

Figure 6-19. The rotation-translation operation on faces and edges of {4,3} (a), to generate $3^4.4$ (e), and 4.6^2 (i).

In generating all of the regular and eleven of the thirteen semi-regular polyhedra, three polyhedra appear as mid-phases in the operations: $\{3,5\}$, $3^4.4$, and $3^4.5$. Each of these polyhedra is con-

sidered central to a group of generated polyhedra.[11] By using the
principles of the rotation-translation operation it is possible to
generate one polyhedron from another in a continuous series. However,
it is not feasible to present the details of every operation here.
We do show the polyhedra that result from the operations and the
manner in which these polyhedra relate to one another.

The {3,5} Group. Figure 6-20 shows the polyhedra generated in
the {3,5} group. The {3,5} is the mid-phase between: $(3.5)^2$ and
3.10^2; {3,3} and 3.6^2; {3,4} and $(3.4)^2$. The {3,3} also generates
directly into {3,4}. The transformation shown in Figure 6-18a
through g is in this group, where {3,5} can be seen as the mid-phase
between {3,4} and $(3.4)^2$. In this group {3,3}, {3,4}, $(3.4)^2$, and
3.6^2 are space-filling polyhedra in the 4.3.2 symmetry family. The
other polyhedra, belonging to the 5.3.2 symmetry family, are not
space fillers.

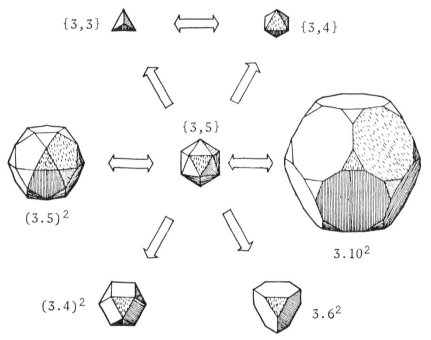

Figure 6-20. Polyhedra generated in the {3,5} Group by the
rotation-translation operation.

[11] Except for 4.6.8 and 4.6.10, all of the regular and the semi-
regular polyhedra can be generated by the rotation-translation oper-
ation. The $3^4.4$ and $3^4.5$, which are not easily generated by the trun-
cation operation, are central to two of the three groups in the rota-
tion-translation operation. The Archimedean duals are not generated
by this method.

The $3^4.4$ Group. The polyhedra generated in this group are shown in Figure 6-21. The $3^4.4$ is the mid-phase between: $\{3,4\}$ and 3.8^2; $(3.4)^2$ and 3.4^3; $\{4,3\}$ and 4.6^2. The $(3.4)^2$ also generates directly into $\{4,3\}$, as shown in Figure 6-18h through l. In this group all of the polyhedra except $3^4.4$ pack to fill space and belong to the 4.3.2 symmetry family. Details of the transformation from $\{4,3\}$ to 4.6^2 are shown in Figure 6-19.

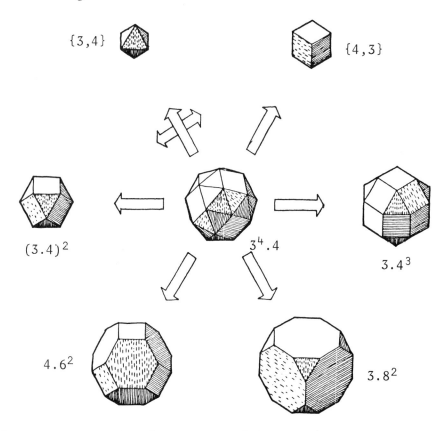

$\{3,4\}$

$\{4,3\}$

$(3.4)^2$

$3^4.4$

3.4^3

4.6^2

3.8^2

Figure 6-21. Polyhedra generated in the $3^4.4$ Group by the rotation-translation operation.

The $3^4.5$ Group. The polyhedra in this group are shown in Figure 6-22. The $3^4.5$ is the mid-phase between: $\{3,5\}$ and 3.10^2; $\{5,3\}$ and 5.6^2; $(3.5)^2$ and 3.4.5.4. The $\{5,3\}$ also generates directly into $(3.5)^2$. None of the polyhedra in this family are space-filling polyhedra and all belong to the 5.3.2 symmetry family.

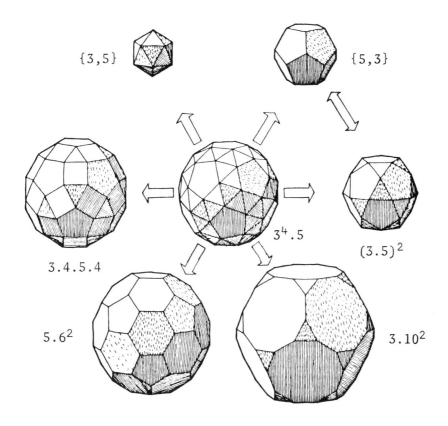

Figure 6-22. Polyhedra generated in the $3^4.5$ Group by the rotation-translation operation.

Operations on Aggregated Polyhedra. Because some of the poly-hedra generated by the rotation-translation operation are space-filling polyhedra, it is possible to perform the operation on aggre-gated polyhedra. An examination of Figure 6-23 reveals that this operation is equivalent to the vertex motion operation; motions of vertices within unit cells transform aggregations of $(3.4)^2$ into $\{3,5\}$ and finally into $\{3,4\}$, by rotations and translations of their faces. The voids among groups of $\{3,4\}$ are $(3.4)^2$ (Figure 6-23e). These interstitial polyhedra undergo similar transformations, first into $\{3,5\}$ (Figure 6-23c), and finally into $\{3,4\}$ (Figure 6-23a), as the polyhedra in the unit cells undergo their respective changes.

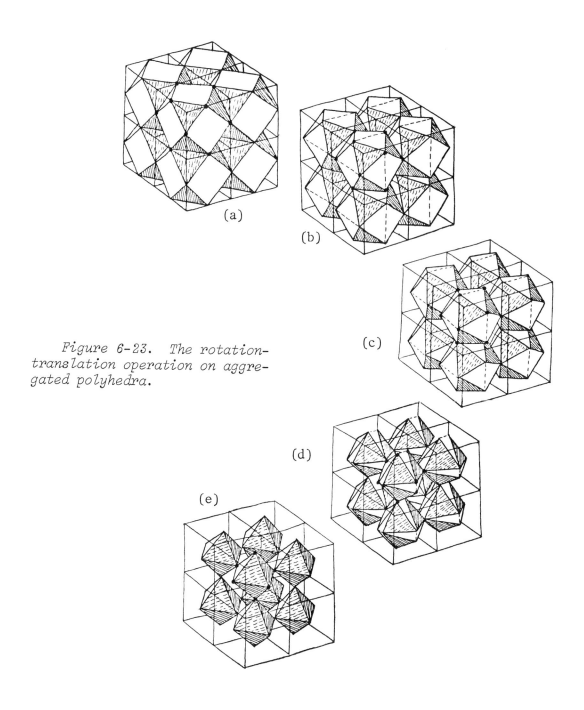

(a)

(b)

(c)

(d)

(e)

Figure 6-23. The rotation-translation operation on aggregated polyhedra.

6-6. AUGMENTATION-DELETION

In a simple sense the *Augmentation-Deletion* operation involves either the addition or subtraction of vertices, edges, and faces on existing entities. This is done symmetrically or randomly. For example, Figure 6-24 shows two {4,4} tessellations with edges removed in various ways to generate new forms. Figure 6-25 shows $3^2.4.3.4$

with vertices added or subtracted in various combinations within unit cells to generate a variety of new formations of polygons.

Figure 6-24. Tessellations derived by deletion of certain edges and vertices in the {4,4} tessellation.

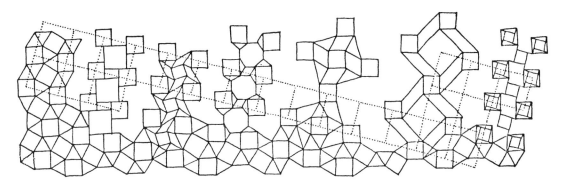

Figure 6-25. The $3^2.4.3.4$ tessellation with augmented or deleted edges and vertices to generate new tessellations.

Single Edge Development on Individual Polyhedra. A group of forms consisting of an infinite number of solids with curved or saddle faces was discovered recently.[12] With the exception of two, these solids seem to occupy a transitional position between the stellated and the simple polyhedra. In other words, they are in the class of polyhedra because they divide space into two parts. Although not made of star polygons, they are in a sense stellated; and, although made of regular *saddle* polygons, they cannot be deformed into a sphere without a change in topological properties (with the exception of two cases).

[12] For an extensive documentation of these forms, see: Burt, M. 1966. *Spacial Arrangement and Polyhedra with Curved Surfaces and their Architectural Applications*. Haifa: Israel Institute of Technology. See also: Pearce, P. 1966. *Synestructics*. A Report to the Graham Foundation.

For the most part, these solids can be generated by the use of the augmentation-deletion operation. Consider, for example, the spherical {3,3}, shown in Figure 6-26a. If six new vertices are added at the six edge bisectors, then connected to the existing four vertices by straight lines, a solid with four saddle hexagon faces is generated (Figure 6-26b). This solid has six vertices made from two edges, and four vertices made from three edges. In a polyhedron, a *vertex* is defined by a minimum of three edges. In saddle solids, the vertices made from two edges are considered *false vertices*. When the

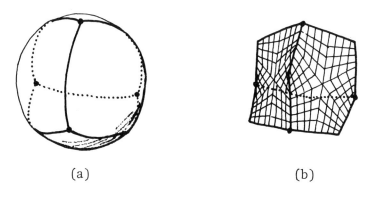

(a) (b)

Figure 6-26. (a) the spherical {3,3}, (b) the corresponding saddle solid, s{3,3}.

saddle solid (Figure 6-26) is deformed onto a sphere, it changes topologically from a form with ten vertices, twelve edges, and four faces to a form with four vertices, six edges, and four faces. Because of the topological change, this saddle solid and others like it are not simple polyhedra.

Seven polyhedra with regular faces have equivalent vertices and equivalent dihedral angles. They are: {3,3}, {4,3}, {3,4}, {3,5}, {5,3}, $(3.4)^2$, and $(3.5)^2$. (See Chapter 3.) A saddle solid is generated from each of these seven polyhedra by bisecting edges and pulling the false vertices onto the surface of the circum-sphere of the polyhedron. Saddle solids derived in this manner are given the symbol of their topological equivalent preceded by an *s*. The solid in Figure 6-26 has the symbol s{3,3}. Figures 6-27 through 6-30 show saddle solids s{4,3}, s{3,4}, s{5,3}, and s{3,5}, respectively. In Figure 6-30 we see another interesting feature of saddle solids: As the false vertices are added to a polyhedron, they are positioned at the vertices of another polyhedron. In the case of s{3,5} (Figure 6-30), the false vertices are those of $(3.5)^2$.

Single edge development of the quasi-regular polyhedra, $(3.4)^2$ and $(3.5)^2$, generate saddle solids with two kinds of saddle faces. A portion of $s(3.5)^2$ is shown in Figure 6-31 along with the generating polyhedra, $(3.5)^2$ and 3.4.5.4. Table 6-1 gives data on saddle solids generated by single edge development of the seven polyhedra.

226

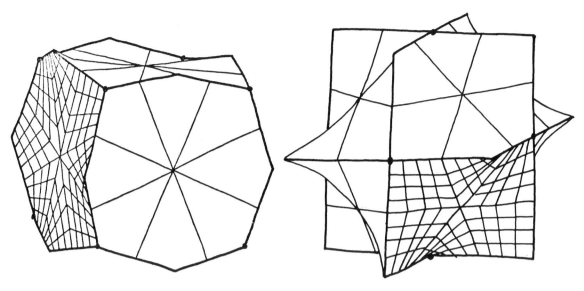

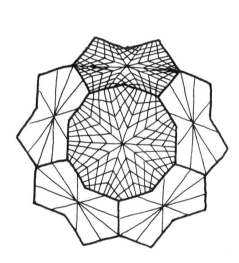

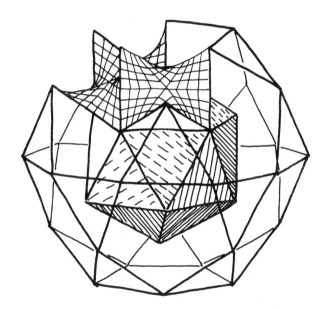

Figure 6-27. The saddle
solid s{4,3}.

Figure 6-28. The saddle
solid s{3,4}.

Figure 6-29. The saddle
solid s{5,3}.

Figure 6-30. A portion of
the saddle solid s{3,5} and the
polyhedra that define its vertices.

227

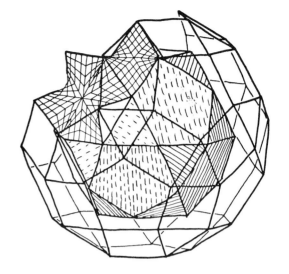

Figure 6-31. A portion of saddle solid $s(3.5)^2$ *and the polyhedra that define its vertices.*

Figure 6-1. SADDLE SOLIDS WITH REGULAR SADDLE FACES GENERATED
BY SINGLE EDGE DEVELOPMENT

SADDLE SOLID	TOPOLOGICAL EQUIVALENCE	SADDLE FACES (No.)	SADDLE FACES (KIND)	FALSE VERTICES DEFINED BY
$s\{3,3\}$	$\{3,3\}$	4	6	$\{3,4\}$
$s\{4,3\}$	$\{4,3\}$	6	8	$(3.4)^2$
$s\{3,4\}$	$\{3,4\}$	8	6	$(3.4)^2$
$s\{5,3\}$	$\{5,3\}$	12	10	$(3.5)^2$
$s\{3,5\}$	$\{3,5\}$	20	6	$(3.5)^2$
$s(3.4)^2$	$(3.4)^2$	8	6	3.4^3
		6	8	
$s(3.5)^2$	$(3.5)^2$	12	10	$3.4.5.4$
		20	6	

<u>Double Edge Development on Individual Polyhedra</u>. Seven addit-
ional solids are generated by double development of edges of the
seven polyhedra listed above. Each edge is replaced by two new edges
such that, in addition to the original polygons, digons appear on
the polyhedron. The edges are then bisected and produced (or devel-
oped) until a solid with saddle squares and saddle p-gons is gener-
ated. Figure 6-32 shows an example of a saddle solid generated by
double edge development. It is derived from $\{3,3\}$, and is composed
of six saddle squares and four saddle hexagons. It is topologically
equivalent to a polyhedron with four triangles and six digons, in
which three digons and three triangles meet at a vertex. Saddle
solids in this group have the symbol $s(p.p)^q$. The solid in Figure

228

6-32, therefore, has the symbol $s(2.3)^3$. Table 6-2 gives data on the seven solids generated by double edge development.

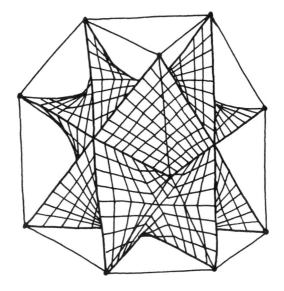

Figure 6-32. The saddle solid $s(2.3)^3$.

Table 6-2. SADDLE SOLIDS WITH REGULAR SADDLE FACES GENERATED BY DOUBLE EDGE DEVELOPMENT

SADDLE SOLID	GENERATED FROM	TOPOLOGICAL EQUIVALENCE	NUMBER & KIND OF FACES	FALSE VERTICES DEFINED BY
$s(2.3)^3$	$\{3,3\}$	$(2.3)^3*$	6-4; 4-6	3.6^2
$s(2.4)^3$	$\{4,3\}$	$(2.4)^3*$	12-4; 6-8	4.6^2
$s(2.3)^4$	$\{3,4\}$	$(2.3)^4*$	12-4; 8-6	3.8^2
$s(2.5)^3$	$\{5,3\}$	$(2.5)^3*$	30-4; 12-10	5.6^2
$s(2.3)^5$	$\{3,5\}$	$(2.3)^5$	30-4; 20-6	3.10^2
$s(2^4.3^2.4^2)$	$(3.4)^2$	$2^4.3^2.4^2*$	24-4; 8-6; 6-8	
$s(2^4.3^2.5^2)$	$(3.5)^2$	$2^4.3^2.5^2*$	60-4; 20-6; 12-10	

* It is not possible to construct this polyhedron from planar faces, but it can be constructed as a spherical surface.

In addition to the fourteen saddle solids with regular faces, there are two infinite groups of saddle solids that are roughly analogous to the prisms and di-pyramids described in Chapter 3. The solids of one group are composed of saddle squares. Examples are shown in Figure 6-33. These solids are topologically equivalent to a covering of a sphere with digons whose edges meet at polar vertices. The solids of the second group, the *prismatic Crown-bodies*, are

composed of: (1) a pair of saddle p-gons, where p is even and ≥ 4; and (2) $p/2$ saddle 4-gons. Two examples are shown in Figure 6-34. The latter group is topologically equivalent to covering a sphere with two $p/2$-gons and $p/2$ digons.

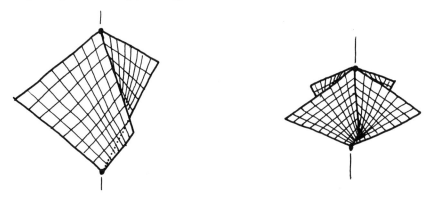

Figure 6-33. Examples of saddle solids composed of saddle 4-gons.

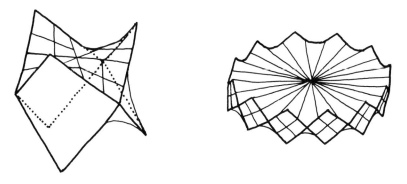

Figure 6-34. Examples of the prismatic Crown-bodies.

<u>Saddle Polyhedra</u>. Relaxing condition (1) of the five conditions for polyhedra regularity in Chapter 3, such that regular saddle polygons are admitted, generates no new polyhedra. Therefore, there are no regular polyhedra with saddle faces. By relaxing conditions (1) and (4), admitting two kinds of vertices, two polyhedra with saddle polygons are possible (Figure 6-35). These are the only simple polyhedra in the group of saddle solids. The first, $sV(3.4)^2$ (Figure 6-35a), is composed of twelve saddle square faces; it is topologically equivalent to $V(3.4)^2$. Its vertices are the vertices of $\{3,4\}$ and $\{4,3\}$. The second, $sV(3.5)^2$ (Figure 6-35b), is composed of thirty saddle square faces; it is topologically equivalent to $V(3.5)^2$. Its vertices are vertices of $\{3,5\}$ and $\{5,3\}$. (This polyhedron also has re-entrant vertices, which are not usually admitted into families of regular or semi-regular polyhedra.)

230

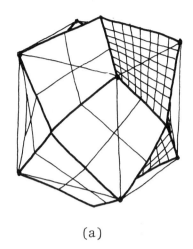
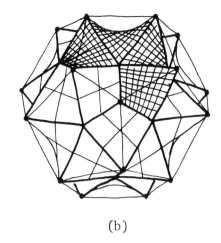

<div align="center">

(a) (b)

</div>

Figure 6-35. (a) the saddle polyhedron, $sV(3.4)^2$; (b) the saddle polyhedron, $sV(3.5)^2$.

These two polyhedra close the set of individual saddle solids and polyhedra in which the saddle polygons are regular. It should be noted that a saddle polygon is regular when its angles are congruant, and its edges are equal. Unlike a planar regular polygon, which has definite face angles, there are many angles possible for each regular saddle p-gon. Therefore, regular saddle p-gons, although they have the same angles in a specific saddle solid, do not necessarily have the same angles when they appear in various saddle solids and polyhedra.[13]

Networks. A *network*[14] is a set of points connected by lines. A network is considered *uniform* if every shortest path or circuit leading from a vertex passes through the same number of congruent edges to return to the starting point. A network is *regular* if, at each vertex, the same number of congruent edges meet at the same angles.

Generating networks in two-dimensions is a process of aggregating polygons. This is discussed in Chapter 2. The uniform networks in

[13] Many other individual saddle solids with non-regular saddle faces can be generated by these operations on semi-regular polyhedra.

[14] For extensive work on networks, saddle solids, and their relation to crystal structures, see: Wells, A. F. "The Geometrical Basis of Crystal Chemistry," *Acta Cryst.*, Part I. 1954. v. 7, pp. 535-544; Part II. 1954. v. 7, pp. 545-554; Part III. 1954. v. 7, pp. 842-848; Part IV. 1954. v. 7, pp. 849-853; Part V. 1955. v. 8, pp. 32-36; Part VI. 1956. v. 9, pp. 23-28; Part VII. 1963. v. 16, pp. 857-871 (with R. R. Sharpe); Part VIII. 1965. v. 18, pp. 894-900; Part IX. 1968. v. B24, pp. 50-57; Part X. 1969. v. B25, pp. 1711-1719.

two-dimensions are {3,6}, {4,4}, and {6,3}; they are 6-connected, 4-connected, and 3-connected, respectively.

In three-dimensions, networks are generated in a number of ways:

(1) Polyhedra can be aggregated, and their vertices and edges are considered networks. Examples are shown in Chapter 5. Only one three-dimensional network of planar polygons is uniform. This is the space-filling aggregation of {4,3} (Figure 5-1).

(2) Groups of two-dimensional tessellations can overlap in different planes (Figure 6-36), and have new edges connecting vertices between planes, as in Figure 6-37. A large variety of aggregated planar polyhedra can be generated in this way using the tessellations in Chapter 2, as well as others.[15]

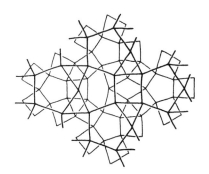

Figure 6-36. Overlapping planar tessellations.

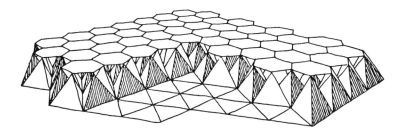

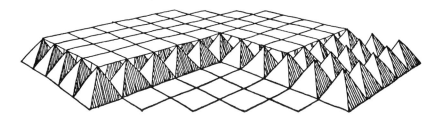

Figure 6-37. Examples of polyhedra generated by overlapping planar tessellations with vertices connected between planes.

[15] Borrego, J. 1968. *Space Grid Structures*. Cambridge, Mass.: M. I. T. Press; Makowski, Z. S. 1965. *Steel Space Structures*. London: Michael Joseph.

(3) Vertices in a plane tessellation can be pulled out of the
 plane and connected to vertices of tessellations in other
 planes; or, new vertices can be added to a plane tessell-
 ation, pulled out of the plane, and connected to vertices in
 similar tessellations in other planes. This method generates
 aggregated saddle solids.

From Chapter 2 we observed that plane p-gons can be changed to
skew p-gons by pulling every other vertex into a new plane; further,
these p-gons change to saddle polygons when a continuous curved sur-
face fills the interior region of the polygon. This can be done only
where p is even. All of the two-dimensional **tessellations** in which
every p is even can generate saddle tessellations of this kind. An
example of the {6,3} saddle tessellation is shown in Figure 6-38.

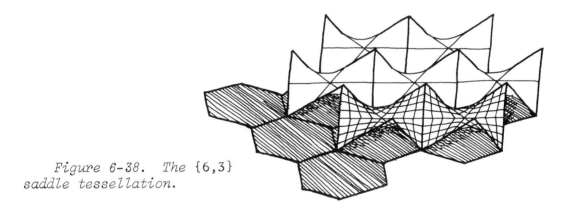

*Figure 6-38. The {6,3}
saddle tessellation.*

A 4-connected uniform network defining aggregations of the
saddle solid s{3,3} is generated by taking planar layers of the {6,3}
tessellation (Figure 6-39a), connecting layers of opposite verti-
ces by edges (Figure 6-39b), and pulling the vertices out of their re-
spective planes (Figure 6-39c). Figure 4-2 shows this network and
its corresponding saddle solid generated from sphere packings.
Another 4-connected network is generated by planar layers of the
{4,4} tessellation, where each vertex of one layer falls above the
center of a {4} in the layer above and the layer below. The edge
bisectors of the tessellations are then directly above one another.
Connecting all of the bisecting points between layers generates the
4-connected network shown in Figure 6-40. This network defines
space-filling aggregations of saddle solid s{3,4} (Figure 6-28).
Similar vertex, edge bisector, edge trisector, etc., connections be-
tween layers of two-dimensional n-connected networks can generate an
endless variety of networks and polyhedral aggregations. They can
have a *singular connection mode* as those just discussed, or they
can have *multiple connection modes*. For the singular connection
mode, the connections are $3 \geq n \leq 12$. The 12-connected network de-

fines aggregations of {3,3} and {3,4}, as shown in Figure 5-9. An increase in modes of connection to two or more greatly increases types of networks and packing configurations. An important 4,8-connected network is defined by aggregations of $V(3.4)^2$, shown in Figure 5-4.

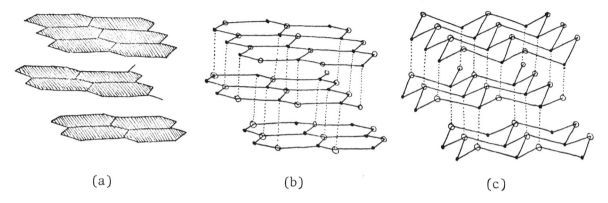

(a) (b) (c)

Figure 6-39. (a) planar layers of the {6,3} tessellation; (b) vertices interconnected between layers; (c) edges and vertices pulled out of their respective planes to form the uniform 4-connected network defining aggregations of saddle solid s{3,3}.

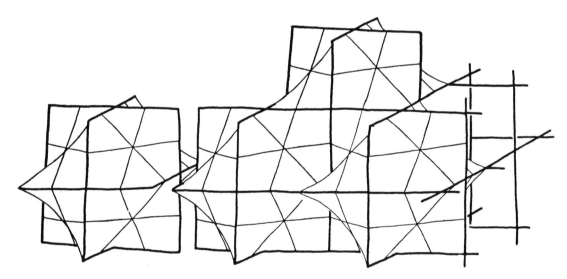

Figure 6-40. The space-filling aggregation of saddle solid, s{3,4}.

Three-dimensional 3-connected networks are generated by subdividing edges of planar 3-connected networks and joining the new vertices (which are 2-connected) to similar vertices in other layers of 3-connected networks. For example, in Figure 6-41a two edges of each

{6} are trisected by new vertices. One set of vertices (∘) is connected to a set of similar vertices (∘) in a plane above, while the other set (•) is connected to a similar set (•) below. The three-dimensional 3-connected network is then stretched until all of the edges are congruent, and all of its juncture angles are identical.

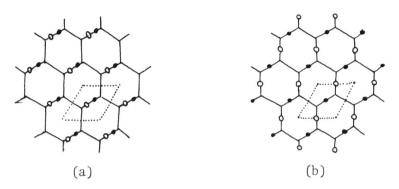

(a) (b)

Figure 6-41. The formations of new vertices on planar 3-connected networks.

Figure 6-42 shows the resulting network defining aggregations of saddle solids, each with four saddle 10-gons. Similar operations on Figure 6-41b will generate the network in Figure 6-43. This space-filling saddle solid is made with three saddle 10-gons in another form.[16]

Figure 6-42. A three-dimensional 3-connected network defining aggregations of saddle solids, each with four saddle 10-gons.

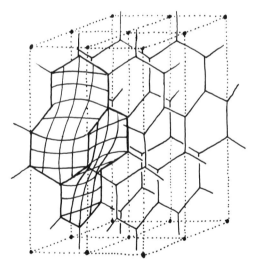

[16] Wells, A. F. 1955. *op. cit.*

235

Figure 6-43. A three-dimensional 3-connected network defining aggregations of saddle solids, each with three saddle 10-gons.

By creating new vertices in other arrangements on layers of two-dimensional 3-connected networks and interconnecting the layers, it is possible to generate many other three-dimensional 3-connected networks. Some of them define saddle solids with more than one kind of saddle face, as shown in Figure 6-44; while others define saddle solids with both planar and saddle faces, as shown in Figures 6-45 and 6-46. Figure 6-45 is a 3-connected network that defines saddle solids with four planar 6-gons, four saddle 6-gons, and four saddle 12-gons. The planar-saddle solid defined by the 3-connected network in Figure 6-46 is a truncated form of the saddle solid, $s(3.4)^2$, shown in Figures 6-28 and 6-40.

An example of a three-dimensional 6-connected network is the aggregation of $\{4,3\}$, shown in Figure 5-1. Another 6-connected network can be generated by an aggregation of saddle solid $s(2.3)^3$, as shown in Figure 6-47. In contrast to the uniform network of $\{4,3\}$, this network has circuits of both 4-gons and 6-gons from each vertex.

Only four of the saddle solids discussed in Figures 6-26 through 6-35 are space fillers when packed with identical solids: $s\{3,3\}$, $s(3.4)^2$, $s(2.3)^3$, and $s2^4$ (Figure 6-34).

Figure 6-44. A three-dimensional 3-connected network and its corresponding saddle solid.

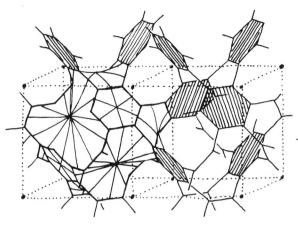

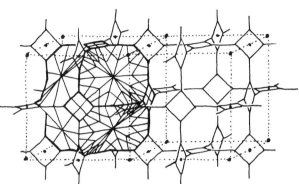

Figure 6-45. A three-dimensional 3-connected network and its corresponding planar-saddle solid.

Figure 6-46. A three-dimensional 3-connected network and its corresponding planar-saddle solid.

Figure 6-47. A three-dimensional 6-connected network generated by an aggregation of saddle solid, $s(2.3)^3$.

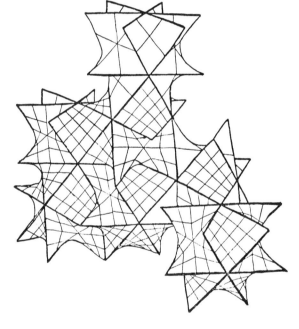

6-7. FISTULATION

In the *fistulation* operation, continuous interwoven cavities or tunnels divide space into two or more parts. This is accomplished in two ways.

Dilation of Network Edges and Vertices. In this operation the edges that define an n-connected network in two- or three-dimensions can be expanded or tunnelled to generate a continuous space within. In Figure 6-48, for example, vertices and edges of the uniform 4-connected network (see Figure 4-2) are shown in regular and dilated form.. The dilated network, if infinite, divides space into two parts: that within the edges and that outside the edges. In this operation the topological unit cell (see Chapter 2) is the basic element, since it is the simplest repeatable form in a network. The topological unit cell becomes a polyhedron when it is removed from a dilated network. Its surface can also be divided into saddle polygons of various kinds.[17]

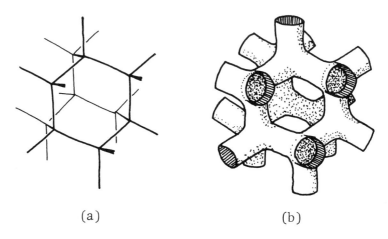

(a) (b)

Figure 6-48. (a) the uniform three-dimensional 4-connected network, (b) the same network with its edges dilated.

Polygonal Aggregations. From Chapter 2 we know that not more than six {3}, four {4}, and three {6} can aggregate about a point without overlapping. However, greater numbers of {p} can be aggregated about a point if they are allowed to move out of the plane; four {6} and six {6} can do this. Groups of aggregated {6} make an *infinite skew polyhedron*; i.e., an infinite polyhedron (in the sense of infinite n-connected networks) made of {p}, dividing space into two parts.[18] Groups of {6}, four at a vertex, are identical to an infinite packing of 4.6^2 (Figure 5-2), with all {4} faces removed. Groups of {6}, six at a vertex, are identical to an infinite aggregation of {3,3} and

[17] Wells, A. F. 1963 and 1969. *op. cit.*

[18] Coxeter, H. S. M. 1937. "Regular Skew Polyhedra in Three and Four Dimensions, and Their Topological Properties," *Proc. Lon. Math. Soc. (2).* v. 43, pp. 33-60.

3.6^2 (Figure 5-10a), with all {3} faces removed. The third regular skew polyhedron is made of groups of {4}, six at a vertex. This polyhedron is equivalent to the 6-connected network defining aggregated {4,3} with the faces of every other {4,3} covered. These are the only regular skew polyhedra.

Semi-regular skew polyhedra can also be generated by aggregating two or more kinds of {p} at a vertex, such that their combined vertex angle is > 2π. Figure 6-49 shows an example of a semi-regular skew polyhedron.[19] If the polygonal surfaces of this skew polyhedron can be replaced by curved surfaces, it would then be identical to a dilation of the 6-connected network that defines aggregated {4,3}.

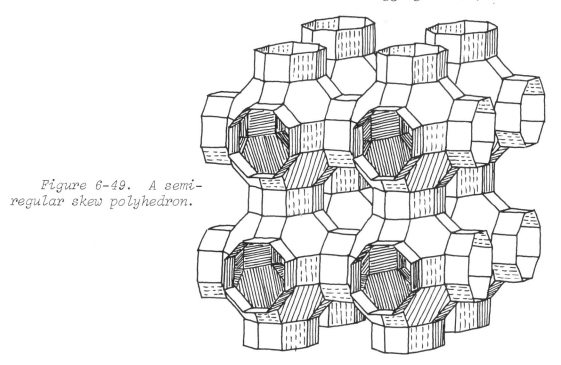

Figure 6-49. A semi-regular skew polyhedron.

Regular and semi-regular skew saddle polyhedra are also possible Figure 6-50 shows a few examples of saddle polygons that can be aggregated to form these infinite polyhedra. An example of a skew saddle polyhedron is shown in Figure 6-51.[20]

[19] Wells, A. F. 1969. *op. cit.*

[20] Burt, M. *op. cit.* The works of sculptors Erwin Hauer and Norman Carlberg (circa 1955) are tunnelled structures made from saddle polygons. See: Burnham, J. 1970. *Beyond Modern Sculpture.* New York: George Braziller, Inc.

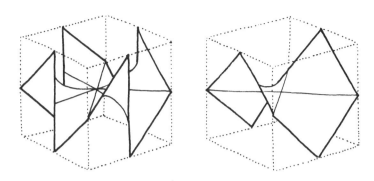

Figure 6-50. Saddle polygons generated by various bisections of the edges of {4,3}.

Figure 6-51. An example of a skew saddle polyhedron.

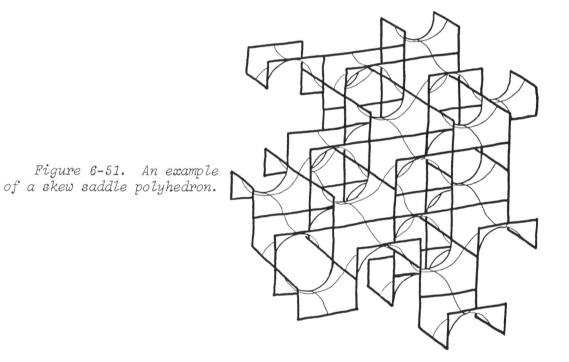

6-8. DISTORTION

The *distortion* operation consists of expanding, contracting, twisting, flattening, and stretching polygons and polyhedra, either in isolation or in aggregation. Figure 6-52 shows examples of simple distortions of aggregated hexagons; Figure 6-53 shows simple distortions of 4.6^2.[21]

[21] Wood, D. G. 1968. *op. cit.*

240

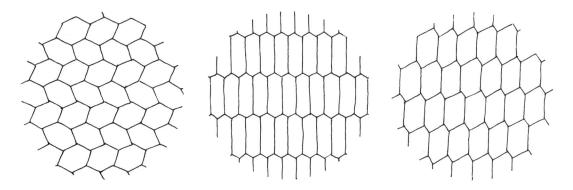

Figure 6-52. Simple distortions of the {6,3} tessellation.

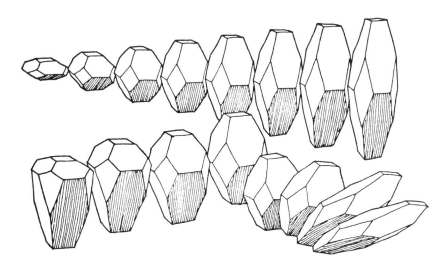

Figure 6-53. Examples of simple distortions of 4.6^2.

A special kind of distortion involves *zonagons* and *zonahedra*.[22] A zonagon is a p-gon, where p is even, and there are $p/2$ pairs of parallel edges. A zonahedron is a polyhedron made of zonagons. The {8}, shown in Figure 6-54, is a zonagon. It can be stretched or contracted along axes parallel to pairs of parallel edges, as shown in Figure 6-54b through d. Aggregated zonagons can be distorted in the same manner, as in Figure 6-55. Zonahedra, either isolated or aggregated, can also be distorted. Figure 6-56 shows the zonahedron 4.6.8 stretched in one on its zones. In these distortions, neither the face nor the dihedral angles change.

[22] Chilton, B. L. and H. S. M. Coxeter. 1963. "Polar Zonahedra," *Am. Math. Monthly*. v. 70, no. 9, pp. 946-951; Coxeter, H. S. M. 1963. *Regular Polytopes*. New York: Dover, pp. 255-258.

<p style="text-align:center;">(a) (b) (c) (d)</p>

Figure 6-54. Examples of stretching an individual zonagon.

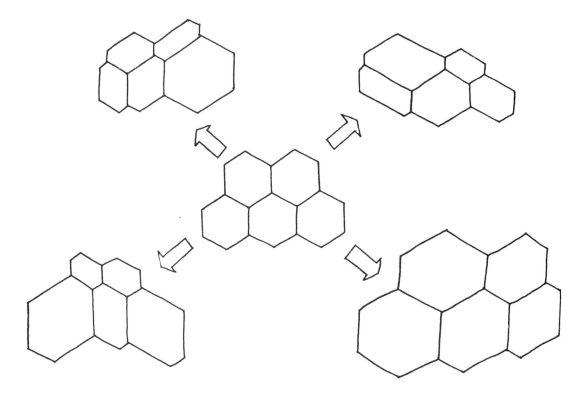

Figure 6-55. Examples of stretching aggregated zonagons.

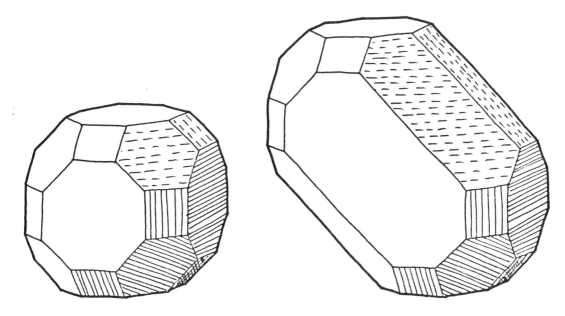

Figure 6-56. The zonahedron, 4.6.8, stretched in one of its zones.

Polyhedra such as 3.8^2 (Figure 6-57a) can be considered *partial zonahedra*, since some of the faces are zonagons. In Figure 6-57b and c, we see 3.8^2 contracted along a zone, resulting in a polyhedron composed of {3}, {8}, and hexagons. This polyhedron will fill space with {3,4}.

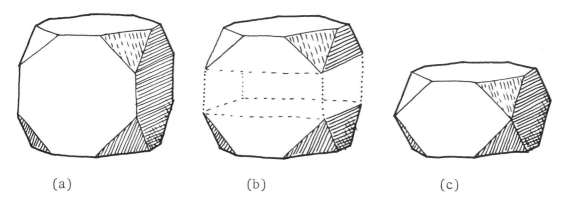

(a) (b) (c)

Figure 6-57. A partial zonahedron contracted in one of its zones.

All polyhedra can be expanded by separating edges and pulling faces away from the center of the polyhedron, thereby allowing new faces to appear. Some of the Archimedean semi-regular polyhedra can be derived from regular polyhedra in this manner. For example, Figure 6-58 shows {4,3} expanded to generate 3.4^3. Figure 6-59 shows

V(3.4)2 expanded in this way, thereby generating a polyhedron with twelve rhombi, thirty {4} or rectangles, and eight {3} or triangles. The generated polygons in any of these polyhedra can be {p}, but they can also be stretched into other distorted forms.[23]

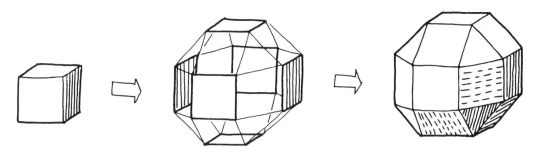

Figure 6-58. The expansion of {4,3} to generate 3.4^3.

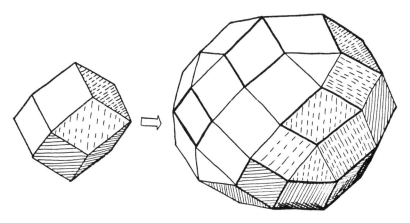

Figure 6-59. The expansion of V(3.4)2 to generate a larger polyhedron.

6-9. DISSECTION

We have dealt somewhat with *dissection* in Chapters 4 and 5, where polyhedra were broken down into component polyhedra of 'A' or 'B' orthoschemes. In general, any space-filling polyhedron can be dissected into component polyhedra that can re-combine to make other space-filling polyhedra. The possibilities are endless. Figure 6-60

[23] Baer, S. 1968. *Dome Cookbook*. Corrales, New Mexico: The Lama Foundation, pp. 31-35.

shows various dissections of {4,3}; all space-filling polyhedra.[24] Some of these polyhedra can be re-combined to generate familiar polyhedra. Eight of the forms generated in Figure 6-60b can combine to define 4,6^2, as shown in Figure 6-61a. Eight of the forms generated in Figure 6-60d combine to define V(3.4)2. Combining four of the forms generated in Figure 6-60g defines {3,4}.

In dissections of stacked {4,3}, a space-filling octahedron can be generated (Figure 6-62a); it can be further dissected into four space-filling tetrahedra (Figure 6-62b). (See Table 5-1 for volumes.) Six of these octahedra, or twenty-four of these tetrahedra can combine to generate V(3.4)2 (Figure 6-62c).

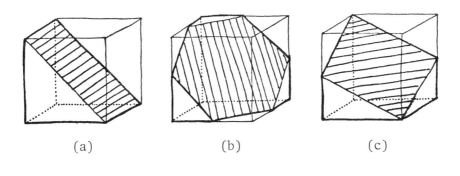

 (a) (b) (c)

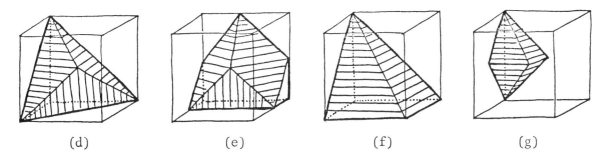

 (d) (e) (f) (g)

Figure 6-60. Dissections of {4,3}.

[24] Ehrenfeucht, A. 1964. *The Cube Made Interesting*. New York: Macmillan Co., Many polygons, including {p} can be dissected and re-assembled to generate other polygons. See: Lindgren, H. *Recreational Problems in Geometric Dissections*. New York: Dover.

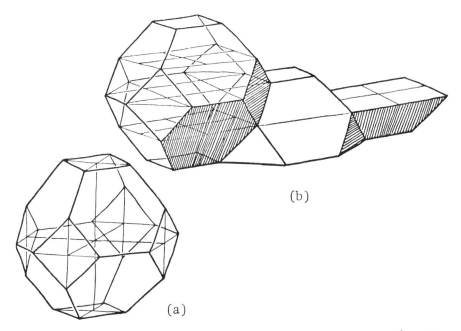

Figure 6-61. (a) an orthogonal dissection of 4.6²; (b) horizontal
dissections of 4.6² generating other space-filling polyhedra.

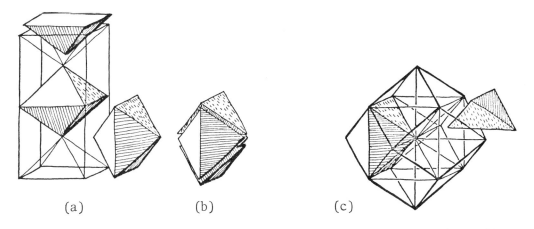

Figure 6-62. (a) a space-filling octahedron generated by dissect-
ions of aggregated {4,3}; (b) space-filling tetrahedra generated by
dissections of the space-filling octahedra; (c) the space-filling
octahedra and tetrahedra as they relate to V(3.4)².

Any group of aggregated polyhedra (see Chapter 5) can be system-
atically dissected by parallel cuts through the aggregation. By
careful inspection of a polyhedron (or an aggregation of polyhedra)
in various orientations, the positions of the parallel slices can be
determined. We see, for example, 4.6² resting on {4} in Figure 6-61.
Horizontal planes can be placed in a number of convenient positions,

and new space-filling polyhedra are generated. In Figure 6-63, 4.6^2 is resting on {6}. New horizontal slices generate another group of space-filling polyhedra.[25]

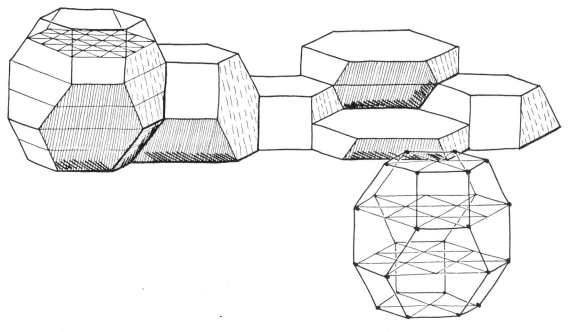

Figure 6-63. Horizontal dissections of 4.6^2, which generate other space-filling polyhedra.

6-10. SYMMETRY INTEGRATION

In *symmetry integration*, forms are combined in ways that may not be readily apparent by an analysis of face angles, dihedral angles, and the like. Naturally grown crystals demonstrate properties of integrated symmetries called *twinning*; this results from two or more crystals growing in close proximity. As the growth surfaces of in-dividual crystals meet, new planes are defined; we see truncated forms in apparently random groupings. Figure 6-64 shows examples of the integration of symmetry properties of polyhedra by twinning. However, the forms that we are ultimately concerned with do not grow like crystals; we have to design them. It would seem, therefore, that an understanding of the symmetry relationships among polyhedra in the 5.3.2 and the 4.3.2 symmetry families is basic to developing new and unique aggregation relationships among forms.

[25] Williams, R. E. 1967. *Geometry, Structure, Environment.* Carbondale, Illinois: Southern Illinois University., pp. 97-112.

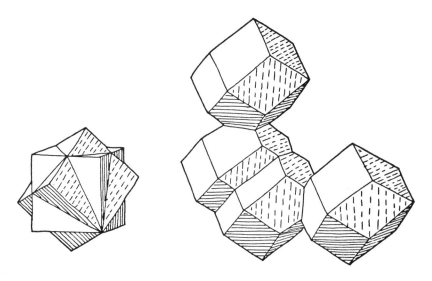

Figure 6-64. Examples of twinning in aggregations of polyhedra.

The rotational symmetry properties of the 4.3.2 symmetry family are most easily understood through an analysis of {4,3} (Figure 6-65). We see in Figure 6-65a, that there are three axes of 4-fold rotational symmetry; in Figure 6-65b, four axes of 3-fold rotational symmetry; and, in Figure 6-65c, six axes of 2-fold rotational symmetry. (If spheres are placed at each axis point, we find that Figure 6-65a gives the simple cubic packing, Figure 6-65b gives the *bcc* packing, and Figure 6-65c gives the *fcc* or *ccp* packing.) Projecting all of these thirteen axes onto the surface of {4,3}, we have lines radiating from its center in twenty-six directions.

(a) (b) (c) (d)

Figure 6-65. (a) the three 4-fold axes of rotational symmetry in {4,3}; (b) the four 3-fold axes of rotational symmetry; (c) the six 2-fold axes of rotational symmetry; (d) the combined thirteen axes of rotational symmetry in {4,3}.

The rotational symmetry properties of polyhedra in the 5.3.2 symmetry family are shown in the spherical {3,5} (Figure 6-66a). There are six axes of 5-fold rotation, ten axes of 3-fold rotation, and fifteen axes of 2-fold rotation—thirty-one in all. By inter-

248

connecting the 3-fold axes on the surface of the spherical {3,5}, we define {5,3} (Figure 6-66b). The remaining regular polyhedra, having 4.3.2 symmetry properties, can be defined by interconnecting certain axes of symmetry on {3,5}, thereby integrating certain symmetry properties of both the 5.3.2 and the 4.3.2 symmetry families. These three polyhedra—{3,4}, {4,3}, and {3,3}—are shown inscribed on the surface of the spherical {3,5} in Figure 6-67a, b, and c, respectively.[26]

Of course, not all of the axes of symmetry in one family are present in the other. This can be seen in Figure 6-68a, where the thirteen axes of {4,3} pass through the surface of {3,5}. The 4-fold and the 3-fold axes of {4,3} correspond to certain 2-fold and 3-fold axes of {3,5}, respectively. In Figure 6-68b, the thirty-one axes of {3,5} are projected onto the surface of {4,3}. Figure 6-68c shows the thirty-one axes of {3,5} and the thirteen axes of {4,3} projected onto their respective surfaces. Eighty-eight lines radiate from the center of {3,5} and {4,3}. They are shown in Figure 6-69. The node represents the integrated symmetry properties of polyhedra in the 4.3.2 and the 5.3.2 symmetry families; it can be used to both generate and describe a significant number of the polyhedra, polyhedra packings, sphere packings, and networks with which we have been concerned in this work.

(a) (b)

Figure 6-66. (a) the symmetry properties of {3,5}; (b) the interconnection of the 3-fold axes to define {5,3}.

[26] Baer, S. 1970. *Zome Primer*. Albuquerque, New Mexico: Zomeworks Corp.

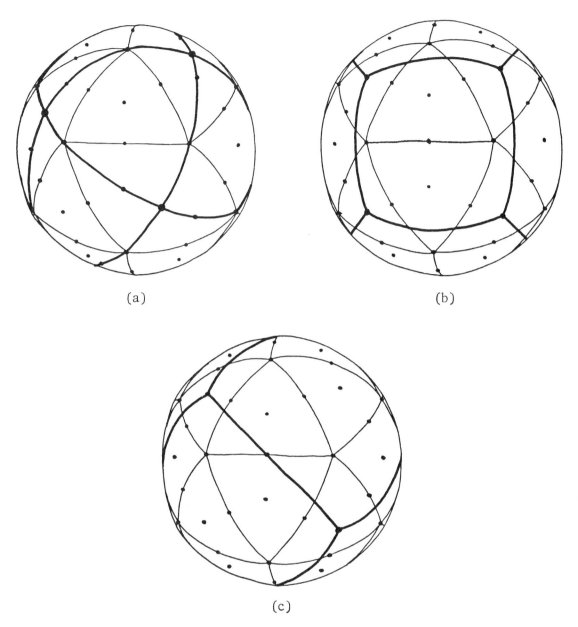

(a)

(b)

(c)

Figure 6-67. (a) the {3,4} defined by interconnecting certain
axes of symmetry of {3,5}; (b) the {4,3} defined by interconnecting
certain axes of symmetry of {3,5}; (c) the {3,3} defined by inter-
connecting certain axes of symmetry of {3,5}.

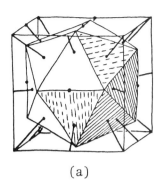

(a) (b) (c)

*Figure 6-68. (a) the thirteen axes of rotational symmetry of
{4,3} projected on the surface of {3,5}; (b) the thirty-one axes of
rotational symmetry of {3,5} projected on the surface of {4,3}; (c)
the combined forty-four axes of rotational symmetry projected on the
surfaces of both {3,5} and {4,3}.*

*Figure 6-69. The node containing the
forty-four axes of symmetry of the poly-
hedra in both the 4.3.2 and 5.3.2 rota-
tional symmetry families.*

6-11. EPILOGUE—COMBINING OPERATIONS

The operations described in *Part Three* can be combined in many ways to generate new forms. In addition, the operations can be performed on entities with which we have not dealt directly. For example, Figure 6-70 shows spheres of various sizes with small circles inscribed on their surfaces. As the planes of these small circles intersect, their surfaces define some of the space-filling polyhedra with which we are quite familiar. These spheres can be *truncated* and aggregated in various combinations to cover space. In addition, the polyhedra defined by small circles can be horizontally *dissected*. Figure 6-71 shows one of the many spatial arrangements of some of these aggregated structures.

In another example, the symmetry integration, dissection, truncation, and augmentation-deletion operations are used in interesting ways. First, the symmetries of 4.6^2 and $V(3.4)^2$ are combined. Each plane face of these polyhedra is perpendicular to one of the twenty-six radial lines of the thirteen axes of rotational symmetry shown in Figure 6-65. The {4} of 4.6^2 are perpendicular to the axes of 4-fold rotation; the {6} of 4.6^2 are perpendicular to the axes of 3-fold rotation; the rhombus faces of $V(3.4)^2$ are perpendicular to the axes of 2-fold rotation. By replacing the faces of 4.6^2 and $V(3.4)^2$ with small circles perpendicular to these twenty-six radial lines, the circles quite beautifully intersect one another at their perimeters. A triangulated small circle structure can be made by augmenting edges and vertices. This structure is shown in Figure 6-72. It can be truncated in twenty-six different directions and aggregated in many space-filling and open packings. Figures 6-73 and 6-74 show these structures in many combinations. Horizontal dissections (see Figures 6-61 and 6-63) can be made within these structures. Figure 6-75 shows these structures combined with polyhedra generated by horizontal dissections of 4.6^2.[27]

Of course, placing any of these theoretical structures successfully in the human environment is another matter. By far the simplest aspect of the problem is the development of the physical means of production, erection, etc. But much more important is our continuing problem of successfully relating the physical form and the user in ways offering maximum probability that the user can maintain human traits. This is a crucial next step in human existence.

[27] Williams, R. E. *op. cit.* pp. 113-172.

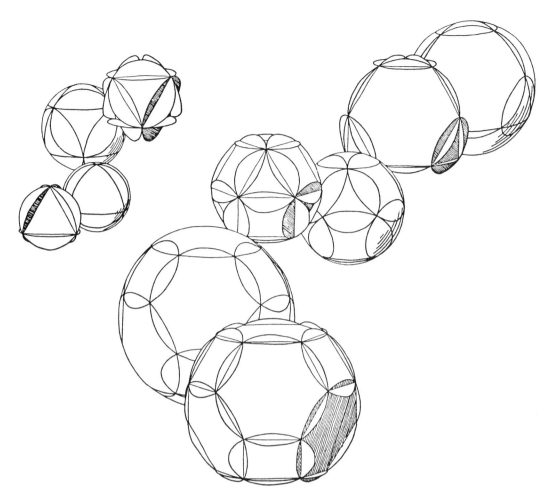

*Figure 6-70. Small circles inscribed on spheres to define faces
of {3,3}, {3,4}, (3.4)², 3.6², and 4.6².*

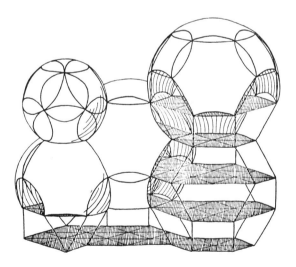

Figure 6-71. An aggregation of polyhedra and small circle spheres.

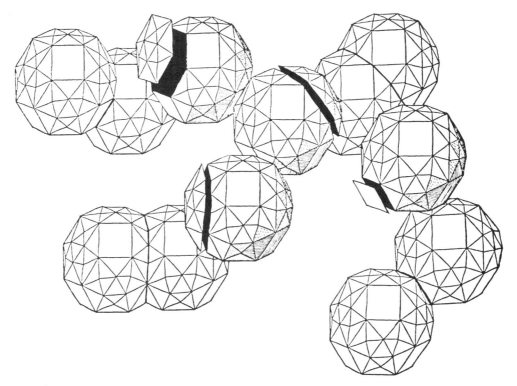

Figure 6-72. The truncation planes of the small circle triangulated structures.

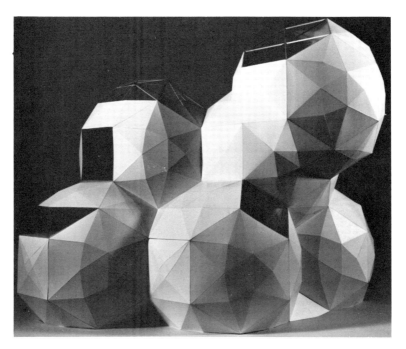

Figure 6-73. An aggregation of small circle triangulated structures.

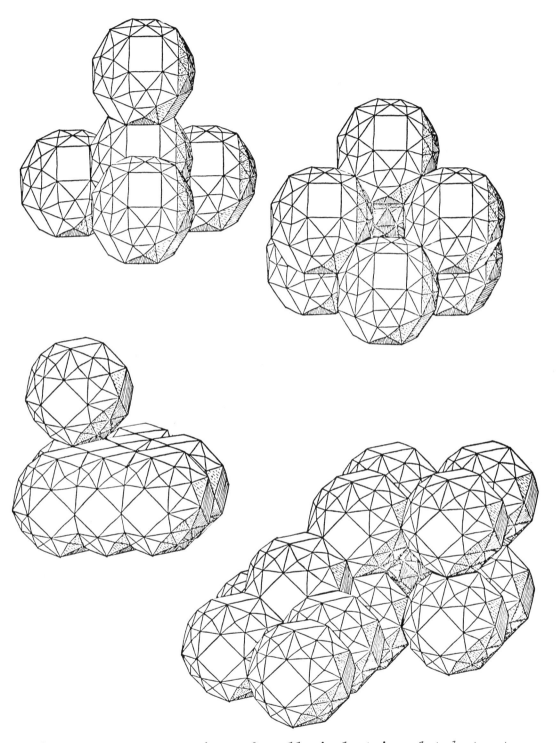

Figure 6-74. Aggregations of small circle triangulated structures.

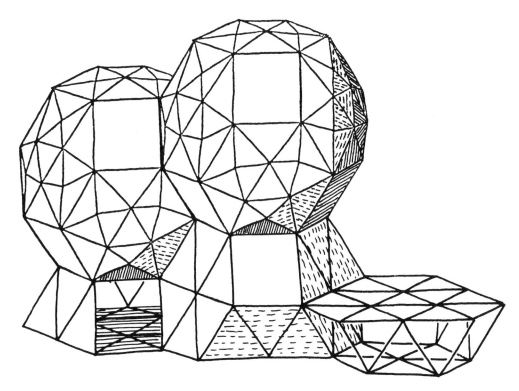

Figure 6-75. Small circle triangulated structures aggregated with polyhedra generated by dissections of 4.6^2.

SELECTED BIBLIOGRAPHY

BIOLOGICAL FORM
Thompson, D. W. 1963. *On Growth and Form*. Cambridge: Cambridge University Press.

CRYSTAL CHEMISTRY
Azároff, L. V. 1960. *Introduction to Solids*. New York: McGraw-Hill Book Co., Inc.
Pauling, L. 1960. *The Nature of the Chemical Bond*. Ithaca, New York: Cornell University Press.
Phillips, F. C. 1963. *An Introduction to Crystallography*. New York: John Wiley & Sons, Inc.
Wells, A. F. 1962. *Structural Inorganic Chemistry*. London: Oxford University Press.

ENGINEERING DESIGN
Borrego, J. 1968. *Space Grid Structures*. Cambridge: M. I. T. Press.
Makowski, Z. S. 1965. *Steel Space Structures*. London: Michael Joseph.
Martin, B. 1968. *The Co-ordination of Dimensions for Building*. London: Royal Institute of British Architects.

ENVIRONMENTAL DESIGN
Alexander, C. 1967. *Notes on the Synthesis of Form*. Cambridge: Harvard University Press.
————, S. Ishikawa, and M. Silverstein. 1968. *A Pattern Language Which Generates Multi-Service Centers*. Berkeley: Center for Environmental Structure.
Kern, K. 1961. *The Owner-Built Home*. Oakhurst, Calif.: Ken Kern Drafting.
Larson, T. C. (ed.). 1965. *Environmental Abstracts*. Ann Arbor: University of Michigan, Architectural Research Laboratory.

FORM
Whyte, L. L. 1968. *Aspects of Form*. London: Lund Humphries.

GEOMETRY
Coxeter, H. S. M. 1963. *Regular Polytopes*. New York: Dover.
Cundy, H. M. and A. P. Rollett. 1961. *Mathematical Models*. London: Oxford University Press.
Fejes Tóth, L. 1964. *Regular Figures*. Oxford: Pergamon Press.
Ghyka, M. 1946. *The Geometry of Art and Life*. New York: Dover Publications.

HIERARCHICAL STRUCTURES
Whyte, L. L., A. G. Wilson, and D. Wilson, (eds.). 1969. *Hierarchical Structures*. New York: American Elsevier Publishing Co.

LINGUISTICS
Chomsky, N. 1968. *Language and Mind*. New York: Harcourt, Brace, & World, Inc.
Hymes, D. (ed.). 1964. *Language, Culture and Society*. New York: Harper & Row.

PHYSICAL ENVIRONMENT
Dubos, R. 1965. *Man Adapting*. New Haven, Conn.: Yale University Press.

PHYSICAL SPACE
Jammer, M. 1969. *Concepts of Space: The History of Space in Physics*. Cambridge: Harvard University Press.
Lanczos, C. 1970. *Space Through the Ages*. London: Academic Press.

PROXIMICS
Hall, E. T. 1959. *The Silent Language*. New York: Fawcett Publications, Inc.
———. 1966. *The Hidden Dimension*. New York: Doubleday & Co.
Sommer, R. *Personal Space: The Behavioral Basis of Design*. Englewood Cliffs, N. J.: Prentice-Hall, Inc.

PSYCHOLOGY
Argyris, C. 1957. *Personality and Organization*. New York: Harper & Row.
———. 1964. *Integrating the Individual and the Organization*. New York: John Wiley & Sons, Inc.
Watzlawick, P., J. H. Beavin, and D. D. Jackson. 1967. *Pragmatics of Human Communication: A Study of Interactional Patterns, Pathologies and Paradoxes*. New York: W. W. Norton & Co.

SYMBOLIC ANALYSIS
Argüelles, J. & M. 1972. *Mandala*. Berkeley: Shambala Publications, Inc.
Brunes, Tons. 1967. *Secrets of Ancient Geometry*. Rhodes Press, Inc.
Cirlot, J. E. 1962. *A Dictionary of Symbols*. New York: Philosophical Library.
Critchlow, K. 1976. *Islamic Patterns: An Analytical and Cosmological Approach*. New York: Schocken Books, Inc.
Crowley, A. *The Book of Thoth*. New York: Lancer Books, Inc.
Duncan, H. D. 1968. *Symbols in Society*. New York: Oxford University Press.
Hall, M. P. 1962. *The Secret Teachings of All Ages*. Los Angeles: Philosophical Research Society.

Jung, C. G. 1958. *Psyche and Symbol*. New York: Doubleday & Co.
Pettis, C. & S. 1976. *Cosmic Geometry: Tantric Transformations*.
 Ithaca, New York: Bliss Press.
Plummer, L. G. 1970. *The Mathematics of the Cosmic Mind*.
 Chicago: Theosophical Publishing House.

Surface area relationships, 17, 102-3
Symbol, 11, 19
Symbolic component, 16
Symbolic level, 16, 19
Symbolic meaning, 11-2, 19
Symmetry, 31, 140-1, 165-99
Symmetry families, 17, 101-2, 122-48
Symmetry integration operation, 247-51

Taft, E. A., 199
Tessellation, 24, 34-51
 Archimedean, 37
 demi-regular, 43
 dual, 35-41
 polymorph, 43
 regular, 37
 semi-regular, 37
Tetrahedral juncture angle, 151-2
Tetrahedral sphere packing, 106 120
Tetrahedron, 63
Tetrahedron-octahedron truss, 4
Tetrakaidecahedron, 153-61
Tetrakis Hexahedron, 79
Theophrastus, 22
Thompson, D. W., 19, 45, 52, 152
Thompson, W., 153
Topology, 17, 44-7
Transformation, 20
Transformational grammar, 16
Translation, 20
Trapezohedra, 98
Trapexoidal Hexecontahedron, 93
Trapezoidal Icositetrahedron, 81
Triakis Icosahedron, 89
Triakis Octahedron, 77
Triakis Tetrahedron, 73
Truncated Cube, 76
Truncated Dodecahedron, 88
Truncated Icosahedron, 90
Truncated Octahedron, 78

Truncated Tetrahedron, 72
Truncation operation, 208-16
Twinning, 247-8
Tyng, A., 52

Unit cell
 crystallographic, 48, 203-6
 topological, 48, 238

Vertex figure, 57, 165
Vertex motion operation, 203-6
Victoria regia, 3
Virus, 20, 31, 139-47, 196
Volume relationships, 102-3
Volvox colonies, 10
Von Foerster, H., 20
Voronoi, G., 43
Voronoi polytope, 43, 111

Wachsmann, K., 3
Waugh, J. L. T., 147
Wells, A. F., vii, 47, 106, 231, 235, 238-9
Whitrow, G. L., 22
Whorf, B. L., 14-5, 28
Whyte, L. L., 27
Widemann, 4
Wiener, N., 116
Williams, J. R., 20
Williams, M. W., 155-6
Williams, R. E., 27, 127, 158, 183, 247, 252
Wilson, A. G., iii, iv, 27
Wilson, D., iii, iv, 27
Wood, D. G., 43, 203, 205, 240
Wulff, J., 107

Yovits, M. C., 10, 20

Zonagon, 241-4
Zonahedron, 241-4
 partial, 243
Zopf, G. W., 20
Zwikker, C., 173